THE FIRST SHOW

THE FIRST SHOW

Painting and Sculpture from Eight Collections

1 9 4 0 – 1 9 8 0

DOMINIQUE DE MENIL

HOWARD AND JEAN LIPMAN

DRS PETER AND IRENE LUDWIG

GIUSEPPE AND GIOVANNA PANZA DI BIUMO

ROBERT A ROWAN

CHARLES AND DORIS SAATCHI

TAFT AND RITA SCHREIBER

THE WEISMAN FAMILY

The Museum of Contemporary Art, Los Angeles

in association with The Arts Publisher, Inc., New York

EDITED BY JULIA BROWN AND BRIDGET JOHNSON

This exhibition is part of The Temporary Contemporary, the Museum's inaugural series of exhibitions and related events. Development of The Temporary Contemporary was funded in part by a major grant from Citicorp/Citibank.

"The First Show: Painting and Sculpture from Eight Collections 1940–1980," has been published by the Museum of Contemporary Art, Los Angeles, in association with The Arts Publisher, Inc., New York.

Design: Tina Beebe, Santa Monica, California
Typesetting: Mondo Typo, Santa Monica, California
Printing: W.M. Brown & Son, Richmond, Virginia
Binding: Sendor Bindery, New York
Text: Berthold Walbaum and Univers
Paper: 80 lb. LOE dull

Printed and bound in the United States of America.
Library of Congress Catalogue Card Number: 83-062369

ISBN 0-914357-00-x

We congratulate The Museum of Contemporary Art on the occasion of its inaugural exhibition, "The First Show: Painting and Sculpture From Eight Collections 1940–1980." This exhibition will provide an opportunity to see outstanding paintings and sculptures of the last forty years, many of which are seldom shown publicly, and to explore different aspects of the philosophy and process of collecting art. It is fitting that as MOCA begins to build its own collection, its opening exhibition should be a major survey of works from some of the world's finest private collections.

Special thanks to the exhibition's lenders; to Pontus Hulten, Richard Koshalek, Julia Brown, and Kerry Brougher, the exhibition's curators; to staff members Sherri Geldin and Robert Sain; and to the Board of Trustees of The Museum of Contemporary Art for its vision and diligence.

The Warner Communications Foundation is indeed honored to sponsor this exhibition and catalogue. We hope that they will be a source of pleasure and inspiration to those who view them.

Steven J. Ross
Chairman of the Board and Chief Executive Officer
Warner Communications, Inc.

Contents

Acknowledgements

Richard Koshalek
Director

Pontus Hulten
Founding Director

This exhibition and its catalogue are the result of the combined efforts of many individuals over a long period of time and mark not only the particular exhibition but the opening of The Temporary Contemporary, the inaugural program of The Museum of Contemporary Art. It is for this reason that we first thank the Board of Trustees, the City of Los Angeles, the Community Redevelopment Agency, the Founders, and the many other supporters of the Museum whose work and contributions have allowed this institution to be realized.

In particular we acknowledge the tireless efforts and dedication of Eli Broad in building the Founding Endowment and his strong commitment to the Museum as Chairman of the Board; the enlightened leadership and constant support of William F. Kieschnick, who led the fund raising for The Temporary Contemporary and its program; the determination and skills of Frederick Nicholas who brought The Temporary Contemporary to completion; Carl Hartnack for his counsel on the management of this project overall; the intelligence and sensitivity of Lenore Greenberg, Chairman of our Program Committee; Judge William Norris, whose early leadership and ongoing counsel as Founding President has been instrumental to our development; Morton Winston for his assistance with our membership program and the development of the 1984 Program Fund; Betye Burton for her support of our audience development plans and for her many efforts as Chairman of Community Relations; and Ignacio Lozano, Jr. for his assistance with MOCA's community newspaper, first published for the opening of The Temporary Contemporary.

We thank Mayor Tom Bradley, Councilman Gilbert Lindsay and his assistant Cathy Moore, and City Councilman Joel Wachs who have provided invaluable support for this project, and for their commitment and enthusiasm for The Temporary Contemporary. Fran Savitch, Administrative Coordinator to the Mayor, and Maureen Kindel, President of the Board of Public Works, have been of tremendous assistance to us from the inception of the Museum. Special thanks are also due to Sylvia Cunliffe, General Manager of the Depart-

ment of General Services; Fred Croton, General Manager of Cultural Affairs; Brookes Treidler, Assistant Director of Public Buildings; William McCarley, Assistant City Administrative Officer of Budgeting and Program Division; Tom Grant, Analyst for Management Services Division. These individuals along with Ed Helfeld, Community Redevelopment Agency Administrator and Donald Cosgrove, Senior Deputy Administrator of the Community Redevelopment Agency have worked to forge a partnership between the Museum and the City that has supported the creation of a new cultural institution in Los Angeles.

The creation of this exhibition, drawing on the richness of eight great collections of contemporary art, is a result of the quality and strength of the individual works and the generosity and involvement of the collectors whose participation in the initial program of the Museum marks a belief in its beginning and its future that we very much appreciate. Their work with us on the development of the checklist, the organization of the exhibition, and their participation in the catalogue has been invaluable. We also thank those individuals who assisted in the arrangement of important loans for the exhibition: for the Ludwig collection, Dr. Evelyn Weiss, Director of Museum Ludwig, Cologne; Dr. Wolfgang Becker, Director of Neue Galerie, Aachen; Dr. Dieter Ronte, Director of Museum Moderner Kunst, Vienna; Dr. Christian Geelhaar, Director of Kunstmuseum, Basel; and Dominique Bozo, Director of Centre Georges Pompidou, Paris; for the de Menil collection, Elsian Couzens, assistant to Mrs. de Menil; Mary Jane Victor, Curator of the Menil Foundation Collection; Paul Winkler, Assistant Director of the Menil Museum; David Ryan, Director of the Fort Worth Art Museum; for the Lipman collection, Tom Armstrong, Director of the Whitney Museum of American Art, and Patterson Sims, Associate Curator of the Whitney Museum of American Art; Delmar Hendricks, Booking Manager of the Lincoln Center for the Performing Arts; and Richard Oldenburg, Director of the Museum of Modern Art; for the Weisman family collection, Mary Halm and Lee Larsen; and for the Schreiber collection, the special help of Lenore and Bernard Greenberg.

We extend our thanks to Guy de Gramont for his dedicated assistance in the coordination of scheduling and transport of the works and to Denise Domergue, Conservator, for her counsel and assistance. Much appreciation is also extended to the participating transport companies for their care and attention to special needs of the works and to the many registrars and conservators who gave their expertise and support to this endeavor.

It has been a special aspect of this exhibition to have a number of works built on site, and we thank those artists for their generous involvement and that of their assistants. We thank Brent Saville of Welton Becket Associates

and his assistant Annie Laurie Pritchard, for the design of the exhibition installation; Paul Marantz for his consultation regarding installation lighting and John Bowsher, Chief Preparator, for overseeing the installation.

Architect Frank O. Gehry, working with Project Architect, Robert Hale, was responsible for the design of The Temporary Contemporary and Andrew Huisman, General Superintendent, and Peter Rylick and Mike Hummel of HCB Contractors realized the renovation of the Museum buildings.

This catalogue has been designed by Los Angeles designer Tina Beebe and published with the Museum by James Witt, President of The Arts Publisher Inc., New York. We thank them both for making this book with us. We greatly appreciate the contributions of Bridget Johnson, Co-Editor of the catalogue and Susan C. Larsen as author of the essay on the eight collections.

This exhibition and catalogue and the Museum itself could not have been realized without the combined and sustained efforts of the entire staff. Sherri Geldin, Administrator, has maintained the organization of the institution throughout its evolution; Robert Sain, Director of Development, with his staff Sue Johnson, Pamela Wilson, Cardie Kremer, and Jeri Grubbs have raised the funds necessary to realize the goals of the Museum, both for The Temporary Contemporary and for laying the foundation for the future. Julia Brown, Senior Curator, was responsible for the organization of the exhibition and its publication and served as Co-Editor with Bridget Johnson. Kerry Brougher, Assistant Curator, provided crucial assistance in all aspects of exhibition and and catalogue organization and was responsible for the coordination of loans, exhibition installation, and photographs for the catalogue. John Spray, Curatorial Intern, researched and contributed greatly to the Founding Director's essay. Kim Bradley, Registrar, and Natasha Ebeling-Koning, Registrarial Assistant, organized shipments of works for the exhibition working with the challenge of geographic complexity and new facilities. Curatorial Secretary June Kino-Cullen provided the secretarial support essential for the realization of this exhibition. Julie Lazar, Curator; Sylvia Hohri, Public Outreach Coordinator; Elizabeth Smith, Assistant Curator; Jacqueline Crist, Curatorial Assistant; and Cathy Allen and Patti Cleere, Curatorial Secretaries, continued work on other parts of the exhibition program critical to The Temporary Contemporary overall. Laurraine Gordon, Office Manager; Sylvee Whitter, Director's Secretary; Toni Randall, Bookkeeper; and Julie Mayerson, Administrative Assistant, provided administrative support essential to the successful realization of a museum program. Renee Kaplan, Volunteer Coordinator, helped us when needed and Toni Tully, Ann Goldstein, Carter Potter, Norman Laich, and Sally Bickford among others, gave generously of their time and skills to assist us.

We extend special appreciation for ongoing counsel and assistance to Lily

Auchincloss, Ivan Chermayeff, Leo Castelli, Stephen Garrett, James Demetrion, John Hallmark Neff, Robert Irwin, Margo Leavin, Dorothy Sherwood, Gene Summers, Aviva Covitz, Herman Guttman, Robert McFarlane, Robert Barnett, Jeffrey Grausam, Nancy Howard, Charles Rosenberg, Robert Fitzpatrick, and Winthrop G. Brown.

Major funding for this exhibition and its publication has been provided by the Warner Communications Foundation, with special thanks to Steven J. Ross, Chairman of the Board and Chief Executive Officer, Warner Communications, Inc.; Roger R. Smith, Vice-President, Corporate Affairs, and I. Peter Wolff, Executive Director, Warner Communications Foundation. Additional support was provided by Mr. and Mrs. Albert Levinson. We thank Wayne M. Hoffman, Chairman and Chief Executive Officer of Tiger International, Virginia Dixon and Peter Hubbard for the assistance of Flying Tigers in the transportation of works for this exhibition and Michael L. Muse, President of Muse Air Corporation for providing shipment of particularly fragile works from Houston to Los Angeles. We thank Gerald Foster of Pacific Telephone for sponsoring an international press conference by telephone so as to widely inform the press and public though new channels of information; Knoll International for the loan of Harry Bertoia benches for the duration of The Temporary Contemporary; and Bruce Schwaegler, President, and Franklin Simon, Chairman of Bullocks, for their generosity in hosting the opening reception for The Temporary Contemporary and "The First Show." Saul Warshaw and Monika Young of Ruder Finn and Rotman managed public relations for this exhibition and for The Temporary Contemporary. Initial support for the development of The Temporary Contemporary was provided by Citicorp/Citibank, with particular thanks to Walter B. Wriston, Chairman, Citibank, N.A., and Wilford M. Farnsworth, Senior Vice-President, Citicorp (U.S.A.), Inc.

Foreword

Julia Brown
Senior Curator

This catalogue is published on the occasion of The Museum of Contemporary Art's inaugural exhibition, a selection of painting and sculpture from eight collections of contemporary art, three from Europe and five from the United States. A selection of works of art indicating significant directions in recent art history and historical development and innovation is a means of introducing a very rich and diverse period of visual art and a newly formed museum of contemporary arts. This exhibition assembles important works of art from the last four decades that reveal the unique character of each of these collections. Many of these works will be seen in Los Angeles for the first time.

An exhibition such as this is also a consideration of the activity of collecting art, an area of great relevance to the definition of a museum. A critical question for a museum of contemporary art is how to remain current and responsive to the best new work while still being attentive to the evolving history of art in preserving its recent past and its sources. In so doing, a resource and foundation is created for future work. The public collection has a responsibility to the history of art, to the audience, and to the intentions of the artist. In this respect, it is different from the private collection, which is primarily an expression of the vision and interests of an individual.

The eight collections shown in the exhibition share the characteristic of an intense involvement with the art made at the time the collection was being formed; each has its own particular commitments. These collections have been maintained for the most part as coherent wholes, though each has evolved in a very different way. However, within the parameters of a selection of painting and sculpture, available from eight private collections chosen from among a number of important collections in Europe and the United States, this exhibition cannot be considered a complete survey of the past four decades.

Portraits of the individual collectors emerge through the cumulative effect of their choices. The individual who forms passionate attachments to works of art, who becomes deeply involved in pursuit and acquisition, begins to form

something that takes on a life of its own through the combined force of the individual works and the nature of the collection as a whole. There is an exchange that takes place in this activity. On the most basic level an exchange of money for art, and in some instances one object for another, but also a transmittal of experience from studio to private home and a form of communication between the recipient of the work and the artist through the work of art.

Considering art as a witness to, and an expression of, its time, the serious collector, through a committed involvement with contemporary art, shares an understanding of the world as expressed through an artist's vision. An involvement with a work of art is deeply personal in the way that an individual responds to, and recognizes, an echo of his or her feelings and thoughts. Collecting is an activity that involves both personal response and a larger responsibility to the culture and society in which the collector lives by the forging, consciously or unconsciously, of a link between the present and posterity. Collecting is intrinsically an activity of record, holding and safeguarding what has taken place in the present for the future.

A bridge is created between the existence of the work of art in the studio and its place in the world. The perception of the work of art is influenced by the context in which it is seen; the studio, the home, the gallery, or the public institution or place. There are complex relationships between the private collection and the museum; these entities evolve and continue to be defined as art itself changes. In a collection of art each work influences the other and a cumulative meaning emerges from an assembling of objects. The value of a collection is derived from the quality and potency of its individual works, but the assembling of works takes on added significance. A collection becomes a statement about the styles, values, and ideas of the time. Each work is understood in relation to a larger context of other works, its time and its physical and social place. The choice of works, when reflecting the point of view and understanding of one or two individuals, gives a particular character and direction to a collection. In a contemporary collection, the involvement and intention of the artist in how a work should be seen and understood is particularly important.

The words *collect* and *collection* are inadequate, as they suggest the acquiring, gathering, and housing of objects and do not fully describe the complexity of influences that are engendered in the response to the work of art and its passage from inception to how and where it is finally placed and seen.

In the pages that follow, a number of great modern collections are profiled and the collections that are the subject of this exhibition are discussed as a background to the interviews and notes by the individual collectors. These interviews were conducted by the staff of the Museum in the winter and spring of 1983 and serve as a personal introduction to the assembled works.

Collecting Contemporary Art

Pontus Hulten

The first exhibition in a new museum is an important event. As we were exploring the many different possibilities for the exhibition concept, several ideas stood out and helped to unify our thinking. We wanted to mark out the territory of the new museum and the time frame of its future collection. It was important that the ideas of collecting and building great collections be present. The role of the artist not only as the maker of art but as a secret and visionary force in society should be apparent. In planning the exhibition, we also had practical questions to answer: to whom would we turn to get representative works of outstanding quality, and how could we realize our ambitions for the exhibition in a relatively short time, with a very small staff? We were aware that some of these elements were, if not contradictory, at least pulling in different directions. But we were also aware that there could be an overlapping of intentions, if we were lucky. So we decided to organize this exhibition as an attempt to give an overview of contemporary art as seen through its presence in eight great private collections.

Our first question was, what is contemporary art? The time frame for this exhibition should be the same as for the programs and collection of the museum: the last four decades. This delimitation is as useful as any other necessary delimitation. There is sometimes a tendency to confuse political history with changes in culture; we tend to think about art "before the war" or art "after the war." But it turns out that art during both of the world-war periods in this century was very much alive, although obviously under different circumstances. The greatest American invention in art was the creation of "an American space" in painting–space different from the Renaissance or Cubist perspectives–seen, for example, in the work of Mark Tobey, Jackson Pollock, Clyfford Still, and Barnett Newman. This happened about forty years ago; no more suitable date could be found.

We realized that we had to make some very important and regrettable exclusions from this exhibition, in relation to the domain of the future museum.

For several practical reasons, we would have to wait for another occasion to show works on paper, such as drawings and prints; the huge and important field of photography would have to be dealt with separately, as would art forms that rarely appear in collections or pose special challenges such as video art, experimental film, performing arts, large-scale sited sculpture.

In our research, we found that a small number of collectors were constantly named in terms of the significance and coherance of their collections. As we wanted our exhibition to be concerned with collecting, it seemed obvious that we should focus on a limited number of collections of clear identity that included works of great quality. A selection from a limited number of collections could not present a complete survey of contemporary art, but on the other hand, would such an attempt at making a definitive statement be desirable or even possible? We recognized also that we were making choices from within an already established framework and were therefore making selections from selections. It seemed that we had before us a plan of great complexity, one containing a fair number of interesting ambiguities; even the fact that certain things would *not* be represented in the exhibition might be of interest in revealing the possibilities and parameters for a private collection of art.

A collection starts with a number of random objects. Then, over the years, the willpower and intelligence of the collector shapes the collection, which always becomes a kind of picture of his or her personality or the combined agreement of a couple in taste and approach to life. The role of the great collectors in the evolution of modern art has been immense; it is difficult to overestimate their importance. The fact that they have sometimes made their collections public is important and, in some cases, has probably changed the course of art. But even more crucial is the support and recognition that these collectors have given to artists when they were not yet widely known or accepted by the public.

Here will follow a brief description of nine collections, brought together in North America or Europe during the first half of this century. It is interesting to note that one artist, Marcel Duchamp, who was as important as any other artist in this period in terms of his contribution to the development of art, also played an essential role in advising four of these nine collectors.

At the turn of the century, the great economic and cultural expansion occurring in North America and Europe was also taking place in Russia. It was impossible to hold back the dammed-up curiosity and intellectually dynamic forces, and in a few years immense political and cultural activity took place. Between the beginning of the century and the revolution of 1917, two collectors were very important: Ivan Morozov and Sergei Schukin. Morozov belonged to a family in which art collecting was not unusual, but his judgment was amazing.

He started out as a painter but got more and more absorbed in collecting. Little by little, he liberated himself from the advice of his friends. He bought works by Chagall before anybody else did and helped Chagall go to Paris to study.

At the beginning of the century his interest turned from Russian art (he bought, for example, the work of the great Mikhail Vrubel) to contemporary French art. He commissioned Bonnard, Vuillard, and Maurice Denis to paint large decorative works for his house in Moscow. He bought many works of Cézanne, Van Gogh, Manet, Renoir, Gauguin, and some works from then much less well known young painters such as Vlaminck, Marquet, and Herbin. He hesitated before the power of the paintings by Matisse and Picasso but finally bought very important works by Picasso, whom he met in Paris in 1908 and 1912. In 1912 he bought from Matisse, among other canvases, the wonderful *Moroccan Triptych*. He invited Maurice Denis to come and stay in Moscow for some months. Denis kept a journal, and thanks to him, we know more about art life in Moscow at that time.

The other great collector of contemporary art in Moscow, Sergei Schukin, was perhaps equipped with an even more explosive curiosity than Morozov. He started to collect around 1890 and turned toward the French avant-garde in 1906–that is to say, more or less at the moment that it started to exist. In 1910 he commissioned two enormous paintings by Matisse for his house, *The Music* and *The Dance*, and they became the most daring paintings that Matisse ever did. They were shown at the Salon d'Automne in Paris and then sent to Moscow. Schukin bought thirty-seven paintings by Matisse and fifty-four by Picasso. Asked by a journalist what his criteria were, he answered, "I buy what nobody else buys." His collection was open to the public one day a week, and it became the meeting place of the young intellectuals of Moscow. Thanks to Schukin's sureness of judgment, Matisse's and Picasso's best canvases left the studios as soon as the paint was dry. The French public saw new works at the yearly salons, but thanks to Schukin and Morozov, Moscow was for a number of years the capital of the new French art.

At the outbreak of the war each of the two collectors had about 250 French works in their collections. In 1918 the collections were nationalized, and the French works became the core of the Museum of Western Art, which, in the 1940s, was fused into the national collections of the Hermitage in Leningrad and the Pushkin Museum in Moscow, where they still form the bulk of the French collection. Schukin went through a series of personal disasters and died in Paris in 1936. Morozov became the curator of his own collection in 1919, when it was put into some rooms at the mansion he had formerly owned. Soon afterward, he had to leave the Soviet Union for the newly created Czechoslovakia, where he died in 1921.

The Stein family–Leo (1872–1947); Gertrude (1874–1946); Michael (1865–1938); and his wife, Sarah (1870–1953)–was a very different group of people. In spite of the fact that they were the subject of a beautiful exhibition in the Museum of Modern Art in New York in 1970, it is still not easy to determine who played which role in their personal drama. Gertrude was the one who came to be part of art history due to the support she gave Picasso in one of the most critical periods of his life, 1906–07, when he was working on *Les Demoiselles d'Avignon.* She was probably the one person who profoundly understood what he was doing, and of course, the evolution of her writing style echoes Picasso's painterly experiments.

The Steins were rich Americans who lived in Europe. They had plenty of time to read, study, go to galleries and studios, write, and quarrel. They were dilettantes in the very best sense of the word. They started together but then went their own different ways. In Paris, within the space of a few weeks in the fall of 1905, they all bought their first paintings by Matisse and Picasso. The initial catalyst was Leo Stein.

At the beginning of her life at 27 Rue de Fleurus in Paris, Gertrude had not yet formulated a distinct view of contemporary art. This came through her continuous discussions with Picasso and later Juan Gris, whom she was one of the first to distinguish as an important artist. It also came through her experiments in writing and by a process of osmosis through contact with the guests on Saturday evenings: Henri Rousseau, Picasso, Apollinaire, Braque, Matisse, Marinetti. Those gatherings provided a halfway house of ideas between the old and new worlds. Younger artists such as Marcel Duchamp, Picabia, Marsden Hartley, Joseph Stella, and Charles Demuth, and writers such as Hemingway and the critic Walter Pach were all party to the exchange of ideas that took place there, and it was they who took these ideas back to America.

John Quinn was a lawyer from Ohio specializing in financial law. He started first collecting books, autographed first editions of Joseph Conrad, Ezra Pound, T.S. Eliot, and the Yeats brothers. By the time of the Armory Show in New York in 1913, he had been to Paris twice to look at the new art and was the largest single contributor to the Armory show, lending seventy-nine works. He was also the largest buyer from the show. He was so struck by the exhibition that he visited it almost every evening. He very quickly brought together what became the most important collection of avant-garde art assembled in the United States at that time. In 1915 he bought six major oil paintings by Picasso in one day. The sculptors he was most interested in were Raymond Duchamp-Villon and Constantin Brancusi. With the help of Marcel Duchamp, he eventually acquired almost every known piece that Brancusi produced between 1919 and 1924, and systematically tracked down and purchased every work by

Duchamp-Villon, who had died in 1918. He became very close to Duchamp and listened to his advice. He helped Duchamp to establish himself when Duchamp arrived in the United States.

After a period of illness, Quinn went back to Paris in 1921. He then focused his attention on the work of a few living artists: Matisse, Derain, Braque, and Picasso. His expenditures were so great that he was obliged to sell his book collection.

Quinn died in 1924 without leaving instructions for the disposition of his vast collection. It was dispersed at a series of auctions. Quinn helped to establish New York as an important world art center by buying important art and bringing it there. But equally important were his achievements as a patron of artists and his organizational and legal assistance to artistic causes. He was instrumental in organizing the issues for many art associations, and he won the legal battle that led to the repeal of the import tax on art in October 1913. He believed that supporting living artists and buying their work allowed one to participate in the creative process.

One of the most mysterious art-world figures of this century is Albert Barnes. He came from a very poor background in Philadelphia. While in high school, he started painting which he continued during his studies in medicine at Pennsylvania State University. After leaving the university, he went to Germany to do research in chemistry. Together with a German fellow student, he developed a powerful antiseptic called Argyrol. Barnes very soon bought out his companion and became, in 1902, the sole beneficiary of the enormous profits. He was determined to devote his life to art but was disillusioned with his lack of artistic talent. He started to buy works of other artists. During the first years of collecting, his Philadelphia schoolmate William Glackens gave him advice. In 1912, he sent Glackens to Paris with $21,000 to buy new art for him, and the following year, he went himself and met the Steins. He was at first rather disturbed at what he saw, but he finally bought one Matisse and one Picasso. When World War I came, he sold the patent for Argyrol to the government and thereafter was able to devote his attention exclusively to art. Each year, he made the rounds of the Parisian galleries, bringing home copious additions to his collection. The news of his arrival in Paris spread quickly, as he was known to buy paintings by the dozens. He loved to visit studios and occasionally purchased the entire contents of a studio.

In 1920, Barnes established a foundation bearing his name. It was housed in Merion, a suburb of Philadelphia, and it was presented as a place of study and contemplation for the public. The foundation was open only two days a week and every visitor had to have Barnes's permission to enter; this regulation occasioned a series of endless quarrels. Barnes's rather aggressive style

and overbearing manner did not spare anyone who came in touch with him, and after some years it became something of a sport to provoke his anger. Barnes gave classes in art appreciation at the foundation, favoring the working-class citizens of Philadelphia, in order to "elevate minds uncluttered with any learning." His collection and his educational aspirations soon became the butt of articles in the press. He began leading a more isolated life, believing himself to be a victim of all kinds of persecutions.

These absurdities should not obscure the fact that Albert Barnes put together a collection of outstanding quality, one containing a comparatively small percentage of second-rate work. At his death in 1951 it contained 120 Renoirs, 100 Cézannes, 80 Matisses, 30 Soutines, 25 Picassos, and 10 Van Goghs, many of them among the best works of those artists. The fact that the Barnes Foundation does not allow loans and does not favor any kind of photographic reproduction of the objects in the collection has unfortunately rendered this enormous bulk of great work largely unavailable.

It is very striking that so many of the collectors of the early part of the century had a zeal to popularize contemporary art by trying to educate the general public, and this is certainly the case with Barnes as well as with Albert Eugene Gallatin and Katherine Dreier. Of all of them, Gallatin was the one whose work was marked by the greatest simplicity, consequence, and success. In 1927 he opened his Gallery of Living Art in the South Study Hall of New York University, overlooking Washington Square. For the next fifteen years his collection developed intensively. It was continually on public display, free of charge. It was shown in an informal atmosphere and stayed open evenings to encourage students and working people to visit.

Gallatin belonged to an important New York family with political connections and was known as an elegant socialite. His great-grandfather was one of the founders of New York University. Gallatin's taste ran to clean, intellectual, and nonostentatious art. His collecting was somewhat different from that of most other collectors of the twenties and thirties, in that he was not interested in surveying contemporary styles but instead concentrated on those developments that evolved out of Cézanne, from Cubism to Constructivism and Neoplasticism. He was nicknamed the Park Avenue Cubist. In his own social class his predilection for contemporary art and his activities as a collector were often subjects of ridicule. Gallatin had a scholarly approach to his acquisitions and spent time studying works of the artists he was interested in: Picasso, Braque, Léger, Klee, Miró, Arp, Brancusi, Mondrian, and Van Doesburg. Gallatin was also very interested in Demuth, Hartley, Marin, and Sheeler, and gave them important support. By 1933 his collection was serving the functions of a museum with important groups of works of American and European art. Gallatin

changed its name to the Museum of Living Art. The museum contributed greatly to the education of a generation of American artists in the thirties. Hans Hofmann, for example, frequently took students there to see the collection.

In 1942 the university asked Gallatin to remove the museum, to make more room for the library. Gallatin then donated all the art he owned to the Philadelphia Museum of Art, where it was included in the museum's growing collection of modern art. The collection opened to the public in Philadelphia in 1943.

Art was also something of a cause for Katherine Dreier, but in a rather different way. She was herself a painter, and her interests were extremely wide. As for so many Americans, the Armory Show of 1913 came as a revelation to her. She was one of its financial backers and had a painting in the exhibition, but most important, it gave her a solid introduction to modernism and the European avant-garde.

In 1916 she became involved in the formation of the Society of Independent Artists, which was dedicated to sponsoring unjuried exhibitions open to all artistic styles. As one of the society's directors and chief financial backers, she found herself thrust into the Arensberg circle. Here she was brought into direct contact with the leading artistic figures of the New York avant-garde.

It was during this period that she met Marcel Duchamp, and they became close, lifelong friends. Dreier, together with Man Ray and Duchamp, became a major force on the New York art scene and launched the New York version of Dada with enormous gusto. Dreier wanted to set up a center to promote the newest art. The name that she and her associates chose reflected the reigning Dada spirit. It was Man Ray who proposed that it be called Société Anonyme, the French term for *corporation*. As the Société Anonyme had to have legal status, it became in translation "Corporation Incorporated." Its full name was Collection of the Société Anonyme: Museum of Modern Art 1920–the first time the words *museum* and *modern art* were brought together in a name. It opened to the public in 1923 in two rented rooms in a Victorian brownstone at 19 East Forty-seventh Street. Despite Dreier's more academic approach, she allowed herself to be carried along by Duchamp and Man Ray. For the first show the walls had been stripped of the moldings and were covered with white oilcloth. Each work was framed with a border of lace paper. The announcement for the Archipenko exhibition consisted of a piece in *Arts* magazine that took the form of an advertisement for the "Archie Pen Co."

The Société Anonyme gave the first one-man shows of Archipenko, Jacques Villon, Kandinsky, and Klee. In other exhibitions the work of Miró, Mondrian, and Schwitters was seen in America for the first time.

By 1924 the Société was forced to leave the rented premises and become

a virtual "museum without walls." These circumstances forced it to initiate the first traveling exhibitions. In 1926, Dreier assembled a major exhibition for the Brooklyn Museum, "The International Exhibition of Modern Art." It was the most significant exhibition of modern art since the Armory Show. It was here that Marcel Duchamp showed *The Large Glass (The Bride Stripped Bare by Her Bachelors, Even)* for the one and only time before it was broken.

Dreier lost most of her money in the stock-market crash of 1929 and returned to her home in Connecticut. It was there that Duchamp undertook to repair *The Large Glass*. Most of the collection was stored in Dreier's barn, and she continued to acquire work on a much diminished budget. In 1941 she donated the collection to Yale University, to give it a permanent home, but for ten more years continued to try to fill what she considered gaps in the collection. In spite of the fact that she and Duchamp published a wonderful catalogue that contains some of the best and most surprising writing about modern art, the collection is not well known. This is perhaps because the collection, although extraordinarily wide and varied, includes so many works by almost unknown Cubist, Dada, and Constructivist artists from eastern Europe, Italy, and South America. Katherine Dreier's collection ultimately contained 616 works, including a great number of masterpieces from the twenties.

The other important collector on the New York Dada scene was Walter Arensberg, certainly a very different kind of person from Katherine Dreier. He had studied English literature at Harvard, and wrote poetry inspired by the French symbolists. The Armory Show was the great catalyst for him, as for so many. He met Walter Pach at the show, and in 1915, Pach introduced him to Marcel Duchamp. Their subsequent friendship profoundly affected the direction of Arensberg's collecting. Arensberg had married Louise Stephens in 1907, and they joined their intellectual and economic forces in the building of their joint collection. Louise had studied music and continued her interest in experimental music. She was a quiet and somewhat shy person with a keen sense of humor. When it came to selecting work, the Arensbergs seem to have almost always been in total agreement. Their apartment in New York became a center for New York Dada activities. In an atmosphere of an ongoing party, young American artists and poets met with visiting or exiled European intellectuals. The names of the inner circle conjure up a picture of the magnetism of this couple: Picabia, Man Ray, Albert Gleizes, Jean Crotti, Henri-Pierre Roché, Joseph Stella, Marsden Hartley, Charles Demuth, Charles Sheeler, Arthur Dove, John Covert, Walter Pach, George Bellows, John Sloan.

Arensberg sponsored and underwrote all the Dada magazines that appeared in New York: *The Blind Man, Rongwrong,* and *New York Dada.* In 1921 the Arensbergs moved to Los Angeles to lead a quieter life. They continued

to build their collection, which would become an extraordinary anthology of the best in modern art. They rarely left their home. Walter was involved in studies of Renaissance literature; he tried, by cryptographic analysis, to prove that Shakespeare's plays had in reality been written by Francis Bacon. He shared with Marcel Duchamp something of an obsession for the hidden meaning, the secret voice. During their years in Los Angeles the Arensbergs stayed in contact with Duchamp, who often acted as their agent and was ultimately responsible for helping them acquire over one-third of all the work they owned. The Arensbergs bought all of Duchamp's work that became available. Before the Arensbergs' deaths, in 1952, they had bequeathed their entire collection to the Philadelphia Museum of Art. It then consisted of about forty works by Duchamp, seventeen sculptures by Brancusi, and a great selection showing in a very remarkable way many of the important moments in the history of modern art.

In 1934, Peggy Guggenheim was a wealthy young woman living in Paris with two children. The man she had lived with had died, and she decided to open an art gallery. She was told to read Bernard Berenson, but that did not bring her beyond Impressionism. It was at this moment that Marcel Duchamp became her mentor and with her made the rounds of the galleries and the studios of the Surrealists. She met André Breton, Jean Arp, Jean Cocteau, and many others and was strongly attracted by their work. She opened her gallery in London in 1938. It was called Guggenheim Jeune, an oblique reference to her famous uncle, Solomon Guggenheim, the family elder and great collector.

Guggenheim Jeune lasted for two years, during which the gallery exhibited many important artists including Arp, Moore, Kandinsky, Klee, Tanguy, and Dali. Peggy Guggenheim was the best client of her own gallery, usually buying something from each show and once buying an entire show of Yves Tanguy. By 1939 the gallery was losing $5,000 a month, but by then Peggy Guggenheim was determined to widen the scope of her activities and open a permanent museum in London. She hired Herbert Read to be the curator and found a house in which to display her collection and some works borrowed from others. While preparations were under way, she left for France to choose more pictures. While she was there, World War II broke out. She had gone to Paris with a list prepared by Read, a systematic compilation of works representative of all the major art movements from 1910 to the present. Although she disregarded the earliest periods, it eventually became the blueprint for her collection. She had similar lists compiled by Breton and Duchamp. She determined to buy one work of art a day and set out around the galleries and studios. While the Germans were overrunning France, she bought works by Dali, Man Ray,

Giacometti, Pevsner, and Léger.

When it became apparent that the Germans would soon occupy Paris, she tried to protect her collection. She applied to the Louvre for storage space, but when an official visited her to see the collection, he reputedly declared that it was not worth saving. She finally managed to sequester it in a friend's barn and fled to the unoccupied part of France, where she shared a house with Jean Arp, Sophie Tauber-Arp, and Nellie van Doesburg, widow of the Dutch painter. She gave money to many artists and intellectuals who wanted to flee Europe for America. After considerable difficulty, she left by ship for New York with the collection in the hold. One of the artists she helped was Max Ernst, who was in great danger; being a German living in France, he was sought by both the French and the German authorities. She considered Ernst to be the best of the Surrealist artists and had fallen in love with him. Soon after their arrival in New York in 1941, they were married.

Peggy Guggenheim continued to expand her collection, now guided by Max Ernst and Alfred Barr. She published a documentary catalogue and opened a gallery and museum on Madison Avenue called Art of this Century. The gallery space was reserved for changing exhibitions, including group exhibitions of young artists. While she continued to take advice on the permanent collection, she acted on her own in choosing the new work. Pollock, Motherwell, Baziotes, Reinhardt, Rothko, and Still were among the artists who had their first one-man exhibitions at Art of this Century. Peggy Guggenheim thought that Jackson Pollock was the greatest artist of this new generation and supported him with a monthly allowance. She ended up owning about forty of his paintings. She gave several to different museums, ultimately keeping ten in her collection in Venice. Her early support was essential to Pollock.

She thought of her stay in America as an exile from Europe, so in 1947 she bought an eighteenth-century palazzo on Venice's Grand Canal and moved there. Soon after her arrival in Italy, she was invited to show her collection at the 1948 Venice Biennale. Among the signs on the exhibition grounds identifying the various nations participating was one reading "Guggenheim." Temporarily elevated to national status, her collection was a great success and subsequently traveled to Amsterdam and Zurich.

The palazzo became the final resting place for her important collection of Cubist, Surrealist, and Constructivist art. In 1951 she opened the collection to the public three days a week. In 1957 she set up a foundation to preserve her collection and in her will bequeathed it to the Guggenheim Museum in New York with the stipulation that it had to stay in the palazzo for the summer months and to be open to the public. Italy thus got its first museum of modern art in the true sense of the term. The collection remains one of the best historic surveys of modern art in Europe.

Art now has a greater influence in society than it had earlier, and the role of the collector has become even more important. The collectors of the earlier part of the century all took part in the avant-garde of that time in some way; their adventures happened at the edges of the well-established circles. Collectors are now a recognized and necessary part of the art establishment; their role is central.

When we were deciding what collections would be represented in this exhibition, we wanted to have a wide geographical distribution but with a certain dominance of California collections. We think that we have found a good equilibrium. The California collectors have been friends of the museum for a long time. The collectors from New York, the Lipmans, have concentrated almost all their efforts on helping one museum and are perhaps less well known in California, but their contribution is unique and exemplary. The de Menil collection is well known by reputation and is of course a very special case, housed in three cities–Houston, Paris, and New York. Immediately after our exhibition, the de Menil collection will be shown in a more complete way in the Grand Palais, in Paris. The European collections already are of major importance in their respective countries. The essay and interviews that follow give further insight into the activity of collecting and the relationships formed between art and its audience.

Collecting in Our Time

Susan C. Larsen

Great collections of contemporary art stand poised between the immediate present and the ordered fictions of history. They are dynamic, living entities drawing from the energies of individual artists and adding an unforeseen dimension, that of an intellectual and emotional structure suggested by the collector. The collecting of contemporary art is in large part an adventure in self-development involving the accumulation and orchestration of a series of vital and important objects. Private collectors are unique in that their awareness can grow out of an intimate day-to-day dialogue with works of art. The intrinsic qualities and expressive range of a work are slowly revealed over time and against the background of daily life. Very often the collector's perception of a work changes and deepens as it is seen in the company of other art and other sensitive viewers. Who among us is not aroused to a state of anticipation and curiosity at the prospect of viewing a private collection? We hope and expect to see something marvelous; we also expect to learn more about the collector and look for clues to character in a pattern of significant choices.

In certain instances, this valuable and volatile human instinct for collecting is matched by great sensitivity to works of art, the capacity to take risks in an unknown area, and the ability to discern the inner vitality and lasting value in contemporary art. The collections of such individuals go beyond the accumulation of related objects to become something inspired, illuminating individual works in the ensemble and functioning as a resource for artists and others seriously involved in art. Such collectors rarely conceive of their activity as a static one with a fixed goal. They do not function in the manner of a stamp collector concerned with filling in an empty and predetermined place in a series. Instead, the great contemporary collector is an active participant in his or her own time, sees the interrelationships of the works of individual artists, supports specific styles or directions, and creates a collection with a definite character and point of view. With each new acquisition, the collection shifts and changes, or gains or loses, its focus and must occasionally be put right again even if this involves

a substantial commitment to a new emphasis or a painful process of editing. The private collector is in the unique and enviable position of answering to no one, except perhaps a spouse, and can act as quickly as resources permit. This very independence is a source of risk and a spur to creativity, as the individual is able to express a personal rather than a collective opinion and can put works of art together in ways other than the linear, chronological one standard to most museum practice.

The serious collector functions in a manner unknown to many of his or her peers. Few would suspect how many hours in an average week are devoted to viewing, studying, and pursuing works of art. The actual event of purchase is generally preceded by a period of thoughtful consideration of the artist's work during which acquaintance grows into an early level of understanding. Afterward, the opportunity to live with a work deepens the experience and may alter a person's entire aesthetic sensibility. Most serious collectors also spend a great deal of time traveling and seeking out the many different people involved, including artists, other collectors, dealers, curators, and critics. In the end, the choice is invariably a personal decision but one that is generally grounded in an extraordinary grasp of the aesthetic and theoretical context of recent art and sharpened by conversation, viewing, and reading. What may have begun as an avocation becomes as steady, fluid, and ongoing as a river, drawing the collector's human and economic resources into its irresistibly compelling rhythm. There are, however, enormous satisfactions to be found along the way: a sense of participation in one's own time and culture, the many friendships and profoundly memorable human encounters with artists and others involved in art, and the beauty and speaking power of the works of art themselves. Much is given but much is also received, as the eight collectors have acknowledged in their interviews, each within a unique and personal context.

Among the most ambitious and far-reaching of these eight is the collection of Dr. Peter Ludwig and Professor Irene Ludwig of Aachen, Germany. They are best known in the United States for their holdings of Pop art of the late fifties and early sixties, the finest and most comprehensive collection of this style and period in the world. During those years, the Ludwigs acquired many of the strongest, most challenging works of Jasper Johns, Roy Lichtenstein, Claes Oldenburg, Robert Rauschenberg, James Rosenquist, Andy Warhol, Tom Wesselmann, and others. The Ludwigs were drawn to figurative work with strong political and social overtones–satiric, erotic, and expressing the restless energy of the period. Warhol's *129 Die in Jet Plane Crash* (1962) is a disquieting image presented as an enormous, out-of-scale newspaper photodrama. The aggressive, forward-pressing blast of machine-gun fire in Lichtenstein's *Takka Takka* (1962) is able to dominate and displace its immediate environ-

ment, and Rosenquist's evocative portrait *Untitled (Joan Crawford Says)* (1964) has altered as the public image of the actress is endlessly reinterpreted in the media. It has often been said–and with good reason–that a visit to Museum Ludwig in Cologne is essential to an understanding of American Pop art. The Ludwig collection contains many of the earliest and best-known examples of Pop art, including works by Jasper Johns, the bronze ale cans being the most famous.

The visitor has other surprises in store, for the collection reveals the full range of postwar European art, focusing on Arman, Georg Baselitz, Joseph Beuys, the Cobra Group, Lucio Fontana, and A.R. Penck. It is only in such a comprehensive collection, with its unique grasp of the essential features of both European and American art of the postwar era, that one can begin to grasp the larger context of the period as it has unfolded on both sides of the Atlantic. Seeing the work of the Cobra Group, we are prompted to consider and compare it to the later phases of the New York school during the late fifties and early sixties. We begin to observe how the concrete or pictorial interpretations of found objects function in the accumulated, physically massed assemblages of Arman and the more pictorial, iconographic ones of Rauschenberg. In recent years the gestural yet conceptualized works of Fontana and Yves Klein have assumed a larger place in the history of art, prompting American critics and scholars to reevaluate earlier assessments and to consider the postwar period on an international scale.

Such breadth of outlook is supported elsewhere in the Ludwig collection, which includes a fine group of early twentieth-century European works unusually rich in the work of Jean Arp, Max Beckmann, Alexei Jawlensky, Ernst Ludwig Kirchner, Paul Klee, El Lissitzky, Kasimir Malevich, Franz Marc, and Paula Modersohn-Becker. Perhaps the Ludwigs are so uniquely conscious of the bond between a work of art and its time because they both hold advanced degrees in the history of art and have made a careful study of the art of many periods. They have amassed important collections of antiquities, Pre-Columbian art, and medieval art, which are housed in the Antikenmuseum, Basel; the Rautenstrauch-Joest Museum, Cologne; and the Schnütgen-Ludwig Museum in Cologne, respectively.

Taken together, the various Ludwig collections are too vast perhaps to ever be shown at once. The Ludwigs have transferred the largest portions of their collections to museums in Germany and Switzerland and have continued to acquire works of art with these museum collections in mind. As the Ludwigs have reiterated, the point has not been to build one single collection as a monument but to remain active in a number of discrete areas of art, in order to preserve a freshness and breadth of vision. Thus, they have wedded the flexibility,

resources, and zeal of the private individual to the slower-moving, institutional stability of the museum structure. A recent installation at the Ludwig Collection, Neue Galerie in Aachen has placed even more of their contemporary collection on public view; the collection continues to grow, and institutional affiliations to prosper. In its depth, range, and admirable consciousness of history, the Ludwig collection has helped to shape our awareness of the recent past. Institutions like the Museum Ludwig serve as national cultural resources and lay the foundations for artistic activity and art-historical study for generations to come.

The collection of Count and Countess Giuseppe Panza di Biumo is a brilliant, creative endeavor unlike any we have seen in this century. Guided by his own innate and dramatic grasp of the beauties of architectural space, Giuseppe Panza has sought out the work of contemporary artists who explore the relationships between art and its physical environment, and the impact of light, space, and physical materials on the viewer. During the late 1950s Panza assembled a splendid collection of American Abstract Expressionist paintings by Franz Kline and Mark Rothko, and European Expressionist works by Jean Fautrier and Antonio Tapiés. These hung in the gracious private rooms of the eighteenth-century family villa near Varese and were soon joined by important works by Robert Rauschenberg, Claes Oldenburg, James Rosenquist, Roy Lichtenstein, and George Segal.

It was the advent of Minimal art in the early 1960s that brought out Panza's special genius as a collector; he purchased and installed major works by Carl Andre, Dan Flavin, Donald Judd, and Robert Morris. The classical, orderly, somewhat austere architectural rhythms of the many rooms of the villa complemented the clear, geometric forms and ample scale of this work. As sculptural planes of wood, plastic, and steel encountered smooth, gently curved stone, plaster, and marble surfaces of this grand and beautiful complex of buildings, a special harmony developed, one that animated the sculpture and made it glow in the clear sunlit air of northern Italy. The villa also ceased to be a work of only one historical period and seemed to live anew, refreshed by its proximity to young and vital works of art.

This unique, almost mysterious chemistry of period, site, and patron has occurred at important moments in history but rarely as the overlay of one moment and style on another. Walking through the corridors of the villa and experiencing the unique physical situation and carefully modulated light of each room, the translucent illumination of a work by Robert Irwin, and the unearthly glow of a Dan Flavin experienced in a darkened room, one becomes aware of the special character of this place where precision and sensitivity combine to create an aura of focused intensity. The same might be said of Panza himself,

a powerful, enigmatic man whose speech is serious and to the point, unadorned by narrative or anecdote.

In the late sixties the open, muscular forms of Post-Minimalist works added a dynamic spirit to the Panza collection. Panza invited many of the artists in the collection to travel to Varese and participate in the installation of their own work. Gene Highstein, Richard Long, Richard Nonas, Joel Shapiro, Richard Serra, and others worked with Panza to bring out the best in their work and to illuminate the subtle character of the fine and historical building. Visitors to the villa were often startled to enter a vast space housing one or perhaps two sculptures of modest scale. In such a setting, the best work seemed to gain a new dignity from the amplitude of its surroundings. Few museums could even try to achieve this thoughtful interaction between artist and audience; in fact, the Panza collection has become a living model of what might be achieved if we did not conceive of a museum as a "nation's attic" or a repository filled with a cacophony of styles and voices. This is, of course, something artists have maintained for many years, a position unfortunately too frequently considered unrealistic by museum staffs confronting the practical realities of public institutions.

The carefully installed rooms of the villa establish an aura of serenity with a discernable undercurrent of excitement as dramatically understated works of art command clearly articulated spaces softened by the surrounding Italian landscape. In the late sixties and early seventies a great many paintings by Alan Charlton, Peter Joseph, Robert Law, Robert Mangold, Brice Marden, and Robert Ryman were introduced, and several of Sol LeWitt's wall drawings were realized in architectural environments beautifully matched to the physical needs and aesthetic character of each graphically defined field. It was clear by this time that Panza was pursuing a consistent direction in his collection and was drawn to an art that existed on the razor's edge between austerity and a cultivated, sensuous appreciation of the pleasures of subtle color, touch, and modulated light. Over the same period substantial holdings were developed in the area of Conceptual art, both European and American, with seminal works by Robert Barry, Hanne Darboven, Jan Dibbets, Douglas Huebler, On Kawara, Joseph Kosuth, Lawrence Weiner, and Jan Wilson. Much of this work explored and delineated the boundaries between idea and object, conception and execution, issues that were implicit in Minimalist art and also present in the work of Mangold, Ryman, and some of the other painters mentioned previously.

Panza has provided quietly spectacular spaces for the work of Larry Bell, Robert Irwin, Bruce Nauman, Maria Nordman, Eric Orr, Jim Turrell, and Doug Wheeler. Much of this has been installed at Varese over the past several years, although installations are changed periodically and new ones are created. Panza

has made a substantial commitment to this work and recognized its unique position in the history of art. At Varese one can see the range and personal aspects of each artist's vision–for example, Nordman's desire to plunge the viewer into a state of uncertainty only to bring him back to one of serene quietude or Irwin's shaping of architectural space to establish radiant fields of light filtered through delicate materials or expressed in clean, still air and natural sunlight.

The physical demands of such work are extraordinary and go beyond the means of most private collectors, but Panza's desire to bring together a number of environmental works has provided a unique opportunity to see and experience them in a highly focused and beautifully integrated setting. He has opened his villa on many occasions and received visitors from all parts of the world–artists, collectors, curators, critics, and others seriously interested in contemporary art. No one else has been able or willing to commit the resources for a group of permanent installations of this nature until this remarkably astute, erudite Italian industrialist came along. His qualities of character and philosopher's search for the sublime have made this possible.

Jean and Howard Lipman's collection of modern American sculpture has grown out of the couple's interest and involvement in the entire history of American art. Jean Lipman's many books and articles on American folk art constitute a veritable bibliography on the subject and have contributed to our understanding of the broader aspects of American art and cultural history. The Lipman collection of American sculpture, much of it donated to the Whitney Museum of American Art in New York, focuses upon radical changes in sculpture during the later decades of the twentieth century: the advent of abstraction, the influence of Surrealism, the impact of collage and assemblage, and the interaction of object and environment explored in much recent work. It is a collection with a good deal of vitality and variation, but the Lipmans' connoisseurship is of such a high order that many of the pieces in their collection are now regarded as modern classics.

The works they have chosen give evidence of a particularly intimate relationship between object and maker; a love of craftsmanship and the processes of invention and creation, the stamp of a particular personality, humor, and irony; and a warm regard for the themes of American history. These run like a continuous current through the Lipmans' acquisitions and Jean Lipman's scholarly publications. With characteristic clarity and insight, the Lipmans have sought out important works by Alexander Calder, the finest and most seminal of America's early modernist sculptors. Calder's sophisticated interpretation of Surrealist biomorphism finds playful expression in his large mobile *Seascape* (1947), filled with floating fish and dangling worms illuminated by a shiny,

many-pointed metal sun. *Longnose* (1957) is a dark, looming birdlike creature whose massive silhouette dominates its environment and makes it serve as a visual ground for its buoyantly rounded contours. We see the full range of Calder's vision in *Indian Feathers* of 1969, an abstract asymmetrical stabile based on a theme from American life presented without sentiment or nostalgia in lean, modernist terms.

Another major historical figure in American sculpture, David Smith, is also well represented in the Lipman collection. The collectors have selected key works from a variety of periods. The early *Tank Totem #5* (1955–56) made of machine parts, is one of a long series. This one is especially elegant, its individual found elements having been brought together physically and visually by Smith's disciplined articulation of form. Smith's preference for dramatic asymmetry is expressed in the unexpected tilt of *Zig IV* (1961), with its precarious union of sharply cut planes and partial cylinders. The Lipmans have also chosen the unusual *Cubi XXI* of 1964, suggestively anthropomorphic and evocative of Smith's early Surrealist years.

The work of Louise Nevelson, with its commanding presence and disciplined abstract form, is achieved through a passionate and precise ordering of rough-hewn materials. Her work is direct, tactile, and handmade, growing out of a contemporary urban context but with strong ties to the preindustrial American way of life. There is also a strong pictorial element in her assemblages, with their dramatic lighting and grand spaces capable of establishing dazzling and dark visions. Individual compositional elements of *Royal Tide I* of 1960 assert themselves, maintaining their identities as pieces of broken furniture, spools, railings, and wooden lattices, yet repeated shapes occur with such frequency that they set up steady rhythms that pull these captured fragments into a new dynamic order. In *Night-Focus-Dawn* (1969) we are swept along by the fluid movement of curves as they move upward or downward and then reverse themselves. It is a harmonious order ordained by the artist, existing before, during, and after the process of its making. This lyrical unity is often present in Nevelson's work, but here it stands alone as the driving force behind this strong and memorable work.

The Lipman collection is well known for its fine examples of Minimal sculpture, with frequently exhibited works such as Robert Morris's untitled L-beams of 1965. The Lipmans also have a special fondness for those anticlassical, idiosyncratic, and hybrid works found with fair frequency in the long history of American sculpture. Lucas Samaras's strangely compelling *Box #41* (1965) is a work directed at the viewer's tactile as well as visual awareness, a fascinating provocation. Richard Artschwager, Bruce Conner, Ed Kienholz, Claes Oldenburg, Ken Price, and H. C. Westermann have, each in his own way,

pushed the frontiers of sculpture further in the direction of an aesthetic that celebrates the erotic, the absurd, and the paradoxical in American life.

During the 1950s the Lipmans recognized the difficulties encountered by American museums in the acquisition of major pieces of sculpture, which are often large and expensive to produce, store, exhibit, and transport. For many years they have collaborated with the staff of the Whitney Museum of American Art to acquire and donate major works of sculpture to the museum. As this productive and dynamic relationship developed, the museum's holdings in American sculpture expanded dramatically, traveling exhibitions were organized and financed, and the Lipman collection as an entity became less separate and distinct and more a part of the collaborative process with the museum. As is true of many important collectors of art, they find the designation *collector* to be unwelcome or even distasteful. Living with, and learning from, works of art–sharing one's life with them–is much more than a process of acquisition and accumulation. Inevitably this more humane and enlightened attitude extends itself toward a larger audience, and collectors become involved in the life and development of museums and other cultural institutions. This has certainly been true of the Lipmans' adventure in collecting, writing about, and understanding art. A few years ago, Jean Lipman wrote and edited a book entitled *The Collector in America*, which profiled a number of distinguished American collections. She chose to emphasize the role that the collector plays in the historical process, remarking, "They collect because certain things ought to be set in apposition and preserved for posterity."

Dominique de Menil and her late husband, John, assembled a massive collection of preclassical, classical Greek, African, Oceanic, Byzantine, medieval, modern, and contemporary art during their forty-two years of marriage. The de Menil collection spans virtually the entire range of human history, but its comprehensive nature was the outcome rather than the goal of their search for, and involvement with, art. The pattern of their choices and the strongly expressive nature of their art make one aware of the role of the maker, of the hand of man and the subtle or direct way in which human emotions and experiences are transmitted in works of art. It is this focus on the human experience– moments of exhilaration or fear, the power of transcendental insights, familial and tribal bonding–that gives the de Menil collection its special character and brings this massive and disparate collection into sharper focus.

While the de Menil collection is particularly strong in Surrealism, specifically the art of Giorgio de Chirico, Max Ernst, and René Magritte, the de Menils developed a refined and sensitive understanding of the art of Africa, Oceania, and the ancient world. When a selection of masterpieces from the collection was shown in 1962 at the Museum of Primitive Art in New York, Dominique

de Menil wrote a moving preface to the catalogue, saying of these objects, "They are the most sincere and the most unself-conscious art that ever was and ever will be. They are what remains of the childhood of humanity. They are plunges into the depths of the unconscious. However great the artist of today or tomorrow, he will never be as innocent as the primitive artist–strangely involved and detached at the same time."

The de Menils were early admirers of the work of Joseph Cornell, appreciating its mystery and passion as well as its intricate physical structure. Cornell's boxes retain their "objectness" within the de Menil home, where the affective scale of a work of art is not measured by feet or inches but by its presence. One might feel free to hold an Etruscan god or an African votive figure in the palm of one's hand. Cornell's art was created for just such intimate, one-to-one encounters, for private moments when secrets may be exchanged in whispers. He allows us to travel backward or forward in time. *Untitled* (Medici Family, Bronzino "Dovecote" Variant) (ca. 1952–55), the work filled with a portrait by Parmigianino (1950–52) and the wistful, provocative *Système de Descartes* (ca. 1954) speak of the filtering effect of time on the mind and of our natural desire to achieve an empathic understanding of human beings who lived centuries ago.

For many years the de Menils maintained residences in Houston, New York, and Paris, which allowed them to remain in touch with artistic developments in both America and Europe. As was true of some of the great European collectors of this period, the de Menils understood that the art of the postwar period was a truly international phenomenon, a cultural dialogue taking place on both sides of the Atlantic. Jean Dubuffet's *Paysage aux Ivrognes* of 1949 is a powerfully primitivist, beautifully graphic work, a continuous field filled with ragged marks and gesticulating figures inhabiting a rough, grooved, and pitted landscape. *Desert Rose (Pink Desert)* (1954) is more completely abstract and involved with the fluid movement of pigment over a broad surface; it might be compared to the work of the second generation of Abstract Expressionists in New York and to the style of Nouveau Realisme in France.

The de Menils were among the few Americans to grasp the significant and tragically brief role played by Yves Klein, the central figure of Nouveau Realisme from the late fifties until his death in 1962. Perhaps it was his desire to penetrate the mysteries of the natural world through dramatic action, mysticism, and art that drew these collectors to his work. Klein had an alchemist's fascination with material substances; he used them as something beyond the means to fulfill visual ends. *Requiem* of 1960, a massive mixed-media work in his own "international Klein blue," causes us to confront a vast, unnatural field of color and form that is not depicted but actually present. A silhouetted painted

record of living bodies exists in Klein's *People Begin to Fly* (1961), asserting a condition we know to be untrue but are as prepared to believe as we do the now-famous photograph of the artist flying from the top of a Paris building.

The Rothko chapel in Houston is one of the most ambitious projects ever realized in this country as a commission from a private patron. Dominique and John de Menil met Mark Rothko in 1962 and initiated discussions with the artist that led to a formal commission in the later months of 1964. Rothko worked on a group of mural-scale canvases for three years, virtually completing them in 1967 but continuing to refine, edit, and contemplate them until his death in February 1970. The chapel was dedicated one year later, in February 1971, and has become a much-admired and highly controversial work that boldly sets forth the aspirations and despair of the late twentieth century. The chapel, with its blend of the secular and the transcendental, focuses our attention upon the essence of Rothko's art–his desire to probe deeply into the human condition, and, as he said, to move the viewer to tears. Whether these are tears of exultation or despair may depend on the individual and his or her experience with the paintings, but they are vital, deeply felt works revealing and renewing the role of the artist as seer and witness to the full range of human joys and sorrows.

The entire spectrum of the de Menil acquisitions, their cultural projects, and Mrs. de Menil's plans for a museum to house the collection in Houston create an image of collectors whose lives have been endlessly challenged by, and open to, the emotional vitality expressed by artists through their works. Dominique and John de Menil did not seek out art as an "appeasing influence, a mental soother," to quote Henri Matisse, who did not confine himself to this program even in his own work. Instead, the de Menil collection reflects the breadth and extension of the couple's life together, their ecumenism and concern for human rights, their involvement in educational institutions and projects, and their mutual love of art.

Private collections often do a great deal to enrich the artistic life of their communities, particularly when the collectors are as generous and willing to open their home to visitors and students as Marcia and Fred Weisman have been over many years in Los Angeles. Singularly great Abstract Expressionist paintings form the core of the Weisman collection. Willem de Kooning's *Pink Angels* (1947), a dazzling and sensuous painting of lush bodies flowing in space, is one of these masterpieces known to every serious student of modern art. *Dark Pond*, an important black and white canvas of 1948, was part of de Kooning's first one-man show at the Egan Gallery in New York.

The Weisman collection represents a distinctly personal selection, but the collectors have sought the advice and companionship of many of the artists represented. They have often arrived at a choice after a period of acquaintance

with the artist and his work, looking for a great, rather than a merely good or representative, piece. The Weismans had a warm relationship with Barnett Newman, as evidenced by the title of the sculpture *Here I (to Marcia)* (1962), dedicated to Mrs. Weisman, who personally requested that the earlier plaster version of 1953 be cast in bronze for their collection. At the same time, the Weismans acquired *Onement VI* (1953), a classic work painted during those years when Newman's art appeared to many as an aberration within his generation of Abstract Expressionist painters. The reductive qualities of his art were to be appreciated only by subsequent generations of artists and critics.

Fred and Marcia Weisman had a lively and challenging relationship with the mercurial Clyfford Still, whose concern for the long-term welfare of his art prompted him to query collectors as to their methods and motives. One could not simply purchase a Still painting: one had to prove himself worthy of it. Many visits by the Weismans to the artist's studio, long talks with them, and the overall excellence of their collection convinced Still to release two fine paintings, the beautiful *1947-M* and *Untitled* (1951) to their custodianship. The Weismans' fine group of Abstract Expressionist paintings would have been incomplete without significant works by Pollock and Rothko, and they were fortunate enough to acquire Pollock's unusually lyrical, light-filled *Scent* (1955) and Rothko's radiant blue and green *Untitled* of 1957.

Throughout the many years the Weismans have lived in Los Angeles, these paintings have become almost as familiar to artists, curators, collectors, and students as they are to the collectors themselves. Theirs is the finest group of works of this period to be found on the West Coast; these paintings, fortunately, have not lived in quiet obscurity but have been as accessible to serious students as any works in private hands could possibly be, perhaps more so than many works now in museum collections. This has done a great deal to enrich the Los Angeles art community and to stimulate successive generations of artists. Among these were the generation of Southern California artists who came into prominence in the late 1950s and early 1960s, contemporaries of the Weismans who were eager to fulfill the promise of this large and beautiful part of the country: Sam Francis, John Mason, John McLaughlin, Ed Moses, Ken Price, Peter Voulkos, and others. These and subsequent generations are represented in the Weisman collection, which continues to grow, with an eye on contemporary art of the West Coast and New York.

In their outspoken and tangible support for the art of Southern California, the Weismans set a high standard for their collection and have placed works of art in museums, educational institutions, and hospitals throughout the state. While some collectors might seek to define themselves as international figures operating in a broad multi-national context, the Weismans have played a spec-

ial role in their community, lending their credibility and enthusiasm to the efforts of younger artists and tending to needs and interests closer to home. Even those collectors who prefer to concentrate on the international market must admit that a context for important art is built artist by artist, city by city, and that innovation begins with the artist even before the broader audience becomes aware of it.

Robert Rowan is a familiar figure to anyone seriously involved in art in Southern California; his unflagging enthusiasm takes him to many gallery openings, studios, and exhibitions each month. It seems that he is omnipresent, always looking, eager to learn of the work of young artists or of recent developments in the careers of established ones. One often hears that Robert Rowan has purchased a work by an unknown who has only this moment captured the attention of critics and other collectors. Rowan appears quite as much at home at exhibitions in small galleries and alternative spaces as he does in our larger institutions.

Rowan's is a cultivated, sensuous taste that first found expression in his renowned collection of color-field paintings of the late fifties and early sixties. Morris Louis's lush and massive *Samach* (1958–59) is one of the most beautiful and imposing works in the Rowan collection. The graphic energy and vibrant color of Kenneth Noland's *Via Media (Suddenly)* of 1963 is indicated by its title; it is a work that becomes a determinant of architectural space by virtue of its scale, assertive imagery, and the strong gravitational pull of its central configuration. Another major figure of this school, Jules Olitski, is represented by *Tender Boogus* (1967–68), a work that stands midway between his stained, high-contrast, graphically defined work of the late fifties and early sixties, and his painterly, heavily laden fields of pigment of recent years.

Tomlinson Court Park, by Frank Stella, one of the famous black paintings of 1959–60, is a contemporary classic familiar to every student of recent art. Its substantial physical presence and its brilliant push and pull between absolute flatness and overt perspectival illusionism state the essential premises of Stella's work with firmness and clarity. Now a well-known starting point in a long chain of historical and conceptual developments in painting over the past twenty years, this work still lives on its own, rejecting our attempts to define it by place and time, transcending even its own notoriety. Robert Rowan has maintained an abiding interest in the works and careers of a number of artists in his collection and has followed the progress of Stella's art over the years, adding the vivid *Agua Caliente* of 1970, a work that remains within a Minimalist configuration but transforms its environment by virtue of its enormous scale, bright color, and assertive shape.

The Rowan collection is distinguished by a creative and thoughtful consid-

eration of the art of California, a capacity to appreciate both its abstract and figurative traditions and to savor the distinct differences between Los Angeles and San Francisco. Richard Diebenkorn's *Ocean Park No. 37* (1971) is an unusual work composed within the discipline of a square format. Abstract diagonal tracks establish the architectonic structure of the composition and keep the image close to the picture plane, resisting any reading of the work as landscape. An early Billy Al Bengston, *Count Dracula I* (1960), announces a brash yet enigmatic sensibility, secure in its physical beauty, and bold and clean of line. *Bent Vents and Octangular* (1976), by Ron Davis, is a radiant apparition of colored light trapped by layers of resin and fiberglass, a work both real and illusory that shares the viewer's physical space.

Robert Rowan has a special fondness for the fine-tuned eccentricities of Bay Area artist William Wiley. *Village Green* of 1974 is a dense field of graphic activity as multifaceted as a complex map, in the fragmented style of a Cubist painting. A recent acquistion, Charles Garabedian's *Ruin V* (1981), is a mature work by this major Southern California Neo-Surrealist. Garabedian has invented a race of human beings who are busy acclimating themselves to life on earth, trying out their bodies, moving in space, discovering the forces of gravity and the mysteries of sexuality. Garabedian's meditations on the human condition take on a gentle irony as these people struggle through basic stages of development retraced again and again in each human life.

Robert Rowan has often remarked that he is a collector who takes chances, that he makes mistakes and learns from them. This may be true, but he has never been guilty of premature narrowness or of disinterest in the broader aspects of the art of his time. Quick to acknowledge his own preferences for beautiful and colorful works, for painterly paintings, he nonetheless appreciates and supports a wide range of work out of a warm emotional regard for the authentic expressions of the artist. This is not an intellectual position but a desire for human connection, a respect for the origins of art, beyond history and beyond questions of style.

All six of these collectors have chosen, or have arrived at, public roles in the world of art by virtue of the quality and breadth of their collections, their involvement with public institutions and scholarship, or their lively interests in the events and issues surrounding the creation and acquisition of works of art. During the years in which they were actively collecting, Mrs. Rita Schreiber and her late husband, Taft, were deeply involved in the broader world of art through their associations with the Hirshhorn and Norton Simon museums. Their own collection grew steadily and slowly over the past thirty years as they patiently pursued a select group of rare and important works, focusing upon quality alone. Their friend Charles Laughton, the actor and art collector, encour-

aged the Schreibers when they first began to collect works of art. Laughton helped them to feel at home with early twentieth-century European art and affirmed their own instincts, which told them to strive for a small but ambitious collection, a group of masterpieces rather than a large, unedited survey. Great works of art often have a way of exposing and embarrassing lesser ones; as the Schreibers' collection took form, it established a level of excellence that precluded the easy acceptance of merely interesting or decorative objects.

Among their early acquisitions were a group of paintings by the French Expressionist Nicolas de Staël, of which *The Football Players* (1952) is a fine example of his broad, powerful sense of form and space achieved through the physical layering of intense resonant color. The Schreiber collection is also rich in the art of Alberto Giacometti, showing his physical and expressive range as both painter and sculptor. The small painting *Interior of Studio with Man Pointing and Three Apples* (1950) creates another space within itself, a shift of scale underscoring the enigmatic relationship of the figure to its surroundings. *Tall Figure II* and *Tall Figure III*, two sculptures of 1960, are grand and expressive in their lean-limbed fragility, powerful presences to inhabit the private space of a collector's domestic environment.

It is rare to find an important painting by Piet Mondrian in private hands these days, as his output, especially in the later years, was relatively modest and most of it has found its way into museum collections. Taft and Rita Schreiber acquired and lived with Mondrian's *Abstract Painting* of 1939, a work created at the outbreak of World War II, just as the artist was about to move to New York. Broad horizontal and vertical lines invade and overlap the upper red and yellow rectangles and the blue rectangle at the lower right, opening up new spatial dimensions in the work that would become even more explicit during Mondrian's New York years (1940–44). Just below the center of this canvas, a beautifully proportioned rectangle stands firmly in place, the largest single element in the work and one that repeats the overall proportions of the composition as a whole.

The Schreiber collection is not based, as so many collections are, on a collector's visual or formal preferences–for example, a taste for geometric form or a preference for lush, open-structured Expressionism. Instead, the Schreibers have followed more profound and traditional principles of connoisseurship, arriving at an understanding of the intrinsic qualities of various schools and styles of art and then seeking out the best and strongest works within that set of standards. Thus, the wonderful canvas by Mondrian stands side by side with *Betrothal I* (1947) by Arshile Gorky, the crucial transitional figure from the contained, geometric, Cubist-based abstraction of the thirties toward the open-structured impassioned abstract Surrealism of the early forties. Gorky's

31

firm yet supple calligraphy establishes the rounded contours of the female figure at the center of the work. As the object of desire, she inspires a frenzy of
voluptuous color, tactile surfaces, and rhythmic movement.

Perhaps the most impressive of all the works in the Schreiber collection
is Jackson Pollock's *No. 1* of 1949, raw and elegant within its layered skin of
Duco and aluminum pigment. Even at the time of its making, Pollock's work
seemed destined for the large, substantial rooms of museums, for they require
enormous physical and emotional involvement on the part of the viewer. Only
the strong of spirit would choose to live with a major Pollock. These canvases
present a great challenge and responsibility because of their grand and turbulent
beauty and their often delicate physical condition. So much of our recent history depends on this single figure in American art and the core of his reputation
rests upon his canvases made during the late 1940s. *No. 1* is among that small
group of seminal work.

Seeing a collection as superb as that of Taft and Rita Schreiber, one is
prompted to reflect upon the clear-sighted discipline involved in such an endeavor. It would have been so easy to make compromises, and many worthy works
of art were passed up in pursuit of those that have a special presence, an aura
of inevitability and irreplaceability. They sought works of art able to sustain
year after year the most intense and varied scrutiny, works that can maintain
their vivid presence, remain alive, and provide new experiences with each
viewing.

One of the mysterious aspects of collecting art is the inevitable point
reached by every collector when he falls out of love and out of step with recent
artistic innovation. It is such a rare and fragile thing, this precise fit of personality, period, and style, and it happens to only a few gifted and ambitious collectors, as we have seen in this discussion of important contemporary collections. When a collector reaches this point, the collection begins to move
toward the realm of history, to exist as a resource, to be a continuing pleasure
but one experienced, especially by outsiders, from a historical perspective.
Individual works of art may still glow with their original fire and may even gain
luster from their new status as important objects, but the old feelings of tentativeness and risk are absent and that vital phase of active pursuit and qestioning has given way to a more comfortable familiarity.

It is exhilarating, then, to observe a great collection still in the making,
one created with a zest for exploration, extraordinary aspiration, and a timely
understanding of the international art community. Charles and Doris Saatchi
live in a quiet, older residential section of London surrounded by comfortable
homes, well-tended gardens, and green lawns. Crossing the threshold of the
Saatchi home, one enters an environment filled with vivid and forceful works

of art–enormous and colorful constructions by Frank Stella; luxuriantly calligraphic Cy Twomblys; and a massive recent work by Julian Schnabel made with pigment, canvas, plates, pots, and wooden fragments, and another on a similar scale incorporating the antlers of a deer. A running horse by Susan Rothenberg is not out of place here; in fact, it seems curiously quiet and steady, a central painted image in a room filled with many strong voices. These are among the most assertive works, but one also finds exquisitely subtle ones: the white canvases of Robert Ryman, a particularly beautiful Brice Marden, a small abstracted metal house by Joel Shapiro, and one of his larger recent figural sculptures.

Figurative Expressionist painters of Germany and Italy have attracted international attention in recent years, and the Saatchis have kept abreast of these developments as their collection has evolved. Doris Saatchi is a serious critic and historian of art whose incisive prose appears in a number of international art publications. Charles Saatchi is a dynamic executive, an expert in the realm of media. Together they are creating an extraordinary collection that, like the others we have examined, goes far beyond the immediate and the personal to become a major cultural resource. Several years ago the character of this collection was predominently American, with strong preference for Minimalist and Post-Minimalist work. Even then the Saatchis were passionately committed to the late work of Philip Guston and to the work of Malcolm Morley as they began to move toward a more figurative emphasis in the collection. Now the focus has shifted substantially toward the Italians Sandro Chia and Francesco Clemente and the Germans Georg Baselitz and Anselm Kiefer, among others. The Saatchis' preference for strong, assertive works on a grand scale runs throughout their acquisitions. They seek only major works, with no compromises made for want of space or nerve. At any given moment a great deal of the collection is in storage so that each work displayed at home can be allotted the proper space in which to reveal itself fully. A collection on this scale requires the collector to assume a curatorial role, determining the direction and nature of new acquisitions, caring for the physical display and condition of works of art, and maintaining a clear vision of the whole even though parts of it may be in several locations and important works out on loan to exhibitions. The Saatchis are building one of the world's great contemporary collections, distinct in character, ambitious in quality and breadth of inquiry.

One may ask why we study and appreciate the collector when works of art are the creation of the artist and remain a part of the artist wherever the works may reside. Historians of art are well aware of the important role the patron has played throughout history, a much more intimate and direct one than is common in our own time. However, the contemporary collector is the one who

supports and sustains the artist, the one who lives with, and cares for, the work of art, the one who makes a commitment more binding than that of the critic or the gallery-goer. Too often we think of the collector as the possessor of art when any examination of the matter reveals how appreciation requires and prompts extraordinary acts of sharing with a larger public. The collector plays the multiple roles of critic, partner, steward, and lover of the work of art, knowing that his part is a transitory one. Perhaps this is why the great ones approach it with such wholehearted passion. The collecting of art is one area in which the pleasures of this life can be passed on to posterity in their original form and virtually intact.

Dominique de Menil

New York
December 1982

Why do you collect art?

Dominique de Menil: For many years we were not "collecting art," my husband John, and I. Many people we knew were "collectors," but we could not think of ourselves in this category. We did not care for the social status attached to collectors. We were just enjoying art at home. Yet there is an undercurrent in me that at times would make me grabby for certain things—not for dresses or jewels but for objects that fascinated me for their beauty, their curiosity, or their historical interest. Objects, pictures, but on a modest scale, not things costing a lot of money. It was rather the continuation of my childhood love for shells, cutout images, exotic seeds.

Did you have dolls, doll collections?

DdM: No, no dolls. I only had one doll, which I broke in the midst of a bad temper, and I never had another one. I had no dolls, no soldiers, no cars. But I loved things like those wonderful little objects the Japanese would make. Tiny, miniature things would enrapture me to the point of once stealing from another little girl. I always had a passion for "finding," as on a treasure hunt. And, of course, living in Paris there was plenty to hunt for. It was fun to go to the flea market or to little bric-a-brac shops in my neighborhood. When I came to Houston, there was no flea market. There were only two dealers in antiquities, and all they had was furniture. It was only later that I could again give in to my passion in the golden days of New York's Third Avenue when there were plenty of small antique dealers. It was the time when Carlebach was selling Northwest Coast art acquired from the Heye Foundation. He had been selling them to Max Ernst, Breton, and others. But even apart from Carlebach's early little store, one could make discoveries, and that was one of my favorite pastimes in New York in the fifties and early sixties.

So you started with objects that strongly attracted you rather than consciously collecting painting and sculpture?

DdM: Yes and no. John and I began buying paintings because we started learning about them and loving them. We had not bought any paintings in Paris before the war because we did not have the means but also because it did not even occur to us. John was too busy, too much involved in his work, and I did not think of it. It was not a tradition in my family. My mother and her mother would have loved to buy paintings and could have afforded them, but when my grandmother had wanted to buy a Gauguin, her husband said no, and in those days women did not dare to do anything without the approval of their husbands.

My mother loved the Impressionists, particularly Cézanne, but she never bought anything, because my father did not approve of spending money for paintings. On the Alsatian side of his family, one did not indulge in what was considered "luxury": no rare books, no antique furniture, nothing really expensive except perhaps some silver. Yes, one had to have silver but not paintings. Paintings were considered ostentatious. Certainly I did not inherit a tradition of patronizing the arts, but I inherited the craving, the unfulfilled craving of my mother and grandmother.

In the late forties and fifties John was often in New York for business reasons, and sometimes I accompanied him. During that time Father Marie-Alain Couturier took us around to the New York dealers Paul Rosenberg, Valentine Dudensing, Kurt Valentine, and Pierre Matisse. Couturier, a French Dominican priest, was extremely sensitive to art. Himself a struggling painter, he was a man of vision, of sober eloquence, and of deep spirituality. In the late forties and early fifties he played a major role in the artistic achievements at the churches of Assy and Audincourt, and at the chapels of Ronchamp and Vence. His unprecedented success resulted from the influence he was able to exercise on ecclesiastical authorities as well as from his personal friendships with the masters of his time: Léger, Matisse, Rouault, Le Corbusier. He died in 1954 without having been able to involve Miró and Picasso but certain that if offered the right program, they would accomplish works of great spirituality. He made us greedy, although I was still sort of resisting. Once when I did not accompany my husband to New York, John brought back a watercolor by Cézanne that had cost $2,000. I thought it was a lot of money for just a few blotches of color. It took me a long time to appreciate it. Now I love it. I love the blotches, and I love the empty spaces between the blotches. It is superb, yet it took me a long time to "see" it. John had a more immediate appreciation for art as well as for architecture.

Was the Cézanne your first acquisition?

DdM: Yes. At first we bought modestly, partly for economic reasons. We bought lithographs from Kurt Valentine, and then a Tamayo and a Léger. I was the one holding back–my puritanical side, I guess. But there are no better missionaries than paintings themselves, and once you develop a taste, you only stop when you have to.

What was the first expensive acquisition that you made?

DdM: John and I were both very much in love with a beautiful analytic Cubist painting by Picasso, but we hesitated and finally bought a Rouault instead. At that time the Cubists were still fairly inexpensive. I remember seeing a Léger with Father Couturier. The price was $500, and Father Couturier said, "At this price it would be a crime not to buy it." So we bought it, and that was the end of my puritanical upbringing. The second person who influenced us into buying was Alexander Iolas. He was simply called Iolas by all; he was a Greek born in Egypt, and had an exceptional flair for art and talent for selling it. He headed the Hugo Gallery–later called Alexander Iolas–which, after the closing of Julian Levy's place in the late forties, became the gallery representing Surrealist art. He was so convincing; he was himself so convinced of the importance of what he was showing. We bought our first Braque from him, and he is the one who sold us the beautiful analytical Picasso. I remember my skepticism in front of our de Chirico, *Hector and Andromache.* I was not taken in; I bought it on his word, on faith.

What did you like the most?

DdM: Braque is extremely seductive. In those days I liked him best, but John, who was very architecturally minded, loved the structural strength of Picasso. He was in tune with Picasso.

So you started at the beginning of the century with the Cubists and the Fauves.

DdM: Yes.

Did you buy objects? You have so many wonderful objects from Africa, the Pacific Islands, and other places.

DdM: John Klejman, another dealer, made buying African art very tempting. He lived just a couple of blocks from us in New York, and he had fabulous African and Pacific Islands pieces. We started slowly, but every year added a few more primitive works.

At first you bought the Surrealists. Was that due to what you saw at Iolas's gallery?

DdM: Yes, to a large extent. At first I resisted Surrealism; it was such a strange world. I felt outside of it. But Iolas kept showing us great works, and he was, as I said, extraordinarily convincing. About Magritte he used to say, "One day the force of these images will appear to everybody, you'll see."

I remember very well that Magritte was considered to be a bad painter. People said that he had good ideas but that he could not paint.

DdM: That was because he was painting in a very polished way, very academic, and people did not realize that he had made the decision to paint in a neutral way, like a chromolithograph. He called that "honesty." He wanted to be honest, to paint as simply as possible without any painterly effect. Expressing the mystery of the world was better done without "talentuous" brush strokes. Everything was the idea.

When did you start to meet the artists?

DdM: It was not easy, because we were in Houston. The first artist to come to Houston was Alexander Calder, a marvelous man who loved life. I still see him drinking, dancing, and laughing, and fixing things that needed to be fixed. Max Ernst was the second artist to come to Houston. He had settled in Sedona, Arizona, with Dorothea Tanning. One day he, Dorothea, and their Tibetan dogs drove over in a station wagon with paintings in the back for a show at the Contemporary Arts Museum in Houston. Max made a drawing for the cover of the catalogue which was simply a folded page with a list of his paintings. *Inside the Sight* was among them, and it remained with us. Nothing else was sold from the show. "Another flop," recorded Max, who was quite prepared for it.

Did you discuss other artists with Max and get his opinion about other people in the Surrealist group? You have many Magrittes, Ernsts, and Archimbolds, but you do not have many Dalis.

DbM: No, we did not discuss other artists. We never tried to find out what artist we should acquire. We had no buying policy or counselor. We only bought what we happened to see and could not resist. Max was unrecognized in America until his retrospective at the Museum of Modern Art, and even then he was not treated as the great artist he was. Somehow only his early works were truly accepted.

He was virtually forgotten in Europe.

DdM: Yes, except among a few people who knew how important he was. I remember buying original drawings by Max Ernst, and nobody knew who he was. The Surrealists before 1939 had not been appreciated. They were consid-

ered terrible provocateurs. And here in America he could never achieve success. It was strange because in those days Jimmy, his son, was selling well. Max used to laugh about his own lack of popularity, and he withdrew totally from society. He and Dorothea lived by themselves simply and frugally. Max probably suffered from having left Peggy Guggenheim. We did not have much contact with him; he was in Arizona and we were in Houston.

But you moved from Cubism and Picasso to the Surrealists, and through Max Ernst you came to know Magritte.

DdM: It was not through Max Ernst but through Iolas that we discovered Magritte. There were many wonderful exhibits at his gallery. They included superb Magrittes. Yet he could not sell one or sell an Ernst or a Wols. He could not sell Surrealists.

In those days Surrealism was totally obscured by abstract painting. I always had the feeling that Surrealism was looked upon as one looks upon a member of the family who has gone astray: an unsavory character one does not mention too often. At the Museum of Modern Art, only Jim Soby was truly interested in Surrealism. I think Alfred Barr was very interested in Max Ernst and would have liked to acquire more of his work, but he had no purchase money for such acquisitions. He told me this himself. Since nobody collected Ernst, there was no interest in donating his works.

Surrealist art was considered as an interesting curiosity, definitely not something one would have in one's home.

DdM: We tend to forget how badly anything not totally nonobjective was considered in those days. The taboo against any representation was strong, particularly in art schools and in artists' circles. A mere suggestion of the human body or a glimpse of landscape seemed to disqualify an artist. In front of paintings that showed some representation like the Surrealists' paintings did, the avantgarde artists seemed indignant.

It was kind of an iconoclastic trend.

DdM: Yes, indeed. We were not in contact with critics or museum directors; we had a very provincial life in Houston. Father Couturier did not like Max Ernst's paintings, which was strange because he was a great admirer of Breton. In his diary he quotes Breton, yet he did not accept the collages of Max Ernst. He believed that it was not art becaue the medium was not classical. He was still living with the idea of Maurice Denis that art is a few colors assembled in a certain order on a canvas.

Did the subject of Ernst's Une Semaine de bonté *really bother Father Couturier?*

DdM: I don't think so. I think it was the ambiguity of the work and the visual absence of any medium. Max Ernst was a conjurer. An old and banal illustrated magazine, a few slashes of the scissors, a twist of the wrist, and new images appeared, strange and obsessive. This process did not look like art to Father Couturier. You see, it was such a jump. One had to accept the revolution introduced by Picasso when he made sculpture with bits of wood.

But later Father Couturier became very involved with Matisse.

DdM: Oh yes. But Matisse cutout papers are totally different from Max Ernst cutouts; it was not the same medium at all. When Matisse cut out paper he was cutting out color, as he said. He had carefully chosen the colors that had been applied on large sheets of paper by his granddaughter or Lydia or somebody close to him. So he was still working with paint.

Father Couturier must have been aware of Dada. He did not like it?

DdM: He did not talk about it, and there is no mention of Dada in his writings. He seemed to have bypassed Dada. Considering his liking for Breton, it seems strange. He liked the "trenchant" side of Breton–the man of principles, his beautiful prose, his inflexibility.

When you started to buy these things for yourself, you also started to buy other kinds of art that was somehow related to your interest in the fantastic. You bought Archimbolds and many other fascinating objects.

DdM: That was partly under the influence of Jermayne MacAgy. She had a real leaning toward the Surrealists and the fantastic.

Something that makes your collection so different from many other collections is a strong link between the whole and its many unusal pockets.

DdM: I was under the influence of Jermayne MacAgy. She and Douglas MacAgy had done an exhibition of trompe l'oeil during the war years in San Francisco, when she was acting director for the Palace of the Legion of Honor.

You see, things are complex. I have an inborn love for exceptional objects, things made exceptional by their beauty or their strangeness. Gradually my eyes were opened by Father Couturier, by Iolas, and by Jermayne MacAgy. But I have become more and more difficult to please; objects have to have something very special. It was very late before we would admit we were collectors.

Do you admit it now?

DdM: Indeed. I have to. But the word does not have good connotations for me.

When did you start to buy contemporary art, new works? You might say that Max Ernst was already a contemporary artist in a sense, but I am talking about the generations between the Surrealists and the Pop artists.

DdM: John and I came to New York from time to time, either together or separately. First we had a small apartment, and both Christophe and George were in school here. We all would go together to look at art, and we would grab something. In those days we could better afford it, but things were not always available. One would go to the Leo Castelli Gallery, and the whole show would already have been sold. That is why there are such gaps in the collection.

Did you realize that when you started to do that kind of collecting, you were doing something different from when you bought works from Max Ernst?

DdM: That is a theory, and we did not go by theories. When you love something you just buy it–if you can afford it.

True, but there is a big difference between buying a Cubist Picasso from 1910 and an Andy Warhol. In France, it took people a very long time to make that step–a generation at least. People would say, "Yes, Cubism is fine, but you know contemporary art is dreadful."

DdM: We always had an appetite for painting. We did not go by theories. John particularly had a great feeling for painting, and I guess I did too. I bought one of the first imprints Robert Rauschenberg made. I saw certain things by Rauschenberg that I wanted to buy, but they were not available. When you are not on the spot you are at a disadvantage. Anyway, it did not take any pushing, and we immediately felt a great affinity for the new generation.

How did your children feel?

DdM: My children have always loved the art that surrounded us, and we used to give them a lot of things. They are particularly sensitive to art. I remember when Christophe was a little girl about four years old, she was standing in front of a window in Normandy and explaining to me how beautiful the landscape was. And I agreed. But she insisted, "But do you see, it goes like that, and like that . . ." and she indicated lines of the terrain. It was incredible. Tiny tots usually do not explain to you why something is beautiful, nor are they so interested in landscape.

Did it ever happen that they opened your eyes to things you would not have immediately seen?

DdM: Christophe certainly did because she is exceptionally intuitive with paintings. Right away she either loves or rejects, although sometimes she changes her mind too. She is the one who has influenced me the most, and I bought many things on her advice.

Over the years your interest in art became more and more radical. From the Surrealists you bought Pop and then you moved on to the very latest things. Now you have worked for more than a year elucidating the role of Yves Klein, who is still not such a well-known figure, although he is obviously very important.

DdM: I like Yves Klein. I fell in love with a blue sponge relief when I first saw it, and I bought it right away. Then later I saw the enormous, beautiful *People Begin to Fly*, which Iolas had, and it took me about two years to persuade him to finally sell it to me. When we came back to Houston, I did not see immediately where I could put it, because in those days there were things everywhere in the house. So I thought of hanging it at Rice University, but believe it or not, after looking and looking, Bill Camfield and I could not find one single wall to hang it on. Universities are built in such a way that everything is predecorated. So I finally made room on the brick wall in the entrance of our home in Houston, where it has been ever since.

You and John did one of the most extraordinary things, I think, in the history of modern museums, when after seeing an exhibition of Jean Tinguely, you bought the whole show. At the time Tinguely was not very well known; he was a fairly obscure man of about thirty-five. I have never heard of such a gesture before.

DdM: It was John's idea, and I thought it was a great idea. He had a wonderfully generous nature. He hated to buy small things one at a time. He never shared the love I had for flea markets and bric-a-brac. He would tell me, "Don't buy ten objects; buy one fabulous one." He was a man of grand gestures. We both loved the exhibition Sweeney had displayed at the Museum of Fine Arts in Houston, The space, Cullinan Hall, looked terrific with all those absurd and sublime machines, and John thought they should remain together.

Have you ever made any distinction between old art and new art, or between European art and American art, or between objects, painting, and sculpture?

DdM: We decided not to touch the Impressionists, which were already very expensive and somehow attracted us less than Cubist paintings. But one day we heard that a late Cézanne was for sale from a collector in St. Louis. It was priced at $80,000, which in those days was for us an enormous amount of money. But it was so incredibly beautiful that we decided to buy it. Cézanne and Van Gogh became the two pillars at the entrance of the collection.

You seem to buy problematic art. That is, you have almost nothing that is simple.

DdM: Well, Rothko's work was not problematic for me. I fell in love with Rothko when I first saw his work at the Sidney Janus Gallery. But it is true that his paintings were rejected by most people, who, having at last accepted Picasso, could not believe that these canvases with large blotches of color, one on top of the other, were also paintings, and beautiful ones at that. It is true that I have a taste for the offbeat. Sometimes I have strayed into fakes because they looked offbeat.

Of a certain generation of American artists, Rothko is obviously the one you have been involved with. How did it come about that you decided to do the St. Thomas chapel with him?

DdM: It had a lot to do with the friendship between Jermayne and Douglas MacAgy and Rothko back in California. Rothko had been commissioned to paint panels for the Four Seasons Restaurant in the Seagram Building. When he finally decided not to deliver them, Douglas MacAgy rang us up and said, "Why don't you look at that wonderful ensemble of panels. Maybe you can build a structure for them." We had already talked several times about building a chapel for the campus of the Catholic University of St. Thomas. So we went to Rothko's studio and saw the paintings. We were quite taken by them, and we felt they created a very spiritual environment.

Some were vertical and some were horizontal. We did not think that it made sense to reconstruct the space of the restaurant, so we decided to wait and possibly later on offer Rothko the walls of a chapel. But, you know, building a chapel for the University of St. Thomas was an enormous step that we were not really ready to take at the time. We did take it at the death of Jermayne MacAgy, and it was "un peu d'acte de folie." I remember clearly going to the president, Father Murphy, and telling him that since Jerry was dead, we had to take a new look at what we were doing. In those days federal money was available for university construction, and we had planned with her to build exhibition facilities. Jerry thought it would be great if a place existed for exhibiting and housing the beginnings of a collection. She always insisted that a collection – even a small one – was indispensable for teaching. She felt the need to have artworks, for students should not only look at slides and book illustrations, but should be able to touch real works of art. This approach to teaching played an important part in the formation of my own collection. At that time I started to buy more systematically in certain fields, such as African and Cycladic. So plans had been made to build a little exhibition hall. When Jerry died, nothing made sense anymore. I said to the president, "When the floor collapses, it's time to make an act of faith. You have always wanted a chapel. Let's build it."

We immediately asked Philip Johnson, who was already involved with the whole campus, and we decided to ask Rothko. It came as a most natural thing, because Jerry had loved Rothko, we knew him, and felt that he could create a space that would be spiritual. We had seen his paintings for the Seagram Building in his studio on the Bowery and had been very struck by their majesty and awesome character. The fathers of St. Thomas University agreed, so in April 1964, I went to New York to see Rothko in his new studio. I said to him, "That is what we would love you to do." He said, "I would love to do it." It was very simple. We never talked about details. He just said he would ask Bernard Reis to draft a contract. He did not demand a large amount of money, just the possibility to do it. He was paid a reasonable fee, and we paid for everything he needed: the renting of the studio, the scaffolding, assistants, etc. He went on vacation in the summer and started to work in the fall. He told me, "Now I am not going to contact you for quite a while. Don't be impatient if I won't show you anything. I'll probably go through great anxiety and hesitations. Don't try to see me before I tell you I'm ready." He phoned me one day and told me to come. I entered his studio, and there was one of the monochromes: the deep, deep blackish, purplish maroon. He was watching my face, seeing what reaction I was going to have. Though it was much, much darker than I had expected, after a while I began to be attracted by it. I sat in front of it and looked at it, and he was pleased. I said, "Yes, that's great." And that was that. Everything was very simple.

Yes and very complicated.

DdM: Very complicated for him.

I mean it came about simply because of the extreme knowledge that you had.

DdM: You see, one thing leads to another, and then it comes naturally. We did not go through books on modern art and say, "Maybe we'll ask this artist, or that one."

When did you decide to add the Barnett Newman Broken Obelisk?

DdM: That is another story–a totally unpredictable event. It is really remarkable that the Rothko chapel and the Newman sculpture go so well together that today we are unable to think of one without the other. When you come out of the chapel, you do not want to face houses or be lost in nature. Barnett Newman's sculpture is the answer. It was not planned–not planned at all. It just happened.

How did the Newman sculpture come about?

DdM: The city of Houston had received a matching grant of $45,000 from the

National Endowment for the Arts to buy a sculpture by a living artist. The mayor asked his arts committee to raise the matching funds and decide on an artist. They came to us. We said, "Why do you start with us? There are lots of people in Houston. Try to raise some money first, then come to us, telling us what you still need." After a whole year no money had been raised and an extension was asked from NEA. The extension was drawing to a close and still no money had been raised. A week or so before it was going to expire, John said, "Okay, we'll match it if no other money comes through, providing the piece we buy is Barnett Newman's *Broken Obelisk*; and it shall be dedicated to the memory of Martin Luther King," who had been assassinated not too long before. That created quite an emotion. "Why should we be so specific?" the council asked. "It should be decided by a jury." Well, finally the Barnett Newman *Broken Obelisk* was accepted, but the dedication was not.

It was not acceptable to the National Endowment for the Arts?

DdM: It was not acceptable to the City Council of Houston. So John said, "We cannot change the conditions of our offer. Many blacks are already looking forward to this dedication. When someone offers a work of art to a museum in memory of a friend, would he renege on the dedication?" You see, we could not do that. Having lost our matching funds, the city lost the NEA grant, and we were almost ready to drop the whole matter. But we pondered it. We talked about it late one evening, and in the morning we had made up our minds. We were going to do it alone. As a city project, there had been a search for a site. Even Barney had considered various sites, but a good spot had not been located. When the dedication was not accepted and it became our responsibility to place the *Obelisk*, Barney said, "Of course, it should go in front of the Rothko chapel." It was logical. Barney himself decided on the distance and on the reflecting pool.

It was a totally unpredictable event, but it is amazing. It looks as though it was meant for that very place. I believe that when we do not give up on principles, when we do not compromise, something great may happen.

It was all due to John: his love for the *Obelisk*, his closeness to blacks, and his firmness in saying, "That's my offer and I won't change it."

Dominique, you are now building a new kind of museum for your collection in Houston, and it will not be like any other museum now existing. Could you tell us about it?

DdM: I think it is a partly new, yet very simple concept. I think works of art are like people. If you are at a cocktail party, you do not get much from anybody, but if you are with three, four, or five people you can really have an exchange, a contact in depth, particularly if you are having a tête-à-tête with a person. Like

human beings, paintings speak, but they speak only in favorable conditions. You just cannot put an artwork next to something that is not congenial to it. Everything has to be in harmony with its surroundings. Thus, the way art is shown is very important. The greatest work of art poorly exhibited will not give what it has to give. You should also never show too much at one time. I am convinced that most people cannot take in copious doses; they cannot take the big dose that is usually given to them in large museums. Curators, museum directors, collectors are able to absorb a lot in a short time. I myself rarely get tired of going through gallery after gallery, but people who are not prepared cannot be exposed to so much.

Our collection is too large to be shown all at once, so I have decided on a rotating system. Only a fraction of the collection will be shown, but that fraction will change from month to month. Yet everything will be stored visibly. Anybody who wants to study or is a connoisseur or has a reason will be admitted to the storage. Even the public could be admitted from time to time. The storage will be like a second little museum. Downstairs, on the main floor, art will not be crowded, and great attention will be given to the display. Upstairs, in the storage space, there will be another kind of display–very tight and crowded–as in the salons of the past. Objects will be compressed like goods in a grocery store, and we will play with them when planning the exhibits for the public area. This storage museum will be the "treasure house." If someone wants to see all the Max Ernsts, he will be taken upstairs and be shown the Max Ernst room. Through experimenting, we discovered that if you really place the paintings tightly next to one another, frame to frame, it really does not take so much room. So we will have a display for the public and also a visible storage area.

There is another advantage of the visible storage idea. If a painting is on loan, in the space left empty, a label will say where the painting went. This way a theft would be noticed immediately. By compressing, you also save space, so you save on air-conditioning and on guards. We will have plenty of room on the main floor, and we need it not only because we will use part of the museum to rotate the collection but because I want to have a place to continue the kind of exhibitions Walter Hopps and I have been doing for years. This place will also be available for traveling exhibitions, as there are many excellent ones circulating today. Besides, we must have space for contemporary artists, artists who already have a bulk of excellent work behind them. They would be exhibited for six months to a year. That way, we reduce expenses and we give the city a chance to discover an artist. During the many years I have been doing shows, I have learned that it is important to leave works up for a long time. Even shows that are up for three months will be missed by many. If you present an artist for one full year, nobody can miss it–unless, of course, out of a lack of interest.

It is a new kind of presentation.

DdM: Yes. We hope to give the people a chance to become acquainted in depth with major contemporary artists. We will have the fun of planning imaginative exhibitions, and the collection will be rotated. So really there will be three different sections in the museum, all three on the same floor. The architect Renzo Piano has made a simple and rational design. There is a long gallery that he calls the Promenade. It connects to the various exhibition spaces, so one will not have to go through one space to get to the next. If one wants only to see an Andy Warhol, it will not be necessary to go through Cycladic or African sculpture; one can go back and forth along the Promenade.

Yesterday we visited the Barnes collection, where one finds exactly the opposite situation. Even for somebody who has certain experience, it is very difficult to see everything. On one wall there may be three medieval paintings and a Seurat, or one of Seurat's five greatest paintings, and sixteen Cézannes and perhaps fifty Renoirs and a great Matisse, then a couple of axes and a few more inches and then some unknown painter.

DdM: Indeed, it is overwhelming, and there seems to be no link. In our museum, artists will also be mixed, but it will not be done haphazardly–only where we feel a real affinity exists between the works.

Are you buying new works for the collection, or are you leaving that to your children?

DdM: Well, at the present the economic situation is not good for buying, so I am not much in the market. But occasionally, when something comes up that would reinforce the collection, I do try to buy it. I do it in consultation with Walter Hopps and Bertrand Davezac, and sometimes I act on stimuli from my children.

You have also strongly supported a museum in Paris with enormous gifts.

DdM: I wish I could do more for the Georges Pompidou Museum, but now I must think of the new museum in Houston. Indeed, there are works I would like to add, but we will wait. My effort now is to try to keep my bank account strong.

Is there any particular artist whose work you have followed for a long time?

DdM: Yes, of course: Max Ernst and René Magritte mostly. One of the characteristics of my collection is its partiality; there are certain artists whose work has never attracted me. I feel a private collection does not have to be comprehensive. It is important for a collector to buy only what he likes. That was the

golden rule given to me by Meyer Shapiro when I started collecting. He said, "Don't try to buy what you think you have to buy. Buy only what you love."

What is your opinion of the role of the collector in culture and society?

DdM: The role is extremely important. Without collectors, museums would be starving except where there is great sums of municipal money, as in Holland and in Germany. In Holland the museums are well provided for, they have excellent directors, and they have built fabulous collections. The same has been done in Germany. But I still think that collectors, with all their shortcomings and all their idiosyncrasies, are the vital link between the artist and the museum.

It seems to me that earlier in this century the collector was able to approach art of the immediate present and take risks that museums, at that time at least, were not willing to take.

DdM: I agree. Now museums are so afraid to miss a potentially great artist that they try to cover everything, which may not be the right thing to do either.

I have seen collectors who are just turned on by one or two artists. They love Mondrian or Klee or Schwitters, and that is great. I always thought that one should see several works by an artist. How can one judge an artist if one sees only one work?

When you are collecting contemporary art, do you attempt to establish a rapport with the artist or do you relate only to the work of art?

DdM: I like to have a rapport with artists. It is said that you judge the tree by its fruit, but in art you can judge also the fruit by the tree. I have always been impressed by the fact that interesting art does not come out of people who carry no weight. Artists may be extremely different. Some may be silent, others may be very articulate, but whatever their nature, you feel a strong personality. I have never seen significant works come from people who did not have personality.

I had a very interesting talk last night with an artist who made a very strong statement. He said that art is not done by artists, that society is as much responsible for the product as the artist is. Art happens because a so-called artist is channeling what is possible to do. The concept that artists somehow create the future in their studios is not a good one. They do work in conjunction with collectors, museums and literary people or other artists. And it struck me–though he did not express his idea very well–that there was really some truth in it. The collector plays a very important role not only by providing the physical means for the artist but by listening, asking questions, being a troublemaker; he is also

often a catalyst. What do you think about this statement?

DdM: I think this artist was trying to express something that is very true. Nothing comes before its time. The whole world is in the process of change: change of situations, change of mentality, change of means. The cultural climate changes from year to year. Ideas are in the air, and artists draw from the environment. But to transform the impressions received into valuable works of art takes creative energy and very special gifts. It takes determination, stamina, even a touch of craziness. I have always believed this, but it became very obvious to me while preparing the Yves Klein show. Much of what he did was indeed in the air, but no one had quite the audacity, the self-confidence, and belief in the final product, in its meaning, in its beauty, as he did. Often several people are doing the same thing, but some come up with an oeuvre and others cannot. They keep trying, but they do not have the strength. It takes enormous vitality to be a valid artist.

Are these the sort of qualities, this kind of force, that you look for in works you buy?

DdM: I think I buy because I fall in love. I do not think anybody is going to put up good money for something he is not in love with, something that he has been advised to get by a museum director. The real collector is going to buy only if he has a strong attraction–because, whatever the price, it is always too expensive. The price always settles just above what one feels comfortable with, and a sacrifice is always needed. When you were buying something at $2,000 that is now worth $200,000 it was still too expensive at $2,000. That is the way the market works: it is always a bit out of reach.

I agree totally. Somebody said that the really best acquisitions are made by buying in a category about which people say, "This is not art." That was, for example, what people said about Yves Klein during his lifetime.

DdM: I remember people saying the same about Rothko. "Don't tell me that there's anything there. There's nothing. This is not art."

Absolutely. Another thing that has struck me lately is something that I must ask you about. I have discovered that the really great artists, if they survive to fifty or so, get better and better. I went to see the John Chamberlain show today at Castelli, and he has never done anything better.

DdM: Chamberlain's work is very sophisticated and people do not realize how difficult it is. It is fascinating to see creation happening. At some point the circumstances are right: the emotional, the physical, the social components. Maybe in Europe the artists have seen too much. They know too much. Among the

people who continued to create interesting works at a very old age was Marcel Duchamp, although he hid it. He continued to make art secretly until his death.

One last question: how would you characterize your collection?

DdM: What characterizes my collection? Maybe a passionate curiosity for the past and also a vulnerability to poetry–the poetry of a Cubist collage that sings a miraculous song, poetry of images revealing the beauty and mystery of the world, whether the image is a small and tender Vuillard or a stunning Magritte. And tragic poetry also. The French poet Alfred de Vigny wrote that the most beautiful songs are the most desperate. I am very moved by the desperate art of Francis Bacon, very moved by art that reaches such poignancy and expresses the tragedy of man's ephemeral condition. I would like my collection to be displayed in such a way that it opens new vistas, that it reveals terra incognita–"islands beyond."

Howard and Jean Lipman

Carefree, Arizona
January 1983

Can you describe your collections, both the contemporary collection and the folk art?

Jean Lipman: We did not really mean to form a folk art collection; it rather happened. It actually divided itself up into two collections in 1950. We sold our entire collection of folk art paintings and sculptures to Stephen Clark for the New York State Historical Association at Cooperstown, because the collection had become rather burdensome as a "public" collection available to museums and school groups. We had 273 items, including lots of figurehead and cigar-store Indians, all housed in a little Connecticut farmhouse. That was our collection. From that time on, we really furnished our house with decorated furniture, and that became a second collection, which the Museum of American Folk Art bought recently. They kept thirty pieces and sold the rest at the auction they held at Sotheby's. Since they were building a new museum, they could only afford to keep a few pieces. We never really collected folk art with the idea of creating a formal collection for ourselves; we knew that eventually it would go to some institution.

Would you talk about the house in Connecticut?

JL: Our house in Connecticut was built in 1734 by the Widow Patchem. It was originally a tiny, tiny house, the size of most peoples' barroom, with a tiny ladder that led to the upstairs area, where the children lived. The main part of the house was built in 1775 as a large farmhouse. We lived in it many years; it is an extraordinary house. But living in Arizona, we were very glad to have it go to someone else.

When we acquired it, nothing had been disturbed. It had never been occupied during the winters, so there was no central heating and no electricity. All the floorboards, all the paneling, and all the hardware was intact, which was unusual for a house that dated from the eighteenth century. We furnished

the house entirely with painted furniture, so when it came time to leave and the Museum of American Folk Art purchased our collection, there was nothing left except our mattresses.

How did you go about the folk art collection?

JL: We spent every weekend, every vacation, and every penny that we had to spare traveling around the New England and Pennsylvania countryside. Prices were so low. If I had not kept a little black book with a record of what we bought, where we bought it, and what we paid for it, I would absolutely not believe it myself. One of the best-known folk paintings, *Winter Sunday in Norway, Maine,* is now at Cooperstown. It was a national Christmas stamp and has been reproduced in large colorplates dozens of times. We found it in the early 1940s in a little junky barn antiques shop, and we thought it was marvelous. When we asked how much it was, the dealer said, "Well, I had to pay 50 cents for the frame, so if you want it, you can have it for that." We were not collecting folk art at that time. We just got hooked on it, and we did not realize we were "collecting" for a few years.

Howard, when did the contemporary collection start?

Howard Lipman: If you are a collector, you can't stop: you either are or you aren't. In 1950, I wanted to look for things and I started to buy a few paintings, but I really did not respond to paintings. I had been very interested years before in wood carving and, in a modest way, sculpting.

JL: If I could interrupt, this was when Howard was still very young. He had done wood carving and marble sculpture, and had had one-man shows at the Kennedy Galleries, at the Weyhe Gallery, and at the Walter Vincent Smith Art Museum in Springfield. He is being very modest about that.

HL: I decided that if I was going to make sculpture, I wanted either to do it well or not do it at all. In those days, there were very few places in New York where one could go for a good objective judgment. I took some of my wood carvings to the Downtown Gallery, which at that time was an excellent gallery for American art. The other place to take your work for consideration was the Whitney Museum of American Art. In those days, the Whitney Museum permitted artists to bring examples of their work for consideration once a month. I went there, and they told me that I was not very good. At the Downtown Gallery, Edith Halpert told me the same thing. It would have been silly not to have accepted the judgment of two experts, as I honestly wanted to know what they thought. So I stopped sculpting and began to earn money. When I had enough money and no longer needed to buy things for myself, I began

to look at the work of young artists. I went to every gallery that was showing sculpture in New York and began to buy the work of young sculptors who had not yet established their careers. I did this for at least twenty years.

When I liked something that was being shown at a gallery, I would get to know the artist, who would often ask me to come to the studio to see what he was doing next. New York was then a much smaller community; there were fewer sculptors, and I went to studios frequently. The sixties was such a rich period–really fantastic. So much exciting work was being done in New York; it was possible to constantly see things that you were thrilled about.

I also developed my own archive on American sculptors. It fills about twenty feet of bookshelf files and consists of printed materials on American sculpture. It is now in the Archives of American Art.

JL: Quite a while ago, we concluded that the three artists whom we most admired were Alexander Calder, Louise Nevelson, and David Smith. We have tried to acquire masterpieces by these artists. David Smith's works represent three or four different series, and each of the pieces we purchased was the one we thought was the greatest of that series. We did the same with Calder's and Nevelson's work. These artists are now the old masters of the past generation; however, when we began actively buying their work, not one of the three had sold anything of importance. Even Calder, when we first became interested in his work forty years ago, was just starting to make large as well as small works. Nevelson had not yet sold any major work. David Smith had hardly sold anything, not because he was not well known but because he really did not want to part with his work. When he died, virtually everything he had done during his lifetime was there at his home in Bolton Landing.

Nevelson, in spite of her enormous international reputation, has yet to be recognized here as one of the greatest American artists of all time. Nevelson has an enormous following, partly because of her personal charisma. I think this may have interfered with her reputation as an important artist.

Calder's reputation is firmly established. His name is synonymous with mobiles, and every baby now has a mobile dangling in his or her carriage.

David Smith is scarcely known by the general public. We have a work by Smith in this house, and not one in a hundred people who visit us has a clue as to what it is. When we tell them, they do not recognize the name at all. We have also had a very strong commitment to Lucas Samaras, both for ourselves and for the Whitney.

HL: I was very taken by his work in the early sixties. It was so unrelated to anything that was being done those days; practically everything was becoming Minimal. He is an exceptionally exciting artist. I like everything he has done,

including the Polaroid photographs, which I think are superb.

JL: The common denominator of our interest in these artists has been our excitement about their work, the fabulous experience we had when first confronted with their work. We then began to analyze what they were doing, but our basic reaction to their work was that it was exciting, fresh, marvelous, vigorous, powerful.

Did you see any carry-over between your interest in folk art and contemporary American sculpture?

JL: Lucas Samaras once said to us, "Well, of course you would be interested in Calder if you are interested in folk art." I did not see any significant relationship.

HL: Calder loved people and welcomed anybody who would buy his work. He wanted people to like his work, and it was easy to approach him. It was a delight to deal with Calder, to visit him in Europe and buy whatever he was doing at that time. We knew David Smith well and visited him often; he was the reverse of Calder. He had the highest regard for his work–he had no question about that–but he really did not want anyone to buy it, and he did not part with it graciously. Smith believed in artists; he did not believe in people who were not artists. He doubted that any curator, museum director, or collector would have the sensitivity to respond to his work as he understood it.

As for Louise, she had such rough going through the fifties that by the early sixties anyone who really enjoyed her work immediately became her close friend. In 1961, I was head of a Whitney Museum committee, and we acquired the first black wall that she sold to a museum. This was the origin of a close and intimate relationship, and we have had a very happy and warm connection ever since.

When you were buying these artists' work, were you trying to choose representative works from particular periods of their development, or just the pieces that you really loved?

JL: Just the pieces we really loved. Actually, the concept of forming a collection that is complete by period, place, style, and medium is something we rather tried to avoid. We hoped that if we acquired enough works, they would fit together validly; if not, we let it go. As a matter of fact, I did a book with Helen Franc called *Bright Stars: American Painting and Sculpture Since 1776.* Our idea was to choose the very best works by the artists we thought were the greatest rather than to try to cover everything.

But for your contemporary collection you decided to focus on sculpture, particularly American sculpture?

JL: That was it–nothing else. When we were collecting folk art, we decided 1900 was the break-off point because we had to stop somewhere. We found one absolutely, incredibly marvelous painting that was dated 1901, and we did not buy it. This was an absolute aberration; it was a ridiculous way to collect. The things you did not buy are always the ones that hurt.

When did you begin collecting with the Whitney Museum in mind? Were you building two different collections at the same time?

HL: Yes. We started collecting cooperatively with the staff of the Whitney in 1965, and within two years they had a collection of seventy or eighty sculptures. We thought it would be a good idea to circulate these around the country, so we created a modest fund to reduce the cost. I think we sent them to twenty or thirty small museums. By 1970 we were largely devoting ourselves to collecting Calder's work. We had a verbal understanding with Calder's dealer, Klaus Perls, that if anything important came up for sale, it was offered to us first.

JL: So the Whitney now has the greatest Calder collection, private or public, in the world. However, we did have a definite arrangement with the Whitney: we would not buy anything that they wanted if we did not like it, and they would not accept something that we intended to give if they did not want it.

Although we did not try to be complete in our own collection, we definitely did try to be comprehensive for the Whitney collection. In the course of developing the Whitney's Calder collection, we acquired some very early works from Sandy that could absolutely not have been purchased under any other circumstances. He had kept these early things originally because nobody had wanted to buy them, but had then decided he rather liked them. He did make these available to us to buy for the Whitney with one exception, *The Brass Family*, which we just could not afford, so he gave it to the Whitney. The valuation at the time, I think, was over $100,000. During the course of the Calder show, Louisa Calder donated an absolutely marvelous mobile, *Roxbury Flurry*. As a result of the "Calder's Universe" show, there have been at least a dozen major gifts to the museum.

Did you feel that it was important to maintain personal contact with artists whose work you were collecting? Did you do this through studio visits and by following people's work?

HL: I avoid going to an artist's studio unless I have a knowledge of the artist's

work and regard it favorably. Until then, I really prefer to see work in a gallery. We would ask everybody about artists' work, just as I ask you, "What do you see in France these days?" or "What do you see in California?" But I did not ask for advice.

I think there is a difference between information and advice. Everybody needs information to know what is going on, but it is not the same thing as advice, because you make your own decision.

HL: I sought information constantly and avidly–advice, no. But I must say I respected certain dealers. In the early sixties Dick Bellamy's Green Gallery, for instance, was so remarkable that you could not fail to respect his opinions. If you responded to this kind of thing at all, you had to be influenced somewhat by Dick Bellamy.

Do you feel that collecting is almost a public activity, something done not only out of personal interest?

HL: Well, the Whitney was a very special place for those years. It was the only place that really exhibited American art. It had a very specific purpose–the support of American artists–and I felt that buying things for the Whitney or buying things for myself were the same; we were parallel in our purposes. This has been true for more than twenty years.

JL: I do not really think that we were collectors in the normal sense, because even with folk art, we were never consciously forming a "collection" for ourselves. Although we bought things, we just could not resist and we were interested in the field; we were not forming a collection for public exhibition. I do not think we ever exhibited anything we owned–the folk art or anything–at the Museum of American Folk Art or any other museum.

We have never before exhibited anything as collectors. If you are really interested, you acquire a little more than you know you should and you ruin your house. Actually, at one time we had about fifteen cigar-store Indians in our house; that was pretty ridiculous. Our collections certainly did not enhance our house, let's put it that way.

We have never considered adorning a specific place; if we just could not resist a piece, we bought it and then tried to find a place for it. This Manhantango Valley cupboard, for instance, is a corner cupboard, but we did not have a corner in our Connecticut house. We kept it in storage until we built the house in Arizona, and we had our architect make a corner for it.

Are there any collectors whom you have been influenced by?

JL: I think not, but there are many we admired. I certainly found Joe Hirshhorn a fascinating collector, and his collections seemed extraordinary and totally different. He was accumulating and collecting. I remember once when we had lunch with Alfred Barr, he said, "Hirshhorn is not a collector; he is an accumulator." I always remembered that, but I think Hirshhorn cared very deeply about the things he bought.

HL: Also, I certainly took a look at anything Dorothy Miller did in her extraordinary exhibition series of American artists at the Modern.

Collecting young, unknown artists seems to be something that you were very interested in doing. Could you talk about that–how important you feel it was that the artists needed the support? In New York City there was not very much support for them at the time you started collecting.

HL: Before World War II, practically no one was buying New York art. There were a dozen collectors at the most–who bought work from the Downtown Gallery. They all knew each other. At that time, we were buying folk art, not contemporary art, but I knew the art world opportunities in New York were limited with regard to American art. I relied on the dealers, thinking that they went to the studios and would pick out what they thought was best, so I watched all the dealers carefully.

Have you seen a great change in the art community since you first began collecting?

HL: Of course. It is overwhelming. You cannot use the dealers in the same way. They can no longer select; they show everything.

JL: I am convinced that there is an enormous body of absolutely atrocious work being made, but nobody is willing to say that it is just not good. I think the "Emperor's New Clothes" story is exactly the way I feel about a great deal of art that is now being made–for example, those pseudo-Dubuffet sloppy, miserable things that look as if "any child could make them" and any child really could! I think there is an awful lot of careless art that has no strength, no real intensity, no merit whatsoever.

I have a feeling that all very good art when it first appears has a great problem in obtaining recognition.

JL: Absolutely; no question about it. On the other hand, I do not think that until now there has ever been a time–at least in this country–when thousands of young artists were slapping out thousands of quickies and selling them.

We used to laugh at people who would say they would like a work but would

wonder if the colors would be right over their couch. I think that now many people get a work that is difficult to appreciate and take pride in having it for that reason. When people ask, "What is that?" they can say, "Well, it is hard to explain," and feel very superior. I certainly don't feel that I have totally kept up with the contemporary scene, but I really think we are being flooded with things that are accepted and cherished mostly because people feel very, very clever about having them.

What characteristics do you think are valuable for a collector of contemporary art–for example, an open mind, a sound education?

JL: I do not think that "collecting" is the right concept. I think you possibly end up with a collection, but you have more things than you can furnish your house with or than you can possibly accommodate, so it is fine to give them to a museum. You have gathered together something that is called a collection. But collecting really seems to have more pitfalls than advantages. I think the important thing is that it is exciting when something has crossed your path, something that you absolutely cannot resist, something you think is marvelous either for yourself or your museum. We both have always felt very strongly about being absolutely open-minded about discarding. When we were buying folk art, we sold many, many more things than we kept, even when we were thinking that the things we were keeping would eventually go to a museum. We got rid of twice as many things as we kept, and we were terribly careful about what we actually decided to buy. There was nothing casual about anything we acquired. It was a total commitment to the object at the time, though we might have changed our minds about things later. It also had a lot to do with not having the kind of budget with which we could just go around buying things. It seems to me that easy buying when it is easy to pay is very dangerous.

Just about everybody we have interviewed in regard to this exhibition runs away from the word collector. *Either they do not want to be called a collector or feel that the term does not describe what they are doing. Why is it a dirty word?*

HL: Everybody for whom I have no respect likes to be known as a collector. I started my office forty years ago, and my senior partner, Roy Neuberger, and I were among the few who were collectors. Today it is part of being an estab-lishment, and I hate it.

But what else do you call it?

HL: Well, I no longer buy things unless I have to. In any case, I do not want to be a collector anymore. I do not like the term, nor do I like the connotations.

Is this because collecting has acquired a strong social connotation that has over-shadowed it as a serious activity?

HL: No question about it.

JL: We both dislike casual collecting, which has to do primarily with other peoples' opinions and "name" artists. It is also like a pat on the back if you can afford to pay the highest possible price for a thing. I feel that the private museum, as a trend, is a very dubious concept. The public institutions should be supported, and I think keeping major collections for private museums may be a very dangerous thing.

Something that seems to be increasingly common is a great concern for making the private art collection accessible to the public. I am thinking of your collection through the Whitney; in Italy, Giuseppe Panza's through the restored public buildings in which he will place much of his collection; in Germany, Peter Ludwig's public museum, which is under construction; and in Houston, Dominique de Menil's museum which will eventually house her collection.

JL: There are so many unpleasant sides to the whole concept of collecting that I wish there was some other word for the activity of preserving or conserving.

Do you see preserving a particular time in history as a real role for the collector?

JL: Yes, I do. I think it should be considered a responsibility.

Dr. Peter Ludwig

Aachen, Germany
January 1983

Why do you collect art?

Peter Ludwig: Collecting art is an extremely important part of our lives. My wife
and I met while studying art history. Both of us were instilled with a love for art
by our respective parents, who have collected antiquities and contemporary art.
We both grew up amidst art and art collecting.

We began as students collecting art in a modest way, starting with first
editions of German classical literature of the early nineteenth century and then
by collecting Dutch tiles and, to a modest extent, medieval sculpture and antique
art pieces of the seventeenth, eighteenth and early nineteenth centuries.

Can you describe your collection?

PL: The collection grew rapidly out of the private sector into a collaboration with
a number of museums. We have worked together for more than twenty-five
years with museums in Cologne and Aachen, and are currently working with
nineteen museums in Germany and abroad. We have placed contemporary art
in museums in Basel, Paris, and Vienna; in the Neue Galerie in Aachen; and in
museums in Mainz and Saarbrücken. A great part of our collection has been
donated to the Museum Ludwig in Cologne. The ancient art that formed the
beginning of our art collection can be found in the Antikenmuseum in Basel and
in the Suermondt-Ludwig Museum in Aachen, which contain antiques, medie-
val art, paintings, and sculpture from the fifteenth to the twentieth century. In
the Schnütgen Museum in Cologne and in the Rautenstrach-Joest Museum we
have placed medieval art, Pre-Columbian art, and art from Africa, India, and the
South Pacific. We do not see a fundamental difference between ancient and con-
temporary art, because what is contemporary today is historical tomorrow.

We find contemporary art especially exciting because it is the art of our
present time, in which we find ourselves reflected. Art is always a mirror of the
time in which it was created and for which it gives testimony, and of course, we
understand our own time best. The artists of our own generation therefore
occupy a preferred place in our contemporary collection. If I may name a few

great American artists who are represented in our collection: Robert Rauchenberg, Jasper Johns, Roy Lichtenstein, Andy Warhol, and Claes Oldenburg.

Do you see a distinct difference between your involvement with European art and American art?

PL: We are quite familiar with European as well as American art, and both are equally represented in our collections. Of course, there are distinct differences. European art originates from a different feeling for life than does American art. But I do not see any differences in quality; contemporary art from both America and Europe is of the same strength and same meaning. Yet when looking toward Europe, we ought not forget that art is created in Eastern Europe and Western Europe as well. We have paid much attention to the art of Communist Europe, examined a large amount of Soviet art, and have added many of these pieces to our collection.

With many of the artists in your collection, you have bought a number of works. Is buying in depth a particular interest of yours?

PL: We appreciate it when an artist is represented in a collection by a number of his works. The artist's personality should become evident, and this usually takes place when one has the opportunity to experience a number of pieces, preferably from different creative periods in the artist's development. In our collection we like to introduce important artists with a body of their work. When we think of a truly great artist–Picasso, for example–it becomes evident that his genius can only be fully recognized in a large exhibition such as the one organized recently by the Museum of Modern Art in New York.

Could you discuss your involvement with the placement and installation of the works in your collection?

PL: We give our collections to public institutions, primarily museums, and it there becomes the task of the person responsible to install the works and make them accessible to the public. We do not get involved in this matter, as in our opinion, these tasks should be taken care of by specialists. We are not specialists in the installation and presentation of art, and we do not wish to interfere in any way with museum concerns.

Do you collect solely to possess a specific work, or do you consider the entire collection as a whole or possibly where the work will eventually be housed?

PL: Our collection did not originate through planning but gradually developed over the years. Today even we are astonished by its large dimensions. Every piece in our collection is indexed, every detail is recorded, and exhibition liter-

ature is kept on file. When we look at the whole, the collection indeed appears to be of great interest as "a collection." It is exciting to imagine that in fifty or one hundred years the whole unit will be judged in terms of what we were able to compile during our lifetime.

Could you describe your process of collecting and the way in which you work with artists, galleries, and museums?

PL: We work with galleries and also acquire information through literature, art magazines, art books, exhibitions, and visits to museums. In my profession I do a lot of international traveling, and I always set aside time for exhibitions, museums, and visits with artists. In this way we are able to survey what is happening in the world and have access to a lot of information upon which to base our selections. We try to study art as much as possible, but the impression we get when actually looking at the work becomes the decisive factor in our choices. For example, our knowledge of American Pop art was limited to the literature, and when we saw the originals, we were so impressed that we quickly acquired a comparatively large number of works.

Do you feel that in collecting it is necessary to develop a rapport with the artists whose work you buy, or do you consider only the work itself?

PL: While we do not think that it is necessary to have rapport with artists to collect art, we are pleased when it develops. We expect the work itself to express what is important, and we believe that a great work of art does not need any verbal comments by the artist, because the artist expresses what he wants to say in his work.

Do you consider contemporary art in terms of movements or groups or artists?

PL: Surely when dealing with contemporary art it is wise to consider groups of artists; however, it is ultimately the individual work that is crucial.

Do you consider the ramifications of your collecting on the international art community?

PL: Our collecting activity certainly influences the art scene, especially since we are doing it in full view of the public. Because we work with museums in the West and the East, our acquisitions affect the appraisal of art; but we do not overestimate this. Fortunately, the appraisal of art, the estimation of art, cannot be done individually but requires the agreement of many. It is true that when prominent collectors support new art, it will receive considerable attention; yet whether it will be successful or not depends–and I repeat, fortunately–not only

upon us. We do not wish to influence art, but we want to help make it known and to make original art accessible to the public.

Do you feel that it is important to occasionally purchase works from relatively unknown artists? What do you look for when deciding to buy new work?

PL: Although it is enticing to purchase artworks from relatively unknown artists, it is not a decisive criterion. We try to purchase what appear to be important works. Several times in the last two decades we were able to add unknown works of art to our collection, only to discover that we had indeed purchased important works. This gives us great satisfaction.

Do you feel that your collection would change if its environment and space were changed?

PL: We do not want the artworks purchased by the Ludwigs to be shown as "The Ludwig Collection"; we intend our acquisitions to be part of a large collection. We do not want the viewer to experience "The Ludwig Collection" as an entity in itself but to see the individual works of art related to a total context. When we donate paintings by Robert Rauschenberg to a museum, we want them to be exhibited in a meaningful context, not to be placed in a separate room with other works we have donated. The viewer ought to have an experience of art and its time, and not so much of a specific collection and collector.

We prefer our collection to be viewed as containing key examples representing stages of artists' careers, as containing important works that reflect the particular period or movement in which they were created.

Have you seen a great change in art and the international art community since you first began collecting?

PL: Art is always changing. Art has always existed. Art is the earliest form of expression left behind from epochs when writing, books, and other means of communication did not yet exist. Artworks give evidence of the first human beings on earth. Therefore, art is so important today, and we are convinced it will continue to be as long as mankind exists. Art is in constant movement; it is never the same; it always reflects the present conditions; it makes statements about the social and economic situations in which it was created and about the intellectual and spiritual world for which it stands. Today's art reflects the present, with all its problems, its fears, and its hopes. Art has the clear function –intentional or not–of giving testimony for the time in which it is created. Think of the art of our century; through it we can experience the spirit and intellect of society during its successive periods. This phenomenon is what makes a visit to a museum such a rewarding experience.

Could you discuss your ideas about the place for art after it leaves the artist's studio?

PL: I believe that art belongs to the public. As much as I appreciate how art can beautify or enhance our personal surroundings, its primary function should be to communicate with the public what is happening inside the individual. So I believe that the best place for art, once it leaves the artist's studio, is where it can have an effect on the public.

When we buy art, we intend to make it accessible to the public, and naturally this is of special importance to the artist. We therefore presume that artists like to sell their works to us, because they know we will display these artworks in large public institutions.

Are there certain works of artists you wish you had collected and did not?

PL: We have never sold a contemporary work that we have purchased; but every collector has a good memory of the special pieces he did not acquire. There are great works of art much admired in museums today that we did not purchase because, for example, we did not have sufficient funds at that time. For a collector these are especially painful memories.

What is your view on the sociopolitical and historical ramifications of collecting art?

PL: We hope that our collection gives evidence of sociopolitical and historical aspects. That is why we are also interested in Soviet art. We believe it is not enough to consider only Western art, the art of our own world; we must acknowledge and study what is happening in the Communist world, which is a large part of today's world. Historical and sociopolitical views play a great role in our collection.

What characteristics do you see as valuable to a collector of modern and contemporary art?

PL: I see the collector primarily as a guardian of culture and secondarily as a patron. In our collection we attempt to give a broad and rich impression of the current situation; hence, it has to do with education.

What relationship do you see between the private individual collector and the public institution?

PL: The private collector can take more risks than the public institution, since he is not responsible to the public in regard to the funds he spends. We value the role of the private collector highly. Without the engagement and commitment

of private collectors, museums all over the world would be much poorer. This also applies, interestingly enough, to the museums of the Soviet Union, where the engagement of the great art collectors of the early twentieth century is still imprinted on the museums. The private collector has the ability and the responsibility to do what cannot be achieved by public institutions. This responsibility rests in his ability to act quickly and to take risks while remaining sufficiently informed to justify his decisions intelligently. His decisions, of course, remain personal ones.

Could you discuss your plans for the museum in Cologne?

PL: The museum in Cologne is a municipal museum, built and maintained by the city. Our collection is only a small part of its entire large collection. For decades other citizens of Cologne have donated important endowments to this museum, and we hope this practice will continue in the years to come. The museum is continuously purchasing works of art, but these purchases are of secondary importance compared to the donations of paintings, sculptures, etchings, and drawings. The directors exercise care in their acquisitions so that anything it newly receives will harmonize with the composition and quality of the permanent collection. When we wish to donate something to the museum, we offer it and the museum decides whether or not to accept our offer.

What are your present and your future plans for the collection?

PL: We hope to continue collecting, to accompany the development of our times, and to introduce to the public new art movements in our own and in foreign cultures. I believe that the private collector is of great importance in our present social structure. Today there are many important collectors all over the world, and they are of great significance to our Western culture, in the same way that they were in the past.

Would you discuss some specific works from your collection?

PL: Roy Lichtenstein's *Takka Takka* is one of the most important war paintings of our time. Modeled after a comic strip, it reduces war to banality. War is witnessed as a comic event through the eyes of the mass-media consumers. Although war machinery is depicted, human beings are absent. Only the noise of a machine gun and the inscription at the top of the painting indicate human suffering and resistance. This shocking picture reconstructs exactly our current experiences: we experience war and violence live on television while sitting comfortably in our living rooms. We see the terror that is happening somewhere in the world, and notice it without being touched deeply. Indeed, we have come

to perceive violence as a form of entertainment; we watch reports of violence and acts of terrorism interspersed with fashion shows, commercials, and other popular programs.

In Claes Oldenburg's *Mouse Museum/Ray Gun Wing*, the museum, a place for permanent collections, is interpreted in a very personal way. Oldenburg places the objects and issues that have earlier occupied him into perspective; he places them into a "museum context" and provides us with an image of time in general as well as with an image of his personality. The objects that he has collected in his "museum"–toys, everyday utensils, mass-media products, commercial objects–surround us and mark our lives.

Odalisque, by Robert Rauschenberg, is one of the most amazing sculptures made after World War II. It is especially difficult to interpret: the case with the pictures; the interior form of the lamp, which is synonymous with the breathing rhythm of human beings; the stuffed rooster sitting upon it; and the stuffed pillow on which the whole sculpture rests. The title alludes to Ingres's *Odalisque*, and to sexuality, which is symbolized by the pillow, the stuffed rooster, and the many female symbols repeated in small pictures on the sculpture. Rauschenberg reveals some very personal things about his own life, but as in all great works of art, he has turned what is important to him into a testimony of the period. This sculpture could have only been created in the midfifties, and it gives an impressive interpretation of that particular decade.

Among the number of artworks dealing with materialism, Andy Warhol's *80 Dollar Bills* appears to be one of the simplest: it depicts eighty two-dollar bills. Yet this is done with much sensitivity: he has created a beautiful color scheme indicating how money has become the main criterion of value. Warhol painted the money without any reference to moral values, gods, or social obligations; he painted it as *money*, one of the most important things in many people's lives. The painting is shocking in its implications. It is the image of a period in which one only rarely contemplates where the money is coming from; it is the image of a time in which the acquisition of money is more important than a moral or ethical basis.

My Marilyn, by Richard Hamilton, is an excellent painting from a period in which the movie star, here Marilyn Monroe, became an object controlled by the media. At the moment the star becomes a product of the entertainment industry, she abandons her personal life. In this painting we see how the star herself selects the best pictures to be used in magazine or movie promotion. She appears exactly as the public wants to see her, because her entire career depends upon her public image. I see this painting as moving and touching evidence of the manipulation of an individual in a society ruled by the mass media and a powerful entertainment industry.

James Rosenquist's *Untitled (Joan Crawford Says)* is a classic example of Pop art. The film star–a creature of the entertainment industry–is employed for advertising in a style deliberately imitating the style and means developed for film posters. The image of contemporary man is the image of a mass society dominated by the image of the star. The star is the model for society, has replaced the idols of previous centuries, has even replaced God; yet the star, product of a market, continues to be manipulated by it.

Richard Estes uses photographs as models for his paintings. Yet he does not merely transfer the photographic images to the canvas, but he creates paintings full of the nuances of contemporary city life, carrying on the tradition of Edward Hopper. In *2 Broadway* the world of flashy chrome is extremely harsh and cold, lacking any semblance of human warmth. The glamour of this world is purely external; it does not come from within. Estes has recreated the image of a modern landscape, which has been artificially created by man in his cities, cities that are highly civilized, filled with luxury, comfort, cars, and various reflections.

In *Richard*, Chuck Close depicts the head of his friend the artist Richard Serra. He uses photographs as models for the paintings and heightens the already strong impression of photographic realism. In this huge enlargement every nuance of the skin, the moisture of the eyes, the slightly open corners of the mouth, and the textures of the hair are all subjected to the unrelenting scrutiny of this representation. Close's art explores the way we experience our contemporaries in reproductions and come to think of them in terms of photographic images.

Ed Kienholz's *The Portable War Memorial* seems to be a particularly massive and indestructible construction; but in fact it is a portable tableau, as transportable and movable as the modern wars that flare up here and there in the world. The work does not commemorate a specific war but is rather a memorial to the universal condition of war among mankind. War and death are represented as part of our consumers' world. The Coca-Cola machine and the estranged lounge chair with umbrellas become part of this memorial. Kienholz does not simply represent; his representation spurs reflection. We are encouraged to recognize the danger of war as omnipresent.

Nancy Graves's *Ceridwen, Out of Fossils* joins camel bones in bronze. The camel is the oldest continuously existing mammal surviving on earth. The bones are all that is left of the body's beauty, yet these bones retain a certain impressive monumentality. The sculpture assumes the appearance of a cemetery for these proud animals; the transient nature of all life is turned into a figurative image. The sculpture is a memento of our time and leads the highly civilized city dwel-

Giuseppe Panza di Biumo

Milan, Italy
September 1982

Giuseppe Panza di Biumo: I started collecting art in 1956, with works by Antonio Tapies and Franz Kline. My goal was to collect art that was new, and I started investigating the possibility of finding new and interesting artists. Tapies's work from 1956 to 1958 reflects an attitude close to aspects of traditional Spanish spiritual life. There is a deep interest in being alone, a love of the desert, a need to live in a silent place, and a pessimistic attitude toward the reality of daily life that pushes everybody to act. Tapies deals with questions about something that is absolute, something that does not belong to mundane things which aimlessly move through time and space. He longs for a world that does not exist, something we wish for but are unable to find.

I became interested in Jean Fautrier a year later, especially in the works made between 1945 and 1947. He had an interesting and very refined sensitivity to color and shape, an almost Post-Impressionist sensibility for the beauty of colors and elemental shapes of matter. There was a joy in these beautiful colors and beautiful shapes, and a feeling that these forms were the manifestations of life yet also a manifestation of death and the suffering of man. This relationship between the joyful and the sorrowful was very interesting to me.

I originally became interested in American art because it was almost unknown in Europe at that time. Nobody was collecting American art; American art as something that seemed of interest to a European did not exist until the Museum of Modern Art exhibition of 1958. I saw it in Basel, though it was also shown in Milan. Pollock, Kline, Rothko, and de Kooning were the main artists shown. It was a beautiful exhibition.

My collection contains about six hundred works of museum quality. In 1958, I acquired Mark Rothko; in 1959, Robert Rauschenberg; in 1962, Claes Oldenburg, Roy Lichtenstein, and James Rosenquist; in 1964, Robert Morris, Donald Judd, and Dan Flavin; in 1966, Carl Andre, Richard Serra, Bruce Nauman, Joseph Kosuth, Robert Barry, and Lawrence Weiner. In 1970, I bought the the works of Robert Ryman, Brice Marden, Robert Mangold, and Jan Dibbets; in 1973, Robert Irwin, Larry Bell, Doug Wheeler, Jim Turrell, and others.

When did you make your first trip to the United States?

GP: In 1954, I spent some months in the United States, but I did not make this trip only for art. I was there to learn something of business. I was very young and was interested mostly in my future career. I was also interested in art and visited several museums, but I did not go specifically to the galleries or artists' studios until 1956.

Your collection is, among other things, characterized by concentrations on certain periods.

GP: My method was to collect a large number of artist's works because my decision to buy came only after a long and careful study, when I was sure that the work was really interesting to me. When I arrived at the decision to collect a particular artist, I was willing to have many works because I was sure that the artist was worth collecting. I bought only the artists who, I felt, had an idea and a relationship to a way of life. Beause of this special relationship, I needed to have many works of each artist. My experience was not simply intellectual but was also the opportunity to share life in some way with the artists whose work I collected.

My interest in the artist as a man came only after seeing the work, only after having realized that the artist was able to express himself totally in his work. Only after knowing the work well was I interested in developing a personal relationship with the artist.

You said that in the fifties you were very interested in the American artists Robert Rauschenberg and Jasper Johns but that you had some difficulty in making contact with the art market in New York.

GP: In 1959, I became interested in Robert Rauschenberg's work after meeting John Cage in Milan. Cage was working at the Studio of Phonology for Radiotelevisione Italiana, which had a very good organization for acoustical research. I had the opportunity to meet him because he heard that I was buying Kline and Rothko and that I was interested in American art. He explained what he thought was happening with art in New York. He spoke about Robert Rauschenberg and Jasper Johns, and because of this meeting, I became interested in their art.

Did you see the work of these artists in the galleries of New York or consult with any dealers?

I wrote to Leo Castelli and asked him to send photographs. I wanted to collect many works by these two artists. A few months later I went to New York and met Leo Castelli. We went to his storage room where he had about

twenty Rauschenbergs from which I was able to make a selection.

Did you see the work of Jasper Johns at this time?

Unfortunately it was not possible to do the same with Jasper Johns, because he was making very few paintings. This was a big handicap for me, as the few other collectors who were living in New York had a much greater opportunity to buy the best work than I had. The collectors Mr. Burton Tremaine and Mr. Robert Scull were able to buy soon after a painting was finished; this opportunity was not available to me because of the distance. I have always felt a strong need to have the opportunity to choose among a number of works. I thus lost the opportunity to collect works by Jasper Johns. This has left a great gap in my collection because he is a very important artist.

In your collection, installation and presentation play a dominant role. You have said that one cannot separate the work of art and the space, that they are interdependent. Has this idea developed the more work you have collected?

GP: In the beginning I collected only paintings, and paintings are more flexible in their relation to the space in which they are situated. They can be easily moved from one wall to another. Yet there always exists the need for a painting to be installed in a space that is sympathetic. We cannot easily mix several paintings by different artists. I like to put only work by a single artist in a room because I believe that for an understanding of an artist's development it is very important to see several examples of his work. Each work has an important relation to the others, which should be nearby. If there are several paintings by one artist in a room, there is some kind of energy connecting them, which makes it much easier for the viewer to understand the quality of each work and the meaning of the artist's personality in relation to the work. Each work helps the other to be better understood. If a painting is placed next to a work by another artist and the works do not have ideas in common, they disturb each other. It is impossible to feel something that connects the works.

Is this idea one of the reasons why you have concentrated on environmental works, where the space itself becomes part of the work?

GP: When I became more interested in the relationship between the work and the space, I felt that this issue was important for Minimal, Conceptual, and environmental art. These artists were making work that is very large. When a work is large, its environment is essential to an understanding of it.

The works in your collection are installed in spaces that are neither neutral nor anonymous. Do you consider the context in which art is to be seen to be part of its meaning?

GP: There is no clear distinction that marks a space as suitable for showing art. Whether or not a space is good for showing art depends upon how the architectural qualities of a space mix with a given work. There are some spaces containing much interior decoration, with very strong architectural definition, which may be suitable for certain kinds of artwork. But other artworks might not fit well with this kind of space because the presence of the architecture would be too strong to allow enough freedom for the art to be seen well or easily. Neutral space is good for everything and offers maximum flexibility. If a neutral space has good proportion, there is a nice relationship between the length and width, and the height of a ceiling; if the ceiling has a fine shape, it will be good for almost everything.

A differentiation and classification of which kind of buildings are good and which are not cannot be made in an abstract way. It depends on the quality of a single space and the quality of the particular work. However, it is extremely important to use a space that has quality from an architectural point of view, because we cannot see art well in a space lacking architectural integrity. Spaces that have been designed by good architects are usually good for exhibiting art.

If you are actually working with pieces whose meaning is the actual volume, the amount of space, and the nature of the light, does the architecture also become part of the work?

GP: Yes, surely. There are some spatial environments made with light in which the space has to be changed according to the artist's instructions. In such cases the space is directly part of the work, an essential part of it, and one cannot just use an existing space as it is – it must be modified in relation to the artist's intention.

When you choose the spaces for each piece, do you do it in collaboration with the artist concerned?

GP: I usually select the space because I know how the work will be situated in relation to the other artworks and spaces in the building. When the rooms are selected I ask the opinion of the artist, and if some change has to be made, I will make it.

Could you talk about the distinction between commissioning a work of art for a particular space and installing a work that has already been made? Does this make a difference in the way you work with an artist?

GP: This depends on the artist and the nature of the work in question. There are artists who only make works that are strictly connected to an already existing

space. In this case the work must be commissioned, and the artist needs to see the space itself and to see what is around it. For instance, we had to choose carefully where we would realize the pieces to be made for our villa at Varese by Jim Turrell and by Robert Irwin, because each work opens to the outside and the quality of the view is a very important part of the work.

Since you conceive each space as a total environment, do you also conceive all the spaces together as a rhythm or evolution?

GP: I believe the relationship that exists between the whole building and individual rooms is very important. I am trying to make a kind of environment in which the viewer going through the rooms will have several experiences that are connected to each other and form a kind of progression. In this way it will be possible for the visitor to appreciate not only discrete works but also the totality of works, which taken together have a complexity with its own identity. The experience is more comprehensive; it is stronger when this kind of unity becomes an actuality.

When the artistic isolation of each environment is expanded into a series of potential experiences, it seems that static isolation is somehow broken. In a very broad sense, you create an expansion into life when you physically involve people, their time, and their dynamics, so that you go full circle.

GP: It is important to have a total experience, one that does not only involve the retina or the intellectual activity of the brain but the personality of the people who look at the paintings, the artworks. It is not only an intellectual activity but a concrete experience to see works in a museum. I do not believe this idea is something new. The artists in the Renaissance made works in which they paid much attention to this kind of relationship. One feels strongly that this unity was extremely important in Baroque buildings and churches. The possibility of connecting the building, the architect, and the painter and sculptor in a single experience that was linked to the final goal, where all the parts were put together, was extremely beautiful. These monuments are so beautiful because when a single work of art lives with many others, it becomes something different and the viewer is able to sense physically that these works are related to life itself, not only to an intellectual experience. After the French Revolution, with the development of industrial economies, the artist lost his position inside the cultural activity of his society and became a private individual working for the private collector rather than for society. Something was lost.

Could you talk about the presentation of contemporary art in relationship to the architecture of the Renaissance?

GP: Usually a historic building is very good for exhibiting modern art because it allows one to see the relationship between art that is made today and art that was made in the past. The architecture is clearly related to the art of the past; each period of art history has its own architecture, painting, and sculpture, which have ideas in common. This relationship is abstract and conceptual. Painting and sculpture use images more closely related to a specific kind of art-historical tradition, whereas architecture must deal with gravity and so find solutions to practical problems. This situation has been the same in all historical situations. An architect does not have the freedom of the painter or sculptor to create his own shapes; for this reason many architectural elements are common throughout history. Early Renaissance architecture is especially hospitable to contemporary art because of its very rationalistic view of space; it has a close relationship to Minimal art, which is about the essence of shapes. Early Renaissance buildings share this ideal of archetypal shape.

I am convinced that what is new is also old. If something is really new, it must have some essential quality in common with the essential quality of work made in the past. To reveal a connection between what has been made in the present and what was made in the past is extremely important to me. I hope to show a connection between the contemporary art of my collection and this building in Varese, which was made during a cultural situation very different from today's. I would like to show that this apparent difference is not real. There are so many things in common between the past and the present that it is possible for the art of today to be situated perfectly in these settings, which were made according to completely different rules. The shapes may be different, but the essential ideas, the foundation of each really important work, are not.

When you say that a work of art must have a connection to something essential in the past, are you talking about the placement of the work in historical buildings or about the way that certain essential ideas are continually explored through time?

GP: We cannot believe in art if we do not believe in some kind of unchanging attitude toward, or a timeless standard of, what is beautiful, what is important, and what is essential in life. If we do not have the chance to confront the past with today's art, it will be impossible to form any real enduring judgment, because everything will be subject to change. A judgment that is good today may not be good tomorrow. The only way to test whether art made today will be good tomorrow is to measure it in relationship to the art of the past. Man is always man, and even over thousands of years the essential attitude of man will be the same. Art reveals the continuity in history–the essential quality of man's mind. Through this confrontation with the past, we can form judgments which can be

projected into the future and have confidence that something which is good now will be good in a hundred years. Some things are "new" only because they have been made in the present; they are not really new.

I believe art is just a visualization of men's minds, which are shaped not only by art, not only by philosophy, not only by an interest in science, not only by music. The personality of a man includes interests in every kind of human expression. For this reason we can form a real judgment of something that comes out of an artist only if it has a relationship to all these things.

In my opinion, philosophy is important in judging art because art cannot exist without some kind of judgment about life, and an attitude toward life is always connected to a philosophical system and an analysis of what is true or not true. For this reason we need to make a rational evaluation of different hypotheses, different possibilities, different judgments.

When you talk about the changing role of the artist, are you referring to the intention of the work in terms of the viewer's involvement and the expanded space of the work, the way in which the work is not self-contained, or did you have other things in mind?

GP: Since the beginning of abstract art, since Cubism, since Duchamp, art has been very intellectual. It has been in some way embodied a process within the artist's mind, an elaboration of an idea that is very personal and very abstract. The first half of our century was very different from the historical period preceding it, because of the development of technology, the possibility of changing the economic life of the masses, and widespread production and economic activity, which brought to many millions of people things that in the past had been available only to a few. Perhaps these changes made the artist feel in some way excluded from society. I believe that after the last world war artists felt a need to play an active role within society, to come out of isolation.

It seems that many of the works in your collection share an apparent simplicity of means or a direct and straightforward execution, while expressing very complicated and profound ideas. Would you say that this is true?

GP: I believe a really good work of art must be both simple and complex. Art differs from literature and philosophy in its ability to express complex thought through a simple form. An artist who is really good must have the ability to express his own ideas in a synthetic way. The individual who does not have this capacity is not an artist. He might be a good writer or a good philosopher, but not an artist. It is a most difficult thing to be simple and complex at the same time, to provide with only a single image many equally correct possibilities of interpretation.

Much of the work in your collection is not static; it demands interaction with the viewer in its environment, takes time to be experienced, and poses some difficult questions. Could you comment on this?

GP: Art is not only about art; it deals with all aspects of life. Good art is always strictly connected to life. An artist who makes something that is not located in the real world is making something that has very little meaning and is therefore not very interesting.

Do you prefer to place your collection in already existing buildings rather than in new facilities?

GP: I prefer to use an existing building because we can make clear decisions about what works can be put inside. We know exactly from the beginning the quality and the main characteristics of each interior space. In this way it becomes very easy to make a program and to choose the most suitable works for each space. It is very important for me to make a strict relationship between the work and space and, if possible, to know the space exactly.

Do you prefer any particular sensibility in the art made since 1946?

GP: It is difficult to say I have a preference for a particular style, because each of the works I have collected I have because I like the particular work very much. There are some artists who made work that is easy for the public to approach. There are others whose work is very difficult for the public to appreciate. The artists from Los Angeles who make environments have the most difficult situation because the work is large, it needs much space, it costs a lot of money to install, and existing buildings have to be modified, all of which takes time. It is also difficult for museums to exhibit this kind of art in a permanent way. I feel a preference for environmental work because I believe that these artists have to be helped more than others.

Would you talk in greater detail about your interest in the environmental work from California and its importance?

GP: I became interested in California environmental art around 1966, after I heard a lecture about the works of Robert Irwin and Larry Bell. I met Larry Bell in 1966 or 1967, when he exhibited his boxes at the Sonnabend Gallery in Paris.

I believe that a number of California artists have developed a new kind of relationship between man and his perception of space; a third element—the space within which something was happening—became an important variable. It was discovered by artists living in Los Angeles in the sixties. Up until that time art objects in space were seen only as objects, although in the past, the space

around the object was very important. Before the French Revolution, different kinds of artists worked together to make churches or palaces in which different kinds of visual art—decoration, architecture, painting, and sculpture—were brought together in a harmonious way. But with the artwork in Los Angeles the space itself became important. I believe this is something absolutely new. Light is the primary thing that makes a space exist. The relationship between our perceptions, our way of experiencing what is outside ourselves, and our being is understood through light. Light gives us the possibility to be aware of what exists outside our bodies. An analysis of the relationship between man and what is external to him has been developed in an extremely intelligent way by this group of artists.

I believe this period is extremely important in art history, because something new has been discovered. This discovery is related to the development of space exploration, because it was necessary that scientists consider experience beyond the earth and acquire knowledge of an environment that is completely alien to human senses. I believe this became the scientific basis for a new kind of art. These studies had to undertake a deep analysis of what perception is, and we have never before had the opportunity to make these studies in such a systematic way. The artists who had these kinds of philosophical, scientific, or psychological notions about the behavior of man were the only ones able to understand these investigations and to create something really important, something really new in art. This is the one main artistic achievement in the last thirty years.

Could you talk about some of the California artists who work with perception and environments?

GP: My interest in Robert Irwin's work began with the discs that he was making in the mid-1960s. I first saw these works at Documenta in 1968, although I had earlier seen some reproductions of this work. I felt that he undertook a very complex study of perception and illusion, and I was quite interested in the field of illusion because it seemed to extend the borders of human sensibility. Irwin basically attempted to show that what we see from habit is not all that we can see.

Robert Irwin is very interesting to me because of his systematic approach to perception and to the relationship existing between knowledge and the world. The attempt to know the essence of the world around us, which is really composed of phenomena, is like watching something being moved on a movie screen without being able to know who is doing it. We see only the moving image, which we believe is the real thing. Irwin tries to remove all incidental qualities from his work. He aims to find the thing-in-itself behind external reality and to understand what is real and what is not real. In order to achieve

this goal, he removes everything that is not eternal, everything that changes, everything that is not as close as possible to the ultimate truth. This process is accomplished through elimination of all that is not necessary. This process means throwing away almost everything, because the final truth can be found in every kind of situation. We reach a space impossible to define; it does not have a name, it does not have a bottom or a limit or a horizon or an end. We can only come to know what is real, and what is real must be seen. To see, we need light; only through light can we determine the connection between existing things and ourselves. Endless space and light are Irwin's tools for making art. Knowledge comes out of the synthesis of our perceptions of something and our minds, which realize that something exists. This connection is very difficult to define.

The knowledge we do have is made up of an accumulation of our perceptions and past experiences. Paradoxically, most of our knowledge is an illusion; it is not something real. For the practical needs of our existence, it is approximate enough to be useful, but this knowledge is really very vague. It only looks exact because the end results are practicable.

Irwin's work is related to the experience of Oriental culture and philosophy, which has preserved a knowledge above material experience, a knowledge that is not only rational but is above rationality. This kind of experience opens up a world that we only know in a peripheral way; we have some remote intuition of its existence, but we are not able to enter this world because of the limitation of our minds, which are so deeply involved in our senses.

Doug Wheeler's work deals with an exploration of perception and with the relationship of the individual to the existence of what is beyond. What is very interesting and peculiar to Wheeler's work, however, is the construction of space in which illusion is deeply analyzed. This kind of research perhaps came out of Hollywood filmmaking techniques. Films are made mostly by illusion. When we go to a movie studio, we realize that what appears to be real in a movie is very seldom real. We experience many small models that are photographed so as to appear to be full scale; we see walls that are only screens made of paper; what we see as sky is perhaps only a colored shape behind the actor and the actress. Yet, when we watch a movie, we do not see these tricks of illusion. We believe that we are watching something that has really happened. Wheeler uses many of these devices to reveal to us how real unreality is.

Doug Wheeler was born in Arizona, where he spent many years living and traveling in the desert. He was deeply attracted to, and influenced by, this landscape. Sometimes we see only the horizon, far away and clear. The horizon line is close to the end of the sky because the sky, the light, and the air are very clear; there is no mist, humidity, or smog. When we see the sun go down behind the horizon, we feel a strong attraction for this kind of space, for this kind of nature.

We are in nature, which seems to have no limits, which is in some ways endless. We feel the illusion of immortality because the light in this endless space will be here forever and has existed before us. Wheeler has tried to recreate this beautiful feeling of walking in the desert in a closed space, within four walls.

I met Jim Turrell in Los Angeles in 1973 through Bob Irwin. Turrell made an appointment for me and took me to his studio, which was in his house in Santa Monica, just a little before sunset. He took me into a completely white room, not too large and not too small; there was an opening on the wall facing the ocean, near the very high ceiling. He made me sit down on the floor, and we stayed there without speaking for about an hour. I was very surprised to see how this opening changed color in a steady way; it was unbelievable to see how many colors there were in the sunset. There was red, yellow, and violet; after the night and the dark it became only a black wall. It was extremely interesting to see all these changes through time.

After dinner we went to another room, which faced the street. The walls in this room were completely solid except for some small openings on the wall facing the street. At a given time Turrell opened some of these openings, and we saw the other wall on the right side of the room becoming green, red, and yellow; there was a very strong flash of light, and it became dark again. Soon after, a very small, soft light filled the entire space.

These different light situations were created by opening and closing a hole that used the light from the street. There was a street light nearby with the red, green, and yellow. There were cars crossing the street from different directions because the house was on a corner. Lights from the cars projected different kinds of light inside the room. There was also light coming from other houses, and these lights changed depending on the source, becoming softer or stronger, reddish or bluish. There was something extremely beautiful and new about this work.

In the sky pieces here in Varese, you see the changing sky and the colors. What happens at night with the work?

GP: It becomes just a black hole. At night there is no light coming from the outside, while there is light inside so it is impossible to see out.

Jim Turrell is an artist who likes to fly, and a large part of his life is spent just in the sky. He now lives in Arizona because, I believe, the space is very close to the sky. There are no trees and very little vegetation; there are mountains, but they do not block a view of the horizon. One has the beautiful feeling of being on top of something very high that allows one to see the sky in all directions. The Roden Crater project is a most interesting work, which is in large part a gift

of nature. He is using the crater of a volcano as a work of art. When one stands in the middle of the crater, one experiences an unbelievable feeling that earth and sky are part of a single entity; one no longer feels the split between the earth and the sky. In the crater one feels part of a gigantic sphere, and one no longer feels alone; because earth and sky join in this beautiful point, one feels that one is part of everything.

The first work I saw by Maria Nordman was in the art department at the University of California at Irvine in 1973. It was a large conical room with a small entry. It was large at one end, which faced the garden, but narrowed to ten or fifteen meters at the other end of the corridor. Near the entry, a small strip of mirror ran from ceiling to floor. It was completely dark inside, but after some minutes it was possible to see that the room divided into two parts, one part completely dark and the other one barely illuminated. The transition from complete darkness created the sensation of two different spaces, one endless because it was dark, the other closed in because there was a little light to shape and define the walls. It was also very interesting to listen to sound coming from the garden, as it was amplified in the room. One felt alone in the room yet at the same time heard all the beautiful sounds coming from the garden, the wind blowing over the trees and birds singing.

I became interested in Bruce Nauman's work in the late sixties. Nauman's work is different from the work of other Los Angeles artists because he has a different attitude toward space. In his work the space is just the space; it is not an illusion - it is something very real to which the viewer must react.

Nauman's work is an analysis of the condition of man who lives in the city, who lives in artificial nature between walls. The cities now cover the earth. In the past one could walk fifteen minutes and be in an open space on the grass, among the trees. Now one must sometimes walk hours to get out of the walls. It is unnatural to be surrounded by walls.

So often it is wrong to make a life that is no longer natural, that is very removed from the ways in which men have lived for thousands of years. With the development of an industrial society, urban life has become more artificial, man lives between the walls of houses, the walls of offices, and the walls of industry.

This problem concerns Bruce Nauman; he has made an investigation into the relationship of man to the artificial urban environment in which we live. All artificial things, in the long run, can become oppressive; even our own civilization in the future could be the destruction of humanity, because we are building something that destroys nature. When nature is destroyed, it destroys man.

All the works by Bruce Nauman are related to some idea; they are always metaphors. We make something, we show something, but the act of making

something visible is a relationship to what happens in life. A sculpture like *Two Fans Corridor* works with just this kind of metaphor. The fans run very fast and make a soft sound, a noise not too strong but steady. This steady noise is made by a motion that does not do anything useful; the stream of air just opposes and destroys itself. The fans just make movement; everything moves – all life is made up of movement. Time is the registration of movements made within a person, images or thoughts going through our minds, the fluctuation of something coming and going. Nature is made of things that move. Atoms move; they are not just inert entities. But the reasons why we do things are very often unclear. This work is just a metaphor for the situation in which everything seems to move to reach another point, but it is not clear in which direction it is going.

Bruce Nauman's work explores man's relationship to the world, his connection to external reality and his unconscious reaction to the situations in which he exists. His work is also strongly committed to the problem of the relationship of man to other men; Nauman explores isolation, the need to overcome confinement, and the difficulties experienced in developing relationships.

Do you feel that this body of work is quite distinct from environmental work being done by artists elsewhere?

GP: Yes. Minimal art, for instance, was the first step in this direction. But the sculptures made by Minimal artists are sculptures, objects that take up part of a space and are not yet environmental works. Work became environmental when it started dealing exclusively with perception and light. This is what makes this kind of art different from all the rest. Even though art often created an illusion of space and illusion of light, it always remained an illusion realized with very empirical means and never became this fact in itself. An illusion of a space and an illusion of light were always related to images, to the reproduction of nature in some way, and never became an exclusively psychological and perceptual problem: a combination of the outside world and the responses of the internal faculties of man.

I began to buy Dan Flavin's work in 1966, when I saw it at an exhibition in Cologne and during the same year in Milan at Sperone's. The shape made by the installation of the fluorescent tubes is not the only important aspect; I was very impressed by the fact that light became something material, something solid. The possibility of using light and space as a tool to make art seemed to be really new, a different kind of artistic research. Light is one of the most important immaterial manifestations of physical law. In Flavin's work it is not only a radiation but becomes something that acquires volume, something that fills space. The surface of the painting and the pigments used for making paintings

are artificial products made of chemicals or minerals. While painted color just stays on the surface, colored light fills the volume. The history of art is dominated by this problem. Giotto felt the need to give the illusion of three-dimensional form in a painting, thus making the first attempt to introduce a kind of perspective into painting.

In the Renaissance this problem became a central concern because the artists felt that this knowledge of space was also in some way a knowledge of reality. The attitude of the Renaissance man toward nature is so different from the medieval attitude. The Renaissance man wanted to master nature, to know and use the phenomena of nature for his own interest. The medieval artist was dominated by an ideological vision, and the relationship of man to nature was not as important. It was important for the medieval artist to discover the reason for his existence and his position in a hierarchy of being.

Dan Flavin shares a marked interest in the phenomena of nature. He does not use nature as the material or the vehicle to the fininshed product; rather, it is a tool for making art. The space becomes something physical and the light becomes something real, something the viewer can walk into. It is more than something to look at; it offers an experience of space and of the light inside it.

The color of the light is also important. When we pay attention, we realize that daylight is always different. There are so many changes because of clouds, the time of day, and the position of the sun. No painting can offer so many meanings, so many changes, so many qualities as does light, an element of nature. Seeing his work for the first time, I realized how rich light is–it is not something neutral–and the colors of the light are endless because so many variations of wavelength are possible.

The corridor piece was made in 1976. It was made for this corridor; it was not made to be installed elsewhere. Flavin came to Varese, and after seeing the space, he decided to realize the work in the way it has been made.

Don Judd's work gradually evolved from a concern with the inherent qualities of objects to a concern with very large objects that interact with the size and quality of the spaces in which they are located. Judd's early works–from 1964 to 1970–are relatively small in size; the colors and the qualities of the materials used are the important concerns. In some cases, the materials reflect light, like those made in copper or brass; in others, made of colored Plexiglas, the light goes through the piece. This attention to the quality of the material and to the meaning of the surface is a characteristic of Judd's work, extending even to the larger works made later.

These materials come to resemble painting in a certain way, because the quality of the plywood, steel, aluminum, stainless steel, brass, or copper is enhanced by the way the artist treats the surfaces. This relationship becomes

more evident when the works increase in size. Instead of having only a refined relationship to the sculptural shape of the object, the material used in the larger works bears a direct relationship to the total space. Judd's work is also concerned with a relationship to materials fabricated by industry. He no longer works with handmade materials or with materials that are manipulated and changed by the hand of the artist. Rather, he uses materials that are mass-produced for use in every kind of machinery or construction. The use of industrial materials is new in art. In the past the artist was a man working in very traditional ways: Kandinsky used the same materials used by Leonardo da Vinci–canvas and pigments, which had been used five hundred years before.

Robert Morris has a very complex attitude toward art; his approach to form is very philosophical. He examined the essential, fundamental philosophical problem of man's existence and attitude toward his destiny. The artworks he makes very closely reflect his philosophical attitude about existence. We feel this in his essential forms, which look very cool, geometrical, and very intellectual; but if we pay close attention, we realize that these works are filled with emotion. This apparent coolness is related to a radical inquiry about man's existence. The basic problem of this inquiry revolves around man's capacity to think and his ability to make distinctions about what is true and what is not true. These objects have a very strong metaphysical content: the meaning has evolved beyond its own material existence. The objects reveal something beyond mere physicality, something that we cannot see, something that is the essence of existence–ideas like the Platonic Forms.

What I like about Carl Andre is his capacity to make an essential statement that is simple and at the same time extremely physical. In his work we feel the need to understand and be part of nature. It is not the attitude of Morris, who tries to know what is hidden, what is behind the object, but rather the will to be completely integrated into the natural existence of things. The works that lie flat on the surface of a floor without having a strong third dimension give an idea of being part of the earth's surface. It is like being a mineral returned to its original condition. Although most of Andre's works are made of steel, copper, or aluminum, they still appear to be part of the earth from which they came. The simple mathematical organization of these works refers also to the essential laws of nature, which bear a strong mathematical relationship to everything, just as gravity can be described by an equation. We know these kinds of definitions are always true; they are valid everywhere and cannot be changed. This reality is outside our minds; we can only learn to appreciate this outside reality because it is strong, beautiful, and logical and because we are part of nature as this work is a part of nature. We both have the same origin, whose core is rational and mathematical.

Do you feel that in the works of Morris, Andre, and Judd there is quite a different relationship to materials and to structure?

GP: Yes, there are big differences and completely different attitudes. Morris deals with materials in order to make shapes that have a metaphysical meaning, Judd deals with materials because of a quality of surface, and Carl Andre deals with material because of its inherent connection with matter.

Richard Serra interests me not because he is a maker of large forms but because he gives visual expression to energies. Gravity is the main force that conditions everything, and all of Richard Serra's works give expression to this fundamental energy, which holds everything together. At the same time, because of gravity, everything tends to fall or is attracted toward the center of the earth. Man tends to give everything an orientation, a direction, to characterize everything with a single way of acting, just as this powerful force makes everything act in a given way, without possibility of escape. I believe all of these attitudes are strong metaphors. Modern man is too self-conscious, and he believes himself capable of using his freedom in limitless ways. He believes himself to be free to choose or decide and to follow his own desires. Serra's work very strongly opposes this attitude. Perhaps this interpretation is not clear even to the artist, but I am convinced that there is no possibility of avoiding this kind of energy, which becomes a metaphor for something man believes he can avoid but which he cannot.

My interest in Richard Nonas began in 1970. I find his work to be the logical development of Minimal art. It tries to achieve the extreme consequences of the Minimal aesthetic, which is to find the simplest, the most archetypal way of expressing an idea. All artists dealing with this aesthetic use very different means and different forms. Nonas has reached the very end of this process, because he uses only the simplest shapes existing in reality. Nothing can exist if it does not have width, length, and thickness. This is a basic condition for objective existence. Nonas has explored the philosophical implications of these basic requirements for objective existence. What looks to be the end of a fixed and mandatory process is revealed to be just the beginning. The length, the width, and the thickness exist in an endless relation, and from these three dimensions one can make an infinite number of works.

The Sol LeWitt wall drawings here are extraordinary. How did you come to acquire them?

GP: Since 1968 and 1969, I have been interested in Conceptual art; Sol LeWitt was one of the first artists I met from this group. I was most interested in his wall drawings, which I started to buy. I was planning to give him a larger space in which to realize them, but when I decided to move out the first part of my col-

lection to be exhibited on loan in a German museum, I decided to make space for LeWitt's drawings and to have them realized on walls in the villa. I had bought the concept for making the work, and in Conceptual art, the project concept is sometimes as important as the actual realization of the work. Yet Sol LeWitt's wall drawings are somewhat different, because the space they occupy on the surface of the wall and the connection to the architecture are essential to the work. Sol came to Varese and chose the walls for each work; he made exact working drawings from the measurements of the walls and in this way adjusted the project to the space.

The work of Sol LeWitt interests me very much because it is so strongly connected to Conceptual art; it represents the possibility of conceiving a system that is complete in all its relationships, in which the foundations of the work are completely explored and exhausted in a systematic way.

If we consider thought as advanced material, this investigation becomes very interesting from a philosophical point of view. Conceptual art examines the potential freedom of the human mind but also indicates its limitations. A system is just a system, but it is constructed by means of principles that cannot be exhausted in their variety. Our ability to understand the nature of reality is always approximate, a long way from grasping ultimate knowledge. In Sol LeWitt's work this kind of philosophical attitude becomes something concrete because his drawings and sculpture have a strong physical presence. How this rational system is developed in a visual way is also important; and it is interesting how he integrates this system into an existing reality.

Lawrence Weiner's work is interesting because of the relationships between images and words. When man learned to speak, he was at the same time able to think and able to build a world with his own words, his own concepts, his own ideas. Because he was able to define a concept that was valid for many different real conditions, he was able to create reason in one sentence. Language is the model for an endless variety of phenomena; it was a great achievement of nature to enable man to think. Lawrence Weiner's art investigates the relationship of the word to the way we think. He believes that every word has both an abstract and a real content. Because the word is always abstract, because it stands for something that can have extremely different forms, it is just a model. This situation is good for making art, as models can express a great number of meanings in a synthetic way by using a single image. Words have many connections to reality through our memory and associations.

The possibility of seeing through words is a new concept in modern art. When we look at words, we see images, not only the symbol, because the word is always a symbol of something real. It is interesting to look at art history and to see that words were also important for making art in the past. In the Basilica

of St. Mark in Venice, words are everywhere because in the past the use of the word was very closely associated with the use of images, and it was very important for the artist to establish the connection.

Joseph Kosuth is a Conceptual artist who developed another side of the problem of definition. We think by using definitions, and we believe that when we use our common language, we say or write something that is very clear. But when we pay close attention to the language and to definitions that we use, we realize that they are ambiguous and are only a symbol of something else. This something else is almost impossible to define, because all definitions are related.

Kosuth has tried to show that truth cannot be grasped through logical definition. Truth is something that cannot be explained by words or by our intelligence, because it is hidden. For this reason Kosuth uses tautology. A tautology is a statement that is always true by virtue of its logical form. It tells us nothing about ourselves or about the world. Yet when we speak about ourselves, we are not able to explain what we are. We are just speaking about what we make and what we think, but not about what we really are.

Do you have a firm idea about where your collection is going, or are you letting it develop naturally?

GP: I stopped collecting in 1975 because my collection contains such a large number of works that only 10 to 15 percent can now be shown. It is nonsense to go on; it is not interesting to buy more. My main task now is to provide the space for this work so that it can be shown in a permanent way. To realize this goal is very difficult. It takes a lot of time and energy; to make a museum is a most difficult thing. It is much easier to buy art than to find the space for showing it in a permanent way. I now devote all my time to this task, which unfortunately is slow-going work.

If you were to continue buying art today, what would you be most interested in?

GP: This is a difficult question to answer because in the last few years there has been much change. The artists are going back to painting, to collage, to figuration, and to imagism; and this work is quite different from the kind of work I have collected. This kind of art is very successful commercially, which disturbs me too, as I always bought the artists whom nobody was willing to buy. It would be almost impossible for me to buy artists' work that many other collectors were buying.

Perhaps there is also art now that is little known.

GP: I believe there are always artists who are making interesting works that

few people recognize. All of the art I bought in the past was work very few people were interested in when I began buying it. I had the chance to find this work, thanks to friendships with a few people who have an eye for new art.

I had the opportunity to choose the best. Perhaps for this reason much of my collection is limited to works from a given period of a particular artist's development, because when the work eventually was recognized and many collectors began to buy it, I had to stop collecting these artists.

Could you talk about distinctions between a private collection that has been made public and a museum collection, which has been developed as something always intended to be seen by the public?

GP: I believe the main characteristic of a private collection is the freedom to decide what to buy, without needing authorization from somebody else. Perhaps getting authorization is uncomplicated when one is buying classical art, but when considering new art, which may be recognized by only a few people, it becomes a very difficult issue for an institution. The director of a museum seldom has the right and the opportunity to act alone, and it is usually difficult to reach an agreement among many people's opinions about the importance of a new work. New art is not often well known. The really good new artist makes something that comes out of a tradition and that is different from what we usually see. If a person does not spend time trying to understand what the artist is doing, it is almost impossible to understand the real qualities and worth of the work. Few people have the time, the will, and the passion to spend hours studying a new artist, because it is often not easy to understand what a new artist is doing. I believe that there are very few people who have a thorough knowledge of what is happening in art.

There have been some great collectors and collections in Italy. Have any of these directly influenced you?

GP: In Milan during the thirties, Jesi, Jucker, Mattioli, De Arigeli, Frua, and Feroldi were important collectors of early twentieth-century Italian art. When I began to collect, I decided to buy only foreign art because these other collections contained only Italian art, and I believed it was my task to bring foreign art to Italy.

How did your villa in Varese come to be the focus, the center for your collection?

GP: It is a large space with many rooms, well suited for exhibiting large works of art. Because I was able to use it for this purpose, it became the focus for my collection.

The oldest part of this villa was built in 1751 by the Marquis Menafoglio, who was a finance minister for the duke of Este, the governor of Milan. Menafoglio was a banker who played an important role in the financial and social life of Milan during this time; his family was from a town near Varese and was interested in having a palace nearby.

In Italy there are many beautiful palaces and villas because prominent men showed their position and families' importance by the splendor of the buildings in which they lived or received people; each played a role in society through the building, which was a way to make policy.

Have the installations in your villa changed since you began collecting in 1959 and since they were installed?

GP: I have been forced to change several installations. Although I am fortunate to have a large house, when you buy and do not stop buying, the available space is soon used up and you must make different installations. It has always been difficult to make changes, because we like very much the works we have and it is a very difficult thing to move some things out of view. But what I was buying after the first period of my collection was for me just as interesting as the work I collected earlier. I also felt a need to have a dialogue with the works because I become sure that an artist is good and that the work is right only if I have a steady relationship to the object. Living with an object is the only way I can develop full knowledge of it. If you always feel a kind of sympathy with the works, this means the works can give different answers according to your state of mind. This means that the works are very rich, that they are not confined only to one thing but can play different roles. One can realize this possibility only after looking at a work in different states of mind. This is the final test for a work of art. If it is able to support this kind of relationship in different conditions, it is really good work. If the work is confined in a single given situation, it is not rich–it is poor.

Because of this, you can feel disgusted with a work; you do not want to see it anymore. You realize it is finished when you no longer feel the need to see it, because it does not give you any surprises. A work is great if it always surprises you; each time you see it, you find something new to consider. This is the essential quality of a masterpiece. I go very often to see museums and to see art of other times. If something is a great work, it is always a great pleasure to see. It is always new, never old.

What advice would you give to people who are interested in starting a collection?

GP: Collecting is a personal thing that cannot be taught to other people, and collecting art is a historical thing. We cannot say that one should act in a parti-

cular way, because in the future it may be necessary to act in a completely different way. Art is made by the artist, and collectors are only people who help others to understand the artist's work. It is impossible to establish rules. In the past, every time I tried to make rules or forecasts about the future, I was wrong. I have come quickly to realize that the only right thing was to follow what was happening rather than to think that because of my experience, I was helping something different to develop.

In addition to collecting contemporary art, do you see yourself as a collector of furniture and primitive sculpture?

GP: I like both antique furniture and modern furniture. When I have time, I enjoy looking at antiques because what is old interests me very much. I am interested in the kind of life an object had because of its history and in having an understanding of the taste of the people who made it. The patina of history on the object's surface is unique to old objects. I find this to be very important because it gives me an intuition of life that existed many years ago. In some way, people who no longer exist have left their mark on the object.

I became very interested in primitive art because I feel that the artist of today is close to the life of primitive man. Life has become more complex because of technology, which makes our existence always more dependent on artificial objects and on artificial organization. We risk being taken completely away from nature. The danger in this is that if we do not understand man's limits, we risk killing man himself. Man is not stronger than nature; nature is stronger than man. All primitive peoples had a strong relationship with nature; they had a perception of reality and the powers of nature that we probably lost when man became civilized.

Could you talk about your current plans for the installations at the Rivoli Palace near Turin? Are these intended to be permanent installations?

GP: Yes. Restoration supervised by Alberto Bruno is well under way, and we hope to have the building ready by 1984. The installations of the artworks will be integrated with the building, which is rather unusual in that there are a number of large rooms with very high ceilings and beautiful architectural shape. It is a historical structure built in the seventeenth and eighteenth centuries; it was never finished. It was a part of a very ambitious project, which was the duke of Savoy's dream - to build a palace almost as big as Versailles.

The building holds all the fascination of something so gigantic that it was impossible to finish; we can see the structure of something very much larger than what actually exists. The contrast between the goal and the reality is very strong and very interesting to deal with.

The interior of the building was only partially finished: some rooms have complete decoration, with beautiful frescoes on the ceiling; others have only the masonry structure, but the structure is extremely beautiful. These rooms look like Bauhaus rooms, a very original kind of architecture. The proportion of the walls and of the ceiling to the floor is so beautiful that it makes an ideal space for showing contemporary art. I plan to exhibit very large American sculptures made by Donald Judd, Robert Morris, and Bruce Nauman. These works have very solid, imposing shapes that can stand up to the strong structural presence of this beautiful building.

Another project also under way near Turin uses a royal palace built in the seventeenth century. It has very large spaces inside and beautiful stables that can be used for showing very large work. The stable will be used for Minimal art; the *citroneria* above the stable will be used for environmental work from Los Angeles. The palace, which is near the stable and next to a beautiful church designed by Juvarra, will be used for painting and sculpture, including many works by Robert Ryman, Brice Marden, Robert Mangold, and Donald Judd, and drawings by Hanne Darboven.

Why do you collect art?

GP: I collect because I believe it is something that I need to do. I do not know why. I believe this activity is natural to my personality. It is a way to project myself outside in something real. Perhaps the aim is to do something that can last, something that could show what we are, to show what I am through what I choose.

Robert A. Rowan

Pasadena, California
November 1982

Robert Rowan: I started collecting contemporary art in 1958 or 1959, though I had earlier collected some little French works. While I was at school in England, we would spend holidays in France, and I started looking at painting there. I would go to the Orangerie, where I saw French Post-Impressionist painting. I also spent a yearly holiday in Rome, where I started looking at Renaissance painting.

Do you think that your early interest in Post-Impressionism influenced the way you later collected?

RR: Yes, undoubtedly, because Post-Impressionism has to do with space and color. But I really never analyzed it. When you like something you never forget it.

Did you ever study art history?

RR: I studied economics and constitutional history, though I had really wanted to study philosophy. In those days I thought it would be too difficult a course.

Were your parents collectors and did they have an interest in contemporary art or architecture?

RR: No, they did not collect, but they were possibly interested in architecture. My father constructed about five twelve-story office buildings in downtown Los Angeles, starting around 1910, including the Alexandria Hotel.

How did you become interested in contemporary art?

RR: I returned to America around 1931, and I continued looking at what was happening here during the thirties and forties. When I was in New York, I looked at paintings in the Museum of Modern Art. I remember seeing French Post-Impressionist and Impressionist paintings and the Modern's permanent collection. I really had no financial resources, so I collected little things. I had

about ten Raoul Dufys–four oils and eight or ten watercolors. Dufy was getting $100 for his watercolors.

I became interested in American painting just by looking at it. I bought a Richard Diebenkorn and a few other things from Paul Kantor in 1958.

When I became involved with the Pasadena Museum of Modern Art, I was collecting a few works by German artists. Jim Demetrion, the director of the Pasadena Museum, was also interested in German art. I had one rather good Kokoschka, but I sold the German works and kept to the Americans. I like Kokoschka and Kirchner, but my interest always tended toward the Americans. I am fascinated with the power and strength of painting. The American work looked strong, just as the German painting did. But having limited resources with which to collect, I thought I might as well specialize.

Did you collect the work of Jackson Pollock and Willem de Kooning in the forties?

RR: No, I did not. I missed them. By the time I started collecting, Pollock's work was already fairly valuable, selling from $5,000 to $15,000. I knew about Pollock and I knew the collector Ben Heller, but I really did not understand the work. When I first saw Pollock's painting, I simply rejected it. I could have collected it, but I did not particularly like it, as I was really visually involved in French painting, although I did not own any of it. It is very difficult to make a radical visual shift and to collect something entirely different. I loved Matisse, so it was difficult for me to appreciate what Pollock was doing. I did continue to look at his work, however, and eventually came to be very interested in him.

I liked the work of Mark Rothko and Franz Kline. I owned a pretty good Kline, which I had bought in 1958, but I had no money to collect on a large scale, and I was unsure of my taste. It was only in the late fifties, by continuing to look, that I really began to appreciate American painting. I developed a desire to collect it, and I financed my early acquisitions by selling two of the Dufy oils, which by that time were worth quite a bit.

Many of the collectors we have talked to have also exercised a degree of caution. Yet to the outside world, it looks as though you are collecting rather radical work. Could you comment on that?

RR: I collect spontaneously, but I really look at quite a bit of work. I really do not read much, but I keep looking at the actual objects and talking, or let's say listening. I also see catalogues and museum shows. I've made all kinds of mistakes, and I have a number of paintings that are not very good. But sometimes I am lucky. The thing to remember is the financing. When you cannot really afford to collect and you want to do it anyway, you must borrow money, so you are limited in what you can collect. This was true even in those days. In 1933

my sister and I both wanted to buy a Matisse called *The Woman in the Plumed Hat*. It was for sale at the Carstairs Gallery on Madison Avenue for $6,000. My sister had $3,000, but I didn't have the balance, so we couldn't buy it. It is now at a museum in Stockholm. At that time, my three brothers and I were running our family company, and we all drew relatively small salaries. If the company had a successful year, we were paid a dividend. That was the maximum amount I ever had to work with to support my family, and it left very little to buy art. So there are many things that I did not do that I might have wanted to do.

Do you view your collection as an entity informed by a particular idea? Did you try to fill in gaps or did you collect works one at a time?

RR: I never calculated, I never really thought about it. I spontaneously buy what I like and can afford. If I were offered a really excellent work that would fill in a gap, I would probably try to buy it. My wife, Vivian, and I have approximately fifteen Craig Kauffman paintings, and hers are really among the best ones. I do not have one of the vacuum-formed bubbles, and if a really good one was actually offered to me, I just might buy it for that reason.

What is it particularly about the medium of painting that interests you?

RR: In the thirties and forties, when I was really collecting, there did not seem to be much interesting sculpture. If I look back, there were one or two really good American sculptors, and I can think of one or two in England, perhaps Henry Moore. From my view, painting was the important thing, especially in 1950, 1955, and 1960. Sculpture seemed to derive from painting. We could consider David Smith to be an exception. I saw his first show at French and Company, and I did not have enough money to buy one of his sculptures, but I certainly liked them.

I think this situation is largely true in the last two decades as well. There seem to be many more living painters than sculptors. I can think of Mark di Suvero and of John Chamberlain as coming up, I hope. I can also think of Don Judd, Robert Morris, and a few others who may make it.

When you speak about "making it," are you talking about the long term?

RR: Yes. We want to be as humble as an ant in Arizona. A judgment about a work of art is just an opinion; you look at the work and you better not be too arrogant. You think it will hold up. I think that di Suvero's work will hold up, but I'm not sure. I do not know him well, but I have been acquainted with him for a long time and have always liked his work. I think he gets energy into the steel. Most of his things have such life and are so powerful. Chamberlain

is a big, tough guy, and he has a fighting chance if he keeps it going. His foam–rubber sculpture did not impress me very much, but some of the masses of bumpers do. I really like that sculpture. If I had the opportunity and the financial resources, I would probably try to buy some of those.

I see energy in Anthony Caro's larger sculptures. I also like David Smith's sculpture, though when I first looked at the Cubist sculptures, it seemed really difficult; it looked like he was making such an awful effort. Looking at them years later, they do look much better.

The way you function as a collector is interesting. You are constantly looking at transparencies, looking at work, and talking to other people about what you are doing. How does this activity occupy your life?

RR: Well, it is a hobby, you know. I am really interested in painting and in sculpture. I have spent much of my time in the world of business. The business world, from which I am now retired, never really consumed me, but I had to work in it for survival. I was fairly interested in agriculture, and I took our firm in that direction. My interests are not literary but visual, and the museum is part of it.

I have a philosophy that when one collects, one should also be giving as one goes along. Of course, one also has to survive, and in my case I have had to sell things because I needed the money, but I have also sold work because I was bored with it. I've sold several early quality Pop paintings, for example. I was not really interested in Pop art, so I collected only a few Warhols. At the time, they looked as though they had some power, and I felt that a movement was coming together and was probably going to make it. I liked those paintings, and they were all at the $2,000 level. But generally, Pop painting does not seem powerful enough. It's pretty hard for Warhol to get power into anything, but he managed it.

So, for you, collecting is really a process of constant evaluation and reevaluation?

RR: Yes, and I try to do it by looking. I talk to people about it. I look at things almost every day.

Do personal relationships with any of the artists play a part in your decisions regarding the work? Do you make a point of talking to the artist? Do you think it is necessary to develop a rapport with the artist, or is it just the work that grabs you?

RR: I am primarily interested in the work itself. But it has happened that I know the artist. For example, I am now looking at the work of Eric Orr, which for me has some power, a spiritual power or energy. I happened to meet the

guy, and we chatted a little bit. In the meantime, I've seen him again and I've seen one of his sculptures. I am interested in the way he is able to keep water sticking to the surface as it falls in a narrow band, where a gas flame runs up the sculpture a little ahead of the water. I did not really have a chance to look at this particular work thoroughly, since I happened to see it at night. Over the years, I have come to know Frank Stella, though I think I met him years after I started buying his work. I get along well with him. I think one instantly senses the character, the nature, and the power of the artist. If I find that an artist is talented, I am greatly encouraged to seriously consider his or her work.

Do you have a particular interest or commitment to the work of younger artists and to the artists working in California?

RR: I collect quite a few of their works, though I am not yet collecting any of it in real depth. But I do look at a lot of new work made by artists working here, and some of it really interests me.

Do you think that your collection would have evolved differently if you were not living in California?

RR: If I were living in New York, I think I would be less apt to have works by some of the locally celebrated artists such as Billy Al Bengston. Perhaps I would have several of Sam Francis's paintings, but I do not think I would own works by Craig Kauffman. I might have missed a lot of work by people living out here.

Could you talk about your involvement with the work of Craig Kauffman and Ron Davis?

RR: I've known Ron Davis for a long time, and I bought his work fairly early in his career. I remember that he was the only artist who ever sent the Pasadena Museum of Modern Art money. He just mailed $500, saying he wanted to support it.

Quite a few artists are actually supporting The Museum of Contemporary Art.

RR: True, but this happened in the early sixties, an entirely different era. We made a big effort to create a museum of modern art out here because it would be the only place for contemporary art this side of Chicago. Support from the artists was greatly appreciated, and Ron Davis just did it. I can remember liking the Renaissance dimensions of his painting *The Arch*, a work incorporating perspective and illusion. I bought a pretty good large painting called *Stars*, though I do not think that this painting is as strong as some of the earlier work, such as *Bent Vents and Octangular*. But I will continue watching his work.

What was your interest in John Altoon? What did you like about his work?

RR: The paintings were beautiful, and I have always been amused by the drawings and watercolors. I always felt that Altoon was very talented. I thought that he was a good painter, and he thought that he was a good painter, but he often worried that his talent was more in illustration. It haunted him. I think that his best paintings are pretty damn good.

Have you had any involvement with art that is environmental and deals with a whole architectural space, with Conceptual art, or with work that is done out on the land?

RR: I have been limited in that I have not really spent much time thinking about environmental work. The first environments I noticed were always situated outdoors. Because I work in the agricultural world, I am often outdoors, and I have spent years working in Arizona. I am just so accustomed to big spaces that I have become prejudiced. I have always wondered why those guys were messing around with such tiny bits of soil.

The mesas really do stand out on their own, without intervention by an artist.

RR: I agree. I have been thinking of Michael Heizer's *Double Negative*, the one that is cut across a ravine. I was irritated with it when I first heard of it, but I was judging without really looking at the thing. It looks much better to me now than I remembered it. In my opinion, many artists grew up in lofts down there on Broadway in New York City and never saw the country, poor devils. I mean they were just looking out at the next building. When they stumbled out west, look what happened. I am thinking of people like Walter de Maria, for instance, and the way he thinks as against someone like Frank Stella. Maybe it is just as well; maybe they really can see the country differently.

Are you interested in the idea of space and scale or what has been described as "American space" in the paintings that you have been buying?

RR: I do not use the term *space* as much as some people. When I am looking at a painting, I do not think of the space in it. Of course, the space is there, and color-field paintings deal with space and light. I differentiate the space in a painting from the outdoor space on the planet, in order to compare them. Perhaps I should not do it–it is a category of mine. These different kinds of space contain different kinds of energy and whole different qualities of light. I prefer the big outdoor spaces to the city, and I have always had a hard time with the early Cubist works; I find them cramped, tight, and needlessly difficult –overly complex for me.

Do you see distinctions between the works of California artists and New York artists?

RR: There is a big difference but I never tried to analyze it. I had about eight of Richard Diebenkorn's early paintings, from the Berkeley and Albuquerque series, which really dealt with space in a different way than the eastern painters did. I liked Diebenkorn, but I also appreciated paintings reflecting an eastern sensibility. Sam Francis also has a western feeling, though he spent many years in France and he painted his best work there.

When I first started looking at American painting it was all in New York. There was very little here in Los Angeles, so it always pleased me to think that something was finally going on in the West. I would look at work in the West, I was right here much of the time, and I was happy that the talent and creative ability had come all the way west instead of stopping part way–say, in St. Louis.

Have you ever been interested in European work?

RR: My involvement has been almost entirely with American work. David Hockney might be considered a possible exception, but he has lived in California for a long time.

Are you interested in having work from your collection eventually go to museums or other public institutions?

RR: When I have something I like, I want to share it. In fact, this gets at the basic idea of who it really is that you are collecting for. I think an important part of collecting is sharing the pleasure you get with a lot of people and hopefully with many of the future creative artists. Artists do not often get to see the best examples of artwork. Many artists both in California and New York have told me that they saw and learned a lot, and were inspired by what they saw at the old Pasadena Museum over the ten or eleven years it was exhibiting modern art. Maybe they could not have done what they eventually did if they had not been inspired by the work in some of the exhibitions Walter Hopps, Tom Leavitt, and Jim Demetrion organized.

As a collector who passes along work to the public, do you see yourself as an intermediary?

RR: No, I have never really thought of it like that; I collect what I like. If you are related to a museum, the public is there, so you lend and you give the things you have to the public via the museum. It's funny–I never really thought of the process, but that is exactly what I have been doing. Being museum-

related involves helping to build it, helping to hire the staff. If you are a trustee, trustee interference is a delicate area. The staff produces the shows, hopefully the great ones, and the public and the kids at schools have a chance to see work by the future great artists. The museum process is an educational one, although it depends upon the institution's physical assets. Most trustees have to function in relation to the building and in terms of developing policy. If you are a collector as well and you acquire very large works, the museum will be the place to see them.

I am curious to know about the things that you bought and have lived with, before giving them to institutions. Could you talk about some of them?

RR: If a work is a twenty-foot painting and you decide to buy it, you know you will not be able to keep it in your house. When you make a decision to buy it, you automatically consider it to be a great work. If you are involved in your community and it has a museum, you will find that it will almost always be short on its collection of the major works. If you are involved with a museum that has a lot of space but does not have a large collection, for a good part of the year it is a trustee responsibility to see that the walls of your museum are filled. This was always my life. We had a large amount of space and not much of a permanent collection in Pasadena. The same thing could be said for the San Francisco Museum of Modern Art and certainly for the Los Angeles County Museum of Art. Gifford Phillips and I could almost fill the Pasadena Museum of Modern Art with big paintings, and we had enough so that they were not always the same ones. It is the primary responsibility of every trustee to preserve and develop the institution's collection. It is a fundamental responsibility of the cultural institution to create, improve, exhibit, and preserve its permanent collection.

Do you believe in making a commitment to work with local art and with things made in the present, with the idea of preserving them for the future?

RR: When painting moved across the Atlantic, very few knew it except for the museum people and several collectors. Pollocks and Gorkys were selling for $5,000. These opportunities are beyond belief. It is just common sense for a museum to pay attention to what is new and what is happening in its own vicinity. I think that this answers your question. Your first reaction to a major work is happiness; you are really thankful it exists. If you have the opportunity to buy it and are working with a museum and if you know that it will add to the collection, you plan to donate it later when its value has increased, which will help your income tax too.

You perform a very interesting function: you look at work at the time it is made, you purchase it, and eventually make it available to a public collection.

RR: If I were very strong financially, I might collect differently. I have always been interested in work that is created in the present, but at the same time, I would like to have bought a major Pollock. I would like to have done the things that should be done for the museums, because the museums never have enough money to do them. I would like to buy more great works and get them into a museum in our community. I say that this helps the person who is looking, the artist, the kid, the future creative person. It is better to look at the really great works first.

Where does your desire to give work to museums come from?

RR: I consider it to be a public service; it is elementary. Anyone who has read the Greek classics is familiar with the idea that one is happier when capable of doing a service for the community.

As a private individual collecting art, your involvement with a greater public has occurred on a number of levels. You have lent your work generously to exhibitions. You have placed it on exhibition in institutions such as the Art Center College of Design in Pasadena, and you also give work to museums. Do you have a particular feeling about museums as the most appropriate place for works of art, and do you have different ways of evaluating the various public spaces available for art?

RR: In this secular age, many people have never been to church, and we do not usually have big cathedrals, but people do wander into the museums, and this helps them spiritually. This is one of the functions of a museum. If it has an important collection, it can help thousands of people in just the way hearing great music does.

Do you collect differently when you are purchasing for a museum than you do for your personal collection?

RR: When I collect for myself, I always try to keep in mind that something is a potential gift to a museum collection, so I might as well be collecting works of museum quality. But just as often I will purchase a small work, because I like it.

The question does come up when you are buying the work of a young painter who, for all you know, may stop painting before his career develops. If it is a major work, it looks great, and you think it is of museum quality; if it has energy, power, and is a hell of a painting–all right, you will buy it.

What is more important to you: helping to establish a young artist's career and following that career through, or purchasing things that have already been established as monumental works of art?

RR: Both are important but entirely different issues from my point of view. You have to go for the major works when you are wearing the museum hat. We do not see museums buying the work of all the great young painters. Working toward that end is a human end. It is more fun and it is the high-risk end. But both activities are very important.

When you buy the work of younger people, do you feel that you are supporting the great work of the future?

RR: I hope when I collect the younger artist's work that he or she will happen to be brilliant, get better, and not fold up, and that much better work will come along. You always hope that the artist you stay with and like is making better work, and you sometimes get little signs that the work may improve. Sometimes you stay with someone whom you think is creative, but the person gets worse and worse. Though you try to support him, you just do not collect the work. Now this is a subjective judgment and one that can be wrong. Take Stella, for example, during the five or seven years he was doing the Polish Villages, which were pretty disastrous from my point of view, I just did not buy.

But you stayed with him and kept watching his work?

RR: Yes, as soon as I felt he started to improve, the five years did not matter. When Stella's Protractor series ended, he made the Polish Villages, and five years later he was doing new work. He told me, "You know I couldn't possibly have done the Indian Bird series or the other series without going through the Polish Villages." The later work in the Polish Villages series looks better to me now; the last year looks especially good, and I wish I had bought one. With an artist who is well known or a genius like Stella, one should stay with him even in the bad years.

Have you continued to watch the work that you have not remained involved with?

RR: If the collector thinks an artist's work is getting better and he knows the person is bright, he should probably stay with him if he possibly can. If he sees a bright artist whose work is getting worse and the artist is becoming arrogant and difficult, he might not. Funny thing in the world–each case is different. I've been with William Wiley for quite a long time now, and I am going to stay with him if I can afford it.

Do you go out and look at gallery shows of younger artists?

RR: I often go to the galleries. I think Karen Carson is pretty talented. I own a really fine painting and hope to stay with her. I also like Mary Corse. Dick Bellamy, her dealer, reminds me to get up to Topanga Canyon to see her latest work. I recently bought a major piece, which I really like. I cannot get big, heavy things into my house, but this work is on exhibit at the Art Center College of Design, so I have been able to look at it there. I have seen it about twenty times since I purchased it, and I like it more each time. I have gone back to her studio a number of times, and I do not like the white paintings with the glitter in them as much as I like the ceramic work, though I am going to follow what she does. Vivian Kerstein is another young artist whose work I have started to collect. The first work I saw I bought because I really loved it. It is one of the large elevator paintings, and it has a complicated name. I was not as impressed with her recent show, but I think that she is a talented woman, and I will keep looking at her work.

Do you pay attention to recommendations by certain trusted friends, dealers, and artists, or do you really follow your eye?

RR: I trust Nick Wilder and Dick Bellamy, and they are not afraid to change their opinions about an artist's work. Now any serious collector must go to New York and see the work there. Let's consider John Chamberlain, for example. We know that he has done a great work in Florida, so the next time I am in Washington, D.C., I plan to go there and look at it. In the meantime, I follow his work at Leo Castelli's. Apparently Chamberlain's latest work is the best of his life, or so I am hearing from the dealers. Jim Corcoran calls me–he is in New York at least once a week–and says that I must look at Chamberlain's work.

So you are really involved in a whole network of information that is constantly being updated and revised?

RR: It is like working at a museum; one must keep in touch with dealers, collectors, artists–wherever the information is.

But are there particular things, such as the sense of power, that attract you to a particular work and keep you interested? Are there certain consistencies across the range of the work you collect?

RR: If you think something is a great work, a major work, work with power, you must try to find a way to buy it. If the work is large, you are really thinking in museum terms, so you must ask yourself, is this really great, is it of museum quality?

How would you define that quality?

RR: I do not really know how to define it. I said earlier that there is spiritual energy in a powerful painting. Some paintings are truly great, and some not so special. I do not know how to define it other than to start talking about what energy is, and the discussion becomes kind of metaphysical. It is pretty simple the way I look at it. Maybe it is the scientific point of view. If we consider the universe, there is a lot of material out there, and it reduces to atoms almost infinitely. The whole universe is made of atoms. What about atoms? I always used to think that they were permanent, but I don't anymore. The atom itself certainly disintegrates over a long period of time, and with every atom in the universe disintegrating, we've got energy. If you start thinking in scientific terms, the thing could be pulsing. Is material being formed all the time while it is also disintegrating? It is very hard to define energy, but human beings can sometimes get it into painting and sculpture. They just do.

Do you see the power as emotional energy as well?

RR: I see everything as either actual or potential energy.

To pursue your metaphor, where does that leave the constants that we call art? Never mind the energy, but that constant quality that has always made great art for mankind.

RR: It is the creative energy of the artist that makes it. The energy is in material form temporarily, and it radiates right out to you.

Do you think it requires a person of genius to generate this type of creative energy, or could it have been a mere craftsman in the Middle Ages before the idea of genius appeared in the Renaissance? Could that be spiritual energy too?

RR: I would tend to agree with that. Look at what the artisans did with the church stained glass. We call this person an artisan, but it is just naming. Every human has the potential to develop his creative energy. Sometimes it radiates out. Look at Simon Rodia's Watts Towers. Anything can happen, and just the fact that someone is called an artisan does not make any difference. The personal vision is the creative element. If we consider all material forms, humans are certainly at the top of the birdcage. Humans just have a lot more than other living things. They are energy. They can create. I think the French painters we mentioned had just what we are talking about, and those paintings continue to have it.

Do you think that artists are privileged to have more creative abilities than other human beings?

RR: Yes, but creative individuals in all the fields have it. It would be hard for me to differentiate between a great spiritual leader such as Gandhi or a literary genius such as Shakespeare. These people somehow tapped into it.

In great art there is tremendous knowledge to be found both in the work and in one's personal involvement with it. Do you find something out about yourself through the experience of the painting, so that the experience is not closed or complete but something that is open?

RR: Dead open. I mean open and it goes both ways. The question we start with is, how does a creative artist get the spirit into a material thing, and then have that material, dormant, dead, radiate it right out to the viewer in the museum? It is really complex and really simple at the same time.

Do you see this power coming through in certain ways of working with color and light? Would that particular characteristic interest you?

RR: Yes, but light really is color–it is the way we look at light. Some people are able to see things in ways that other people cannot. Panza can see certain things. I have a pretty hard time appreciating Dan Flavin's work, for example. I was always interested in the color-field painters–as soon as I saw them in fact–and I am still very much interested; but some of those painters have simply changed. Kenneth Noland's early paintings were unbelievable, but as he changed, his work changed.

Do you ever commission new work, or is this out of the question because you basically collect things that are already established?

RR: I do not commission work, because I like to look at something before I buy it. What if the guy produces a real lemon? However, I am not against it in theory. If I were stronger financially, I would like to offer some commissions to give promising young artists a chance.

Do you often change your installations here at the house?

RR: Yes, I do change the works around, but I have very few small things, and it is hard to get the large works down and up.

Do you pay a great deal of attention to the placement of the paintings in your living environment? Do you feel that it is important to juxtapose them?

RR: I do not consciously juxtapose works. I want the paintings to fit the size and balance of the room, and if something obviously does not fit in the house, I send it to storage or lend it to somebody.

When you donate or lend a work, are you concerned with where it is seen or where it actually is in the world?

RR: Yes, it does interest me. They wanted to put the Mark di Suvero sculpture I loaned to the Pasadena Art Center College of Design east of the building, but I told them it was a bad spot, looking down the hill and directly on the cement. I recommended that they place it on the lawn, which they finally did. I am really interested in having a work I donate installed where a lot of people can see it.

Have you seen a great change in the Los Angeles art community since you began collecting?

RR: I do not really think I do; the creative process of the artist is the same. However, the art community as a whole is much more knowledgeable because of the growth of the public media. You can pick up a copy of *Vogue* magazine and see a Barbara Rose article about the latest artistic talent. The creative effort is always there and always will be. It is certainly incredible how much less resistance to contemporary art we see now in the United States. Even the average businessman is fairly knowledgeable. The business people are very flexible and rather alert, and of course, the investment possibilities in America attract a lot of them. If you are a smart executive and if you bought a Pollock for $5,000 twenty-five years ago, it would now be worth $3 million. The amount of increased public awareness is the greatest change.

Do you think that corporate purchasing will replace the role of the private collector in the future?

RR: I do not think it will replace it; I think it will add to collecting in general. When a corporate executive is overseeing construction of a new building, he will consider that 1 percent of the cost must, or should, go to the arts. He looks at the Seagram Building and sees a large Barnett Newman sculpture out in front. He knows that Rockefeller has a collection. All these things work on him, so he buys a Frank Stella. It is easier for him to do it with corporate finances at his disposal, and he will try to make the right choice, so he will go for the name.

Do you ever ponder the ramifications your choices have on the art market?

RR: I do not think about it. The fact that I buy the work of one of the younger painters here does not make any difference to the market. It might make a little difference if I leave a work on hold at the gallery. Someone once wanted to buy a painting I had reserved, because he knew that I wanted it.

Are you continually revising the collection? Are you involved in the process of keeping a work for a time, then selling it and buying new work, or is it more of a static situation?

RR: Next year at tax time I might have to sell something, but I really do not have many works that I want to sell. Those few things I might like to sell are simply unsalable at this time, and it is really easier to keep the things that are not currently worth anything.

My decisions to sell are primarily based upon the need for money to pay for new work. I am constantly buying paintings. I want to buy a Vija Celmins, so I might have to sell something to finance the purchase. I only sell work I am no longer so interested in.

Can you envision getting to a point where you would stop collecting?

RR: I cannot resist collecting. I always think I've made up my mind that for a while I will not collect anything. But then I see something, and although I should not buy it, I do anyway.

So it does go back to your commitments to particular artists?

RR: Yes. I like Craig Kauffman's work. Those early people who showed at Ferus Gallery were very capable artists. If a really great Lobdell were offered to me, I would be tempted. He is an excellent California artist, and I do not own a single painting of his. You see, I never analyze what I do; I just do it. I like the process of collecting. I always imagine the things I could do if I had a lucky break financially–if the oil fields should creep up toward our farm. I would become an aggressive collector. There are quite a few things that I could buy that would improve our collection.

What do you think are the characteristics of a collector of contemporary art, as opposed to someone who collects old masterpieces?

RR: I think he better work hard on it and have good luck. A lot of people always talk about collecting, but so often they find excuses not to buy the work. If someone thinks that he knows what he is doing, he should do it, right or wrong, instead of fiddling. I think that we should be very alert and pay attention to what is happening now in art in places that are prosperous, such as Germany.

Do you look at art in terms of its social or political ramifications?

RR: I do not like violence, and there is a terrible amount of violence in German painting. The power is there, but as soon as we start grinding the ax with it,

political or otherwise, we get into trouble, and the artist's power diminishes– it disappears. I think in terms of where there is economic prosperity. The artists can't starve to death. Where they can survive physically and financially, they thrive.

Charles and Doris Saatchi

London
May 1983

The collection was started in 1969 and is based almost entirely on works produced since 1965. For several years the collection concentrated on Minimal art; Carl Andre, Donald Judd, Sol LeWitt, Brice Marden, and Robert Ryman are each represented by five to eight works. Agnes Martin, Eva Hesse, Robert Mangold, Richard Serra, Robert Morris, and Dan Flavin are each represented by two to four works. The collection also includes works by Bruce Nauman, Richard Tuttle, Jo Baer, John McCracken, Larry Bell, and Fred Sandback. Minimal art remains the core of the collection, and this group of works is still added to fairly regularly.

During the 1970s the work of some of the younger American artists who were leading the way out of the strictures set by Minimalist and Conceptualist thinking was acquired. Neil Jenney, Susan Rothenberg, Joel Shapiro, Jennifer Bartlett, Scott Burton, Joe Zucker, Elizabeth Murray, and Jonathan Borofsky are each represented by three to seven works.

Works by a number of artists whose influence was strongly felt throughout the 1970s on emerging American painters and sculptors were also acquired in some depth. Cy Twombly, Philip Guston, Frank Stella, Malcolm Morley, Lucas Samaras, and Richard Artschwager are each represented by six to twelve works. Among the other American artists represented in the collection are Jim Nutt, Chuck Close, H.C. Westermann, Leon Golub, William Copley, Roger Brown, Bill Jensen, and John Chamberlain.

Later in the seventies, work by a new generation of American artists was added to the collection. These include David Salle, Robert Longo, and Cindy Sherman, each of whom is represented by three to six works. A number of works by Julian Schnabel were acquired in the late seventies and early eighties. Late in the seventies, works by European artists were added to the collection. Georg Baselitz, Anselm Kiefer, Sigmar Polke, and Francesco Clemente are represented by four to eight works each, and the collection includes works by Joseph Beuys, but not in sufficient depth.

For this exhibition four American and four European artists have been selected to focus on particular aspects of contemporary painting as seen in the collection. Philip Guston, Frank Stella, and Malcolm Morley, each of whom took a highly influential new direction in their work during the seventies, are seen alongside Julian Schnabel, whose paintings have made a conspicuous contribution to New York art during recent years. Georg Baselitz and Anselm Kiefer have been equally influential in Europe and, now that their work is regularly seen in America, are also of interest to younger American artists. Francesco Clemente's and Sandro Chia's work has quickly achieved recognition on both sides of the Atlantic. These eight artists are represented in the collection by approximately a hundred paintings.

Charles and Doris Saatchi preferred to submit notes on their collection rather than be interviewed.

Rita Schreiber

Los Angeles
February 1983

How did you get involved with collecting art?

Rita Schreiber: We became involved with art through our friendship with Charles Laughton. Mr. Laughton was a client of my husband, Taft Schreiber. We were also very close friends. It was a joy being with Charles because he was such a wonderful bright person, and he loved art. Taft asked Charles if he would help him develop his ability to appreciate and understand art. Charles was delighted, and Taft was a very apt pupil. I was right beside him hoping that I would get as involved as I knew Taft would.

We discussed art a great deal with Charles, and he brought us many catalogues and books to look through. He had a very good art collection, mostly French modern painting, works by several English artists, and Morris Graves, the American artist. When Charles had to return to London–he was appearing in a play there–he sent us lithographs so we could become more familiar with the works of artists such as Nicolas de Staël, Pierre Soulanges, and Alfred Manessier.

We started with the French modern painters because Charles was most interested in them; he was right there and became friends with the young painters. Unfortunately, the work did not hold up; it did not compare with American painting. As we continued to buy works, we realized that contemporary American painters had much more to offer. It was all so clear, and very exciting. However, we did acquire a mixture of work; we did not just stick to modern and contemporary.

What was the first work that you bought?

RS: The first work that we acquired was by an Irish painter, Jack Yeats. We no longer have the painting, but we loved it when we had it. Of all the pictures that Yeats painted, we found this one to be the most outstanding. It was small, but done so beautifully. Perhaps we loved it so much because it was one of our first works.

Paris was where it started for us. While Charles was working in London, we visited him and traveled to Paris together. We met the French artists whom Charles admired and went to their studios. Many exciting things were made possible for us, and Charles wanted to show us everything and to explain what we did not understand. We were just novices then, but Taft became very involved and we went on from there.

The last painting we purchased before Charles died was the little Cézanne, *Les Baigneuses.* When we brought it over to show him, tears came to his eyes. He was so moved that his "students" could pick out this picture. He died shortly after that, and we lost a very dear friend.

We were then on our own, but Taft did very well. He loved art. He loved buying art. But he was not a crazy buyer; he bought very keenly. We do not have a vast collection. I do not even call it a "collection," I just think of it as paintings and sculpture that we adore and bought because we adored them, not because we thought that we had to have something of everyone's. People who "collect" collect everything; they have closets full of things that they never hang. Taft had a wonderful way of approaching art; he bought art because he loved it. We did not have too much, and everything we had was on the wall.

What kind of process would you go through in buying something? Would you look at something for a long time or read about it?

RS: There were certain artists whose work we were very anxious to have, and we would devote a lot of time to identifying the works we thought were very good, and to discovering if they were possibly for sale. My husband was a very persistent man. When Taft found a painting that he wanted very badly, he was not happy until he was able to buy it. He always managed to convince someone to part with the work, whether it was for sale or not. For example, we bought *View of Agrigente*, a painting by Nicolas de Staël, from the collection of Alexander Rosenberg, the dealer. When Mr. Rosenberg and his wife came to our home for dinner and saw the de Staël hanging in the living room, Mrs. Rosenberg did not want to look at it. I asked what was wrong, and she told me that she could not look at the painting, she was heartbroken that she did not have it anymore. I know they loved it very much and we, of course, loved it too.

How did you come to buy the Jackson Pollock?

RS: Except for the Rothko painting that we purchased two years before, the Pollock was our first venture into contemporary American painting. We discovered it was for sale by a man who knew very little about painting. He had taken it home to show to his wife, but she found it so dreadful that she would

not allow him to keep it in the house. So he took it around and had it shown in different places. When it finally got to Los Angeles, Fred Weisman told us about it and we had it sent over to look at it. We took down a very bright painting and hung the Pollock in its place. It seemed at first to be so dark, and we felt that it drained all the energy from the other art around it. We decided not to keep it and rehung our other paintings. But the room just seemed to die; the electricity was gone. We decided that we had to buy the Pollock.

Were there other artists whom you were particularly interested in?

RS: Well, everyone has favorite artists. I care most about the Jackson Pollock, but I also love the Matisse *Femme assise dans un fauteuil.* It is quite a jump from Pollock to Matisse, but the Matisse is one of my favorites. I also love the big de Staël *View of Agrigente.* Up to the time that Taft passed away we were able to buy the work of almost every artist that we wanted to collect. We were so anxious to have a sculpture by David Smith, but one that we liked never became available. We do have a small sculpture by Jean Gonzáles that has David Smith's name inscribed on its back. We bought it in France, and it turned out that David Smith had bought it from Gonzáles. If Taft were still alive, we would undoubtedly have continued to buy paintings and sculpture, but after he died the excitement was gone for me. It is wonderful living with these works we have, and when the Pollock leaves my house for the exhibition, I will be terribly unhappy.

Is there a story behind the Brancusi sculpture Bird in Space*?*

RS: We got the Brancusi sculpture at auction, and it was a very exciting moment for us. The auction was in New York, and we were in London at the time. We had put in a bid before we left New York, and we went to the London Sotheby's to listen to the bidding on their telephone hookup. When the Brancusi came up, the bidding stopped at our bid. We were so excited. Taft was just beside himself. It received a lot of publicity, as it was the highest price paid for a Brancusi up to that time, which was almost twenty years ago.

Could you talk about some of the other works in your collection?

RS: I bought a small watercolor by Henry Moore in 1954 before we started buying paintings. At that time I did not know anything about Henry Moore, but we later came to be very good friends. We have quite a few of his sculptures. Moore had some of the Impressionists' paintings in his home, but very few. He always claimed he did not make enough money to buy paintings. Once when we were visiting Henry, we saw *Seated Girl* in an unfinished state. He planned the work to include a wall in back of the figure, but we asked him if he would

consider not including it because we loved the fact that we could walk around it and see the entire figure. We were afraid that he might not agree because it was not his original idea for the piece. He agreed and sold it to us as it was, and he never made any comment about liking it that way or not. We always thought that maybe we were presumptuous asking him to change it.

We had seen a small work by Alexander Calder called *Crinkly*. When we told Calder how much we liked the small sculpture and asked if he could enlarge upon it, he replied that he certainly could. That piece became *Big Crinkly*. We also bought a wire sculpture titled *Acrobats*, and have photographs of Calder as a young man in Paris working on it.

Were there any collectors who influenced you?

RS: Taft and I became very friendly with Joseph Hirshhorn and his wife. He was a very exciting man; his enthusiasm was so contagious. He is someone I would call "a collector" because he had closets full of things. In fact, he did not remember everything that he had.

I recall an evening with Joe in 1962 when we were all planning to attend the opening of a George Rickey exhibition here in Los Angeles. Joe knew nothing about his work before that evening, when he saw our large sculpture, *Nuages II*. We had dinner together before the opening. Joe excused himself and told us that he would meet us at the show. When we arrived not too long after, we found that Joe had rushed over to the gallery, and had bought everything in sight.

We collected on a strictly personal basis–not in the early days of course, when we were really just beginning to meet the artists. But after we would spend two or three evenings together, we would often become friends. Although artists, dealers, and collectors from Europe always came to visit us, we could not wait to go back to New York or Paris and see what was happening. At the time, in the late fifties, not much was being exhibited in Los Angeles, although a number of collections were shown here, and a few galleries had exhibitions of work by contemporary artists.

When you bought the works did you buy them with this house in mind, with particular spaces in mind?

RS: Yes, certainly with this house in mind, but as to particular spaces, no, not especially. We never measured walls, but the art always seemed to fit the space.

Excerpt of a letter from Taft Schreiber to Charles Laughton, August 1958

About ten years ago, I had some physical problems and had to take it easy for a couple of years, and it was suggested that I take up painting. I worked at it for about a year and became terribly discouraged and quit. The reason I quit, of course, was that I began feeling better and the therapeutic values, while wonderful, were offset somehow by a realization of how I had gone through life–so many years of it–with little or no power of observation and the few lessons and the little painting I had done delivered a terrible blow to my ego as to my lack of seeing so much that is around us–in color and composition, in nature and beauty, and while I have tried to develop the proper use of my sight, I am convinced that I am an amateur, pure and simple, in that department. I know you have developed this facility and I have tried for years to improve mine, and I am sure you will aid me in that regard and I am more than grateful for your help.

Excerpt of a letter from Charles Laughton to Taft Schreiber, August 1958

Nothing would give me so much pleasure as to lead you to loving painting as I do, but that is a thing that has to proceed by slow stages. I know that when I was young, men that [sic] I admired told me that Cézanne was a great painter. He meant nothing to me, but I lied and also said that he was a great painter. One day years later Cézanne hit me hard and I was ashamed. I do not mind making a mistake for myself, but I could not bear making a mistake for you.

Fred Weisman

Los Angeles
March 1983

Fred Weisman: Basically, my interest in art comes from within. I've been interested in being around art, having it with me, living with it, working with it, studying it since I was a child. I would always have calendars and posters and things of that nature around me. From there I graduated to little drawings. I was never an artist. I never even had any desire to become an artist, so it was not out of frustration that I became a collector. I just like art very much.

I did not study art or take any courses, but I had a thirst, a real hunger for it. I've always gone to museums and art galleries, ever since I can remember. As a matter of fact, I still do. I have a very tight business schedule, but I always plan an extra half day before or after appointments if I am in New York, Washington, Tokyo, or London, and I will take time to visit the museums and art galleries.

Everything that relates to me in the art world comes from within. It's a gut feeling, and a lot of exposure and "I like that," or "I don't like that." If I have to explain to you what I like about art, I cannot do it. I think Marcia can do that, and I respect her for it; she can go into it in depth.

Has your involvement always been with modern and contemporary art?

FW: In the beginning if I saw something that turned me on–a beautiful Edward Hopper, for example–I liked it. From there my interest was in color, shape, form. If a sculpture was round and I could touch it, it was great. The interest in actual colors and shapes led me to contemporary art.

My first interest in abstract art was with the artists Pierre Soulages, Alfred Manessier, Hans Hartung, and Lucio Fontana. I will never forget a beautiful Soulanges I had. I thought Soulanges was great. Then I saw a Franz Kline, and I thought it was so much better. I guess the bridge to the New York school could have been from Soulanges to Franz Kline.

Basically the paintings of the New York school excited me. As far as sculpture, it was Europe. I think I still feel that way. Of course, I really missed the boat on David Smith. But outside of David Smith, Tony Smith, and Bob Gra-

ham, American sculpture is not interesting to me.

I am constantly buying, giving, moving. If you were to come here a week from now, you would see a completely different collection. You would think, what is this, a museum or an art gallery? I am always shifting pieces around the house so that I will see them in a new way. I buy things and then worry about what I am going to do with them.

The environment of the work of art is very important; I can relax and go to sleep thinking about where I'll move paintings. It's my best therapy. I don't count sheep anymore.

I have always seen a collection as something I live and work with. I have three companies in Maryland, and one has a collection of California art. The others have collections of contemporary Japanese art because I am involved with Japanese business, with importing Japanese automobiles.

I go to Japan two or three times every year, and of course, I go to the museums and galleries. Last time I was there, I saw a beautiful Frank Stella show. Ten years ago I saw Jasper Johns, Bob Rauschenberg, and a lot of contemporary American work. As a matter of fact, I bought my Sam Francis painting in Japan.

So your commitment to your collections really has been to Japanese artists, California artists, and the New York school?

FW: Predominantly. Marcia has spent a lot of time with younger California artists. Much of their work was purchased by our companies because Marcia exposed me to California art. She would tell me about an artist, and I would go to the studio and buy work for my collection. Some of the Japanese artists have become friends.

Has much of your collection come about through your relationship with artists?

FW: Yes, and many have become my good friends. Clyfford Still is a classic example of a wonderful artist, and we had a very good relationship. He gave me the big yellow painting as a gift. We bought the black and the red Stills in New York, which released him from living in Manhattan by providing him with enough money to buy a farm in Maryland.

Did Clyfford Still have definite ideas about which work to buy and where it should be?

FW: Clyfford did, and many artists are that way. California artists are real nice guys, and I have a good rapport with them. Some of them are characters. Billy Al Bengston is unique, and Ed Moses is an unusual person. I enjoy being with them a lot. Bob Graham is also a very good personal friend of mine.

Do you follow the work of these artists?

FW: I try to. But it is important that there are good galleries and a good museum to attract these artists; otherwise they die. You can be a great collector, but if there is nothing to see in the museums or in the galleries, then what is there? You have to go out of town to find anything. The new museum is a healthy step forward, and I think that the competition is going to make the Los Angeles County Museum of Art a stronger institution.

Did you buy work of California artists like Sam Francis and John Mason from the artists because you knew them?

FW: Not necessarily. I liked the works, and so I bought them. Lorser Feitelson also really turns me on. We also knew Peter Voulkos very well.

Were you interested in Ken Price's work at that time?

FW: Yes, in the boxes. That work is now in Marcia's collection. We also had John McCracken make two very large works for us. One, called *Post and Lintel,* is a big arch–two poles with a cross between it. It was a blue, a Barney Newman *Onement* color, and we kept it in the garden. At that time I was on the board of the Pasadena Museum, and we gave the other piece to the museum.

I have a beautiful painting by John McLaughlin, which is in storage. We had the McLaughlin at our corporate offices with a Joe Goode, a Laddie Dill, and a beautiful big Sarkisian. Our two other black-and-white McLaughlins are in New York.

Do you see a distinct difference between the art communities of New York and Los Angeles and the art being made in those two centers?

FW: I am not a good judge, because I have nothing to base it on except my own observation, but I think more things are going on in California now, as far as artists are concerned. I think that in New York there is finally an awareness of California art. A few years ago there was no interest.

A while back, Frank Gehry and I were going to start a Soho right here in Venice. We bought some property on Main Street, and we planned to have the Weisman collection there. We were also going to have galleries and artist studios, but the Coastal Commission knocked us down. It never worked out and I am very disappointed about it. It would be great for the artists and the community if there were now an area like La Cienega used to be. Years ago the Greyline buses used to drop tourists there on Monday nights so they could go through the galleries. Some people were interested in art and some were just sightseers. Now La Cienega is spread out: some of the galleries are on Santa Monica Boule-

vard, some on Melrose Boulevard, and so on.

When you were first collecting, did you have a sense of building a whole collection, and were you looking for particular artists whom you felt were important? For example, you said that you were sorry that you did not buy the work of David Smith. Did you have that feeling about certain other important artists?

FW: I had hoped that the Weisman collection would continue to go on and on, in depth and breadth. There are some fantastic collections in the United States. The Ben Heller collection was great, the Bob Scull collection, the Burton Tremaine, and half a dozen others, but they all seem to have disappeared. We even had discussions with Franklin Murphy about how we could leave our collection to three or four museums–one on the West Coast, one on the East Coast, one in the Midwest, and another in Texas. The collection would rotate. We wanted the flexibility to keep it alive.

When you say "to go on and on," you mean you always wanted it to stay together as a collection, not to be added to necessarily?

FW: Oh, no–to be added to. And we always intended that our grandchildren would have the right to have any number of pieces in their homes. It was more of a plan to attempt to keep the thing intact.

Do you see collecting as a social function?

FW: There are all kinds of collectors. I can walk into someone's home, see a collection, and get certain feelings. I may feel that a particular collection is a status collection or that it is an investor's collection–smart buying for investing purposes–or perhaps that this is a collection with a real feeling for the work. I'm being very general. There are certain collections you can walk into and you think, my God, they want to be known as collectors; it's a status thing; they are loaded with money and everything is fine. You can really spot that kind of collection, or at least, I think I can. People may be coming into my home, and I may be falling into those categories myself. There is nothing more marketable than the top-quality work of a great artist. You do not have to worry about the dollar or yen rate of your investment.

When you buy art, are you always aware that you are purchasing key works from a certain period in a particular artist's development?

FW: We always think we are buying the best. Then we find something that is better, and we do one of two things. If the work is one that is important, we will try to sell it. We've sold art at Sotheby's or Christie's, and we've bought

from there. We've made trades with dealers when upgrading our collection. Works that are of medium quality, we have given away; for example, Marcia has given many works to Cedars Sinai Medical Center. We have also given works to the Mayo Clinic in Minnesota, and we have donated works of art to museums. The works that do not wear well we give away or sell. I hate to have stuff in storage.

If you look at a work for a while and decide that it is not "wearing well," what criteria are you using?

FW: I don't know. I can't say. You buy a work because it pleases you. Then something may happen over a period of time; you find it's not wearing well. I've had the experience where I've seen one work, and deciding I liked it, I have bought it. Then I've seen an entire show and it was so much better. You really need to see a lot of an artist's work before you can make that kind of judgment.

Have you commissioned work for your collection?

FW: The only thing I recall commissioning was a Bob Graham door for my office in Century City. I started to think what would happen to it when my lease was over. It got to be so beautiful that I thought, why do I want to put it in my office? When we had the exact dimensions, I showed Marcia the working drawings and she loved it. When it was finally finished, we brought it home.

Did you commission any of the Mel Ramos paintings?

FW: I can tell you a story about that. I used to be the chief operating officer of Hunt-Wesson. At the time we acquired the brand name Hunt, we had been in the business with a good quality, inexpensive product called Val-Vita. When we acquired the Hunt company, we wanted to develop and promote another good-quality product. In those days, *Life* was the big-circulation magazine, and a full-page ad cost $25,000. Young and Rubicam was our advertising agency at that time. I knew Mel Ramos, and I asked him to draw a sketch of something that would attract a lot of attention; I wanted something that was a real stopper. I showed it to Young and Rubicam, and they told me it lacked dignity! Since I did not want to stick my neck out on that one, I asked Mel to do the painting and I kept it myself. I still think it's great. Since then I have commissioned him to do work for other businesses that I have been involved in.

Are there people who advise you about your collecting? Do you work often with dealers or talk to artists about work they like, or do you consider it to be solely your responsibility?

FW: A dealer is always selling, and an artist is usually interested in his own

work. I do it very much on my own. Museum directors are the last people you go to, to find out what the values are.

When you rearrange things in your home, do you juxtapose things to see different artists' works together?

FW: I never think about it that way. At night I will come up with a great idea, and I can't wait to get up, to take a look and figure out the measurements. You see a Cézanne and next to it a Chuck Arnoldi. It is not a matter of, well, this does not belong there with that, or the color is wrong, or this or that. Maybe some of the arrangements are terrible, but that's not the way I feel about it. A collection and its presentation is a very personal matter.

You speak often about giving to museums. Do you feel that the collector has a responsibility to donate and/or circulate the works in his collection? Have you always had a relationship to the community and the public?

FW: Yes. It is terrible keeping art in storage. Some of the art now in storage will be loaned to the Music Center, the Pittsburgh Center for the Arts, the Palm Springs Desert Museum, the Honolulu Academy of Art, and other museums. Just as in business, if you do not go ahead, you stand still. Many American businesses get to a certain size and become very complacent, and it has been the worst thing for them. Japanese and German companies are coming in so strongly. You can always do more and be better. You must think like this; otherwise it becomes boring.

So you do not need to see art as something that has been validated and that you collect but as something living and growing?

FW: Absolutely.

Can you tell us about how you came to buy the de Kooning paintings Pink Angels *and* Dark Pond*?*

FW: That is a funny story. Marcia and I visited a New York collector who owned both *Dark Pond* and *Pink Angels*. *Dark Pond* is on Masonite, and there is a sketch of *Pink Angels* on the back of it. We were thinking we would buy it and put it in the center of a room in a Lucite frame so people could see both sides, but it did not work out that way. We liked them both so much and couldn't decide which one we wanted, so we bought them both. Paul Kantor sold them to us rather inexpensively, though in those days it was a lot of money. We were so deeply involved that I guess I would take chances. I would buy something and worry afterward about where we would put it and how I would be able to pay for it. My feeling was, if something is good, let's buy it. We bought a fantas-

tic Stella, but it was so big that we could not put it in the house. It is now in San Francisco.

David Hockney did a painting of Marcia and me with a big Turnbull sculpture in the foreground and the Henry Moore *Queen* in back. It is called *The California Collectors* and was used in Neil Simon's film *California Suite*. When Hockney finished it, naturally I bought it; but it was too large for our house. Bill Janss was living across the street from us, so we loaned it to him. When we wanted to see it, we would go over and ring his doorbell. We finally sold it.

When I went to Düsseldorf, I met a dealer by the name of Franz Myers. He looked at me and said, "You look familiar." As it happened, he knew the collector in Düsseldorf who owned *The California Collectors*, and he took me over to see it. It was a strange feeling to be in a place like Düsseldorf, Germany, and to walk into a home and there you are. The owners recognized me immediately. Paul Kantor told me that it is now for sale, and they want a lot of money for it. I told Paul, "My God, you know, the subject matter. Who wants to buy a picture of Marcia and Fred Weisman and pay that kind of money for it?" Perhaps I'll buy it back.

Did you go to see Mark Rothko's work in New York at his studio?

FW: We did go to Rothko's studio, but our first Rothko, the green and blue painting, was purchased from Larry Rubin in Paris. When we got back to New York, Ben Heller introduced us to Rothko. He was very difficult to talk to–very shy. We bought the dark blue and charcoal Rothko from Frank Lloyd, who was handling Rothko's estate at that time. We bought the red painting directly from Mark Rothko, but I sold it to a relative in Chicago. I was sorry I sold it.

I bought the red Ad Reinhardt from Arnold Glimcher at Pace Gallery in New York. I love it. We originally bought one of the black ones, but when it was shipped from New York, it got rubbed a little bit. You cannot easily restore a Reinhardt, so it went back.

Did you like Barnett Newman's work the first time you saw it?

FW: Yes, but if you asked me why, I could not talk two minutes about it. It was just there, and something about it moved me deeply. Marcia could come up with a long and meaningful story about it.

Were you very interested in Jackson Pollock's work?

FW: Yes; I own one work, and Marcia has *Scent* and a beautiful drawing. When I see *Scent*, which is his last painting, I wonder where he was really going. We should have collected more Arshile Gorky; that was a big hole from our standpoint. We bought *Terra Cotta*, which is now in New York; our son Richard has it, and Marcia has a beautiful Gorky drawing.

What advice would you give to someone who wanted to get involved in collecting?

FW: It's hard to tell; it's hard to generalize. A person should live with an art-work for a few days before buying it. A person's whole thinking should be to buy something as though he is taking a vacation. If it costs $500 or $5,000 and he likes it, fine; if he does not, he should wait and buy something else. In other words, it is important not to get all hung up about the cost.

A collector cannot be a decorator. You have to feel it, you have to love it. I would feel so terrible if I were living in a room without beautiful art. I do a tremendous amount of flying, and I can see Clyfford Still, I can see Rothko, in the beautiful sunsets. We used to sit at our home on the beach and watch the sky change. Every night the sunset was like a different painting.

Marcia Weisman

Beverly Hills, California
October 1982

Why did you start collecting art?

Marcia Weisman: I started collecting art because I had always had some sort of appreciation for it and, like so many people, I had–quote-unquote–a place over my sofa and I wanted to buy a painting. One thing led to another. I started in 1957, but before that, I had bought a poster at the Chicago Art Institute called *At the Moulin Rouge*. I had it cropped, matted, and framed in a gold frame. I put it over a sofa in my bedroom. I also bought a Van Gogh reproduction, an ink drawing of the fields in Arles in sepia tones, which I had photographed and blown up until it was the right size to go over the couch in my living room. I had it mounted in a beautiful wood frame and matted in linen; in those days I probably spent $50 or $60 on the frame and $5 for the posters. But I knew that I had to have quality things. The artists were not bad and the imagery was good. Later I moved into more serious art.

Some people are alcoholics; I am an art addict. I think Peggy Guggenheim wrote a book about the confessions of an art addict. I do not mind following her any day. If you really care, I think it is something you become obsessed with in a funny sort of way. I do not think I could go through a day without observing something that relates in some way to the visual arts. At times, I can drive down the street and see a building with an automobile in front or a stop-and-go sign, and all of a sudden it just deposits itself in such a way that it becomes an art form. It isn't art in the true classical sense, but it certainly is in today's sense of happenings and space situations.

When you started collecting in a more conscious manner, what kind of art attracted you?

MW: The first acquisitions of a more serious nature started with the idea of the four walls that we particularly wanted to fill with art. My husband really was not much interested in art at that time, but he went along with me, though

I had to convince him a little. We rented artworks from the Los Angeles County Museum of Art and he did not mind living with them. When we went to New York, we were introduced by telephone to Ben Heller, who invited us to his apartment. I expected him to be a much older man because I had heard of his vast collection of work by Jackson Pollock, Mark Rothko, and other artists who I did not really know or understand. When we went to his apartment, we were astounded by his collection and by how young he was. He and his wife really said the right thing at the right time and in the right way, and helped convince Fred that it was okay to collect art, that it was not a bad investment if one enjoyed it. Fred kept saying that he wanted something he could look at and know what it was.

At that time, I was not particularly interested in Jackson Pollock's painting *Blue Poles*. Fred and I were quite angry with the paintings by Franz Kline. It was amazing how much anger we felt toward Kline's work. I did not appreciate Kline then, I did not understand what he was about, and I did not react emotionally to his work. We bought a small work by Kline many years later, and when we saw it, we realized what we had missed. In the interim we bought Pierre Soulages, and Walter Hopps kept on our backs asking how we could compare Soulages with Kline. That was my question too. Soulages was beautiful and Kline was angry. It was a continual conflict.

I must say that I reacted emotionally to Pollock's *One* more than I did to *Blue Poles*. But we never felt anger toward *Blue Poles*; we liked it. I reacted to *Echo*. Fred and I preferred a sense of order. Ben Heller sent us out on our own with the names of several galleries he recommended. Fred and I went to a few together and then separately. When we joined forces later, we showed each other what we found that we cared for.

At that time, were you already thinking about acquiring?

MW: We knew that we wanted four pictures for our four empty walls.

Did you feel that anger as a driving force, as a challenge?

MW: No, not at that time. I felt that whatever Fred would like would be a step in the right direction, toward acquiring more works in the future. Originally I said to him, "You are giving me $2,000 for four walls. What if I bought one picture for $2,000?" He said, "No. No–you've got to cover the four walls." So I was willing to concede anything with the hope that we would eventually have more. But I did not have any idea of what *more* meant.

On that first day when Fred said he wanted to see figurative works, we went to see a work by Ralph Humphrey. It was an all-green painting called *Victoria*, which at the time seemed to be the size of the big Clyfford Still. When

I look back now, I think it was certainly no bigger than about three or four square feet. It had an image of Queen Victoria in it, but that came about after the fact; we found that out in later years. We decided that the things that we liked best were by Paul Brach, Ralph Humphrey, and Adja Yunkers, and we bought the three pictures. We called Ben Heller from a phone booth at the airport as we were about to board the plane, and told him that we did not want his opinion about the art but wanted to know whether $400 was too much to spend on a Ralph Humphrey. He told us that we had gone to the wrong gallery and were looking at the wrong pictures. Fred said, "I told you no opinions. Don't tell me what I wanted. I want to know if it is worth $400. Ben said it was, and Fred told him that was all he wanted to know, that he did not want to be had. The work was not bad, I want to tell you. We figured that we got our $2,000 worth of art. We then bought a Robert Rauschenberg.

One day Ben called and told us that the paintings in a Philip Guston show were going fast. We had seen a Guston at Ben's and we liked it, but it was very expensive. He said he had one that we would really like and asked us to trust his judgment. It was called *Winter Flower*. As we were deciding whether or not we should buy it, our teenage son Richard saw it and started acting like a little kid. He thought it was beautiful. So we decided to buy it for him out of his inheritance money. That was the way we began acquiring art for him. At first he went through all the machinations of saying, "Why are you spending all of my father's money on this stuff?" But later, when Rick Brown was over here looking at a large painting we had bought from Phil and said, "I never cared for Guston," Richard, who was doing his homework in the dining room said, "Mr. Brown, you've been in here five minutes; you can't make a judgment about a painting in five minutes." The young man who hated everything we had been doing was defending the Guston to Rick Brown. Rick just beamed because here was a kid who cared enough to defend it. So we started buying one for Richard, one for us–not necessarily in that order. We started acquiring for him because we thought it would save inheritance taxes on the paintings. And then too, we could afford to buy more art, and we had become hooked very quickly–I would say within two years.

But I really had no idea of what I wanted except that I knew I wanted today's art. I had taken an art appreciation class from Jules Langsner, and I knew a few names. At that time, there were galleries on La Cienega, there was the Ferus Gallery, the Felix Landau Gallery, the Ester Robles Gallery, and the Los Angeles Art Association. We met Walter Hopps at the Ferus Gallery, and we took a class from him at UCLA. He was a very good teacher and the classes always ended up with arguments between Marcia, Fred and Walter, usually about the relative merits of Pierre Soulages and Franz Kline.

Did you take many art classes? Did you follow the evolution of Malevich's painting and things like that?

MW: We bought what we loved. That was it. Ours was a verbal education, a visual education; it was not a reading education. We would go occasionally to lectures. We became interested in what was going on at the Los Angeles County Museum of Art, which, in contemporary art, was zero at that point. I went to the Museum of Modern Art in 1954 and 1955, before we knew what we were doing, and I saw the Miró show there in 1957. We explored, but we never intellectualized what we were buying. After we bought works, we would get books about the artists when they were available. We looked at the pictures, familiarizing ourselves, learning what the artist was about and where he came from. We talked to many art historians. When those people started to come over, we had already acquired art, but prior to that, there was not enough art here for anybody to be aware of or to care about. We did collect exhibition catalogues for every artist we had, and some time ago we gave the entire collection of catalogues to UCLA.

I do believe our collecting was more visceral than most people's because it really developed from what we saw and what we loved. We were committing ourselves to something we cared about from inside the gut and soul, and not so much from the head. The head came later. I must say that Fred had the ability to buy the work. I couldn't have. I always said he was continually putting his money where my mouth was. We would sit at an auction together to buy an artwork, and when we came out, he would say, "Oh, my God. My ribs–they are killing me," because my elbow went into his ribs every time he would make a bid. I would get so panicked. When the two de Koonings *Pink Angels* and *Dark Pond* were presented to us and we were trying to make a choice, Fred finally said, "The hell with it–let's take them both." I almost fainted dead away on the floor because there was no way I could have dreamed of that. But Fred had that kind of businessman's vision and ability to deal with money. Money is a tool, the means to an end.

We used to travel to New York quite a bit because Fred had business there. Originally we would take great pride in being in New York three days and going to the theater five times. All of a sudden we found ourselves in New York for six days without having gone once to the theater; we were going to galleries, artists' studios, and dealers' homes. We were meeting new people and our world was changing. We traveled to Venice and visited Peggy Guggenheim.

So you became collectors?

MW: No, we resented that designation. We were not "collectors." We acquired

the works of art that we fell in love with; we were never collectors. We thought that "collecting" was a contrived method of doing something that had nothing to do with art. But wherever we went, we were involved with art. We met Larry Rubin when he had his gallery in Paris. He took us to buy a work by Giacometti, and we bought a Rothko in Paris. We met Barnett Newman and Mark Rothko through Ben Heller. Barney would invite us to his studio near the Fulton Fish Market. We would go but we did not like his art. There was no question about it; it did not say one thing to us, and we wanted nothing to do with it. But we kept seeing it; we saw the *Stations of the Cross* in the warehouse and thought, "The guy has got to be crazy to paint white stripes on white. Whoever heard of such a thing?"

One day Fred and I were both in New York and had lunch with Jim Elliot. Fred and Jim left for appointments, and Barney said, "Come on up to the studio with me. I want to show you a sculpture." I said, "A sculpture? What could you sculpt? You don't even know how to paint. You never painted anything; how can you sculpt anything?" And he would laugh. So we went up to the studio, and as we walked into the studio, I saw a painting hanging on the wall. It was *Onement VI*–the blue one. It was like everything I had seen all of a sudden rolled into this one work, and I fell apart. I remember standing there on the right side where there is a lightish part; it comes through and turns on right over you. I said, "Barney, now that is a painting!"

Looking back, I realize I must have seen the twenty paintings he had painted up to that point in time, which was 1963. I called Fred, and he asked if I were in Barney's studio. And he said, "How can you sit there in front of him and tell him how gorgeous the painting is when you know I don't like his work?" I was so aggravated because I thought the painting was gorgeous. Barney sat there laughing because he knew very well what was happening. He was a very shrewd and smart man. Then Barney showed me the sculpture in plaster, and I latched on to it immediately and asked when he was planning to cast it. He told me that he was thinking about it. He had made the plaster in 1953, and it had taken him ten years of thinking. I looked at it, and the whole thing started to fall into place. I said, "It is basic. It is real. It is simplistic and it is magnificent. It is powerful." I was just overwhelmed.

I called him every day for two weeks until he finally agreed to cast it. I received a call from Ben Heller, saying, "How did you land that sculpture?" I said, "Did I land it?" He said, "Have you seen it?" I said, "No, have you?" He said, "Well, it's fantastic, but why should you get it?" I said, "Well, you have to talk to Barney about that." Finally Barney called and told me that the sculpture was done, and I said, "Do I get one?" He said, "There is one for you and one for Annalee." Now I paid for it, because I was in no position not to, and I paid

a great deal, you can imagine. He named it *Here I (to Marcia)*, and I was very proud.

About three months later, Fred was in New York and had occasion to go to Barney's studio, and he walked in, called me, and said, "Marcia, I found a painting and I think we should buy it." His memory has never been good, as it is with many of us who are occupied with other things. When he started to describe it, I could hear Barney in the background laughing. And I said, "Don't you remember how you gave me hell for calling you from Barney's studio over that painting?" Oh, yes. We paid $10,000 for that one and $15,000 for the sculpture. That was an investment of $25,000 with one artist, and we have never regretted it. They were very special to me. Subsequently, we did buy the *Cantos*, and I have hopes of finding a special place for them to go. He came to our hotel with the first of the edition, and he signed and numbered them with us. When he did his etchings, he did the same thing, and we took two of those. When he passed away, Tatania Grossman gave us these two lithos and we bought a drawing. As a result, we have something of every medium he worked in.

What do you think it is about Barnett Newman's work that attracted you so suddenly?

MW: I do not think that it was a question of being suddenly attracted; it was more a question of learning. I think when you expose yourself and when you see a lot of something, its nuances become apparent. Those nuances can be negative as well as positive.

You have collected a large amount of work from the twentieth century. Can you elaborate how that reflects your outlook on life?

MW: In 1957, when we were young, we shared the very positive feeling that we were living in the twentieth century and did not need to go backward. Perhaps people think of themselves as I think of myself: that I am a lot younger than I am. One day I may look at myself and say, "You old lady, get out of your pants and put on a little knitted skirt with a little blouse and bow and act your age." But I don't want to do that, and I have a tremendous amount of energy. I think that I am energized every time I walk into this house. Perhaps I am dramatizing, but I think that my love of art has saved my life in many, many ways. I think being in contemporary art gave me the vigor to stay focused in the present and to keep myself occupied in a positive, forward-thinking way. I don't know if I could have gone forward if I had only Rembrandts.

You tend to buy one or two things made by an individual artist from an important period in his career. Is this a conscious way of collecting?

MW: Our collecting depends on what we have seen and what has been available at specific times. At the time we bought the Sam Francis, he was not yet completely established. Nobody knew much about William Baziotes when we purchased a work we liked. I do not think we ever bought a painting because we needed it to make the collection well rounded; it just never happened that way.

So there was really no overall plan on your part to build a collection?

MW: Well, how could there have been a plan when we started with Ralph Humphrey and a few years later were buying Léger and then de Kooning, and then a Cornell box and a Jackson Pollock drawing, and then Max Ernst? What kind of a plan is that? We later bought the big mermaid by Magritte but could not live with it. We owned the five-partition figure at one time, but the kids made fun of it and we decided it might not be such a good thing to have around. We bought works by Sam Francis, Mark Rothko, Ellsworth Kelly, and Claes Oldenburg; it did not make sense, it was not a plan.

Are most of the works in your collection by American artists?

MW: The American works are the largest; they take over in size, but we have works by Kandinsky, Giacometti, Henry Moore, Léger, Cézanne, Gabo, Pevsner, and Tanguy. The Abstract Expressionists' paintings were generally large. One does not often have the opportunity to see paintings of such huge size in a private residence–to find three Clyfford Stills, three Mark Rothkos, and a Barnett Newman hanging in one room and Morris Louis, two Willem de Koonings, a Hans Hofmann, and a Jackson Pollock in another. Finding these major twentieth-century works exposed in a relatively small space, though not one that feels small, one might assume the collection contains only these masters of the spiritualistic movement which concentrated on the emergence of the profound inner self. However, there are many, many smaller things that do not have that kind of scale and proportion, but people do not seem to notice them. They do not have the same kind of visibility when exhibited alongside the larger masterpieces.

I think things get better the more you look and the more taste you acquire. I might add that we found ourselves with an awful lot of art, and we had bins at art warehouses and prints galore. We also loaned a number of prints to the Massachusetts Institute of Technology, and they hung them in the hallways and rented many of them to students at the rate of 25 cents a week. The people at MIT told us, "We want to round off the square corners of our students and give them a little broader spectrum." I felt that it was a very good thing to do. At that same time, we decided that we would not put more work in the warehouse. If we were going to buy something new, it had to be good enough to move some-

thing else off the walls.

The works have to stand up to each other, and as they stand up to each other, they stand up to me. When you see a body of work that is not registering and all of a sudden it clicks, it tells me that the work is making a statement I am finally able to read. I am now probably as good a judge of Barnett Newman's work as anybody might be, not because I am an authority or a scholar but because of the exposure I have had; the passion that I felt makes me experience and understand his work as it was intended. I also feel that way about Clyfford Still, because Clyfford, Fred, and I also had an intense relationship, though it was far more stormy. Barney was always loving and kind. When Fred was ill, he came out here to see him. He offered us a first refusal on every sculpture as a result of the first one. Unfortunately we could not afford to buy them all; they became more and more expensive. We never had that kind of relationship with Clyfford.

How did you become involved with the work of Clyfford Still?

MW: We met him through Jim Elliott. Fred had fallen in love with a yellow Still that we had seen from a slide, and when we were in New York, we met him at a hotel on Fifth Avenue and Fourteenth Street. We must have met him five more times before he allowed us into his studio on Fourteenth Street.

Upon seeing the slides, we had begun to learn about his work. We did see one of his paintings at Betty Freeman's home, and we liked it very much. He allowed us to look at ten pictures, and we thought that was a lot, not realizing that behind them were stacks of fifty or more paintings. He kept the canvases rolled like carpets, each marked by a little sheet of paper with little drawings of every painting in that roll.

So he made a very specific selection of the ones he wanted you to look at?

MW: Absolutely. We debated our choice for eight to ten months, talking to him occasionally, and we had no idea what they cost. By this time we had seen several works–at MOMA in New York and at the San Francisco Museum of Modern Art. After about two years came a phone call: "I have decided to release two paintings to you. They will be forthcoming." He gave no price, no when, no how, no what; we knew nothing. And Fred said, "Very well, Mr. Still, I will take them." After two years it was still Mr. Still, and Mr. and Mrs. Weisman.

I think what really attracted me to Clyfford's work must have been the floating space. When those paintings came, they came in a crate all rolled up, so we had to stretch them without ever seeing the painting. When they raised those pictures to put them up in the living room and they were pushing my furniture around, I was absolutely hysterical, and the red and black paintings were

absolutely perfect. I did not know what to say. I liked both of them immediately. We began debating which we preferred, but there was no way to choose, and no way to send either of them back. They were just ours and that's all there was to it. The red one, from time to time, is just amazing. But when you turn the lights out at this time of day, those blacks come forward and backward–it is just fascinating–but it was a risky business to buy two paintings without ever seeing them. But we had looked at so much of his work that we knew we were committed to it. And Fred asked me if I had ever seen a Still I did not like, and we could not think of one, and we did like those. We altered the walls a bit and hung them. We later bought a brown one, which we had for a while.

How did you choose that work?

MW: We saw it at his new studio in Maryland. Shortly after we bought the brown one, he gave Fred the yellow one as a gift. We had tried to buy two other paintings, the yellow one and the blue one, which is now in San Francisco. Clyfford sent the yellow, but instead of the blue one we had chosen, he substituted a painting that we had never seen. We sent it back with a note and a check for the yellow one, which was $30,000. He subsequently called and said, "Marcia, this is Clyfford. I am telling you that I have returned your check and have torn the signature off. I am retitling the painting *My Declaration of Independence.* Frederick is an honorable man, and you shall have that painting as a gift."

How did you come to buy the Rothko paintings?

MW: We had wanted a Rothko for some time, but we had not found one we particularly liked. We went to Mark's studio; we had lunch with him on occasion. Mark claimed that he and my brother Norton Simon went to high school together in Portland, Oregon, though Norton does not remember. It was always fun listening to Clyfford, who claimed that Mark never would have painted as he did if he had not seen his–Clyfford's–paintings. I used to call him my Jewish Santa Claus. Though Mark had been here at the house, we never had a relationship with Mark the way we had with Barney or Clyfford.

We bought one of the Rothkos from Larry Rubin, the other, at Marlborough Gallery–and it might have been the beginning of the whole mess with Rothko and Marlborough. We told Mark that we bought the paintings, and he told us that Marlborough had bought twenty paintings from him on the condition that the twenty would remain in Europe to be distributed there. So Mark found out that Frank Lloyd had sent half of them back to New York after he had made the deal.

At the same time, you were very much aware of Pollock's work?

MW: We bought our first Jackson Pollock after we had acquired works by New-man and Still. We did a great deal of buying in the sixties. We never met Pol-lock, and the painting we bought was the last one he did. We bought it from Iliana Sonnabend, and I presume she acquired it from Pollock not too long after it had been painted; we saw it at the beginning of the summer. It was the most expensive thing we had ever bought. We had recently purchased some pro-perty in Bel Air and were going to build a house designed by Philip Johnson, but we finally decided to buy the painting instead of building a house. Philip told us not to be foolish. He said that if we were going to spend a fortune build-ing a new house to house our art, it was better to buy the art. The art would take care of the house; we did not need a new house.

Do you feel that it is necessary to have a rapport with the artist whose work you are buying?

MW: I will not buy an artist's work because I love him. There are many artists who are dear, close friends, and I do not own their works. By and large, the works I do not own have not moved me enough to make me want to have them. I would do the artist a disservice to buy something only because I care for him or her personally. I think that you buy art because you love the art; if you do not, it does not serve well. The art must stand out, not the artist. The artist only stands out as a result of the work he does. With the California artists, I am also concerned that people see a coherent body of work, to see how they emerged, where they came from and where they are.

Do you feel any special obligation to collect the works of Southern Califonia artists?

MW: We feel a strong commitment to California. California is where I was born and raised. My father and my children were all born in California. We get our share of rain, and Los Angeles is an hour and a half from the desert and a half hour from the beach. Artists can paint all year without suffering from extremities of weather, and have a good life. Now I see a lot of artists bounc-ing back and forth between California and New York, which is understandable, as the marketplace seems to be in New York. I feel very profoundly about California artists. I am really a California chauvinist, a Los Angeles chauvinist particularly, and I know it. But it is not just for chauvinism's sake. I really believe that this is where the best art is being produced today. I think that the market-place is located in New York and possibly London. But the creative action is here. Look what is all of a sudden happening in Los Angeles. It is more than

just the building of a new museum; it is the environment, and the ambiance. I want to be there.

We began collecting a number of California artists as a result of the gallery exposure on La Cienega in the late fifties. La Cienega was a wonderful place to go on Monday nights from seven until nine o'clock. The galleries were open, and one could roam the streets, see the art, and see friends. The galleries were showing old art, new art, New York art, Washington art, California art. I attributed a lot of our positive feelings about art to that experience. Our major involvement began when I started to teach my classes and visit artists' studios and Fred came to meet the artists.

When we bought *The Birthday*, we started becoming more involved in Ed Kienholz's work. We bought it fresh off the floors in 1962, and it was still gluey. One of the rooms in the pool house became an environment, and it was perfect for the work. We were way ahead of our time on that. I would say that the heaviest buying we did, if it were concentrated into a particular period, would have been from 1961 to 1963.

I have seen Ed Moses's work from the beginning, when he was doing little roses on canvas. I saw Bob Graham's wax figures the first time they were exhibited. As we collected the California art, I liked exposing it to the public. We eventually did an exhibition at the Long Beach Museum of Art about which Fred was very reluctant because he did not think it was going to be an important enough exhibition to warrant segmenting the California artists and exhibiting them in that way. To my way of thinking, it was the best way, because it was an educational situation. The California work in our collection has been kept predominantly in Fred's offices.

Do you feel that major collectors should buy the works from emerging artists?

MW: I hope young artists emerge. I want them to stand or fall on their own, but they cannot do that unless people see their work. I think it is most important to buy an artwork if you love it, if you are willing to give it the credibility of hanging it. But the only way to know whether you like a work is if you see it hanging and you like it. If the moment comes that you are through with it, you are through, and the art should go. I do not think this situation is a discredit to the artist. Some books you read ten times, some twenty, and some you never take off the bookshelf. Just looking at the title brings back the whole book. There are other books you read and are ready to give away because you have had it, and it does not mean that it was not a good book, because somebody else is going to enjoy it. I feel that way about art. I think you should buy what you like, but I do not think that you should buy something and then put it in a closet if you decide that you do not like it.

Have you ever commissioned works for your collection?

MW: Yes, we commissioned a work by Bob Graham and an Andy Warhol portrait. I think that is probably about it. We once saw a George Rickey stainless steel sculpture at Joe Hirshhorn's. It was clanging at the top, and we told Rickey that we loved it but we could not handle the noise unless it offended him for us to say so. He came up with this work, the only bronze piece that he has ever done. It was the *Five Blades*, but they never touched at the top, as the original one had done. He felt that it was a totally different work and that making it had led him in a different direction. Yet I would never want to think that I told an artist what to do, and if I did, I would never want to think an artist would listen to me.

Are there works by certain artists that you wished you had collected that you didn't?

MW: The best collection I have is the "if": if I had bought it, if I had not sold it, or if I had not given it away. We had an early work of David Smith's that we had traded in anticipation of getting a work from the Cubi series, when we got into a horrible fracas with the Marlborough Gallery and would not buy anything from it. We just plain missed the boat with Richard Diebenkorn, and we gave a Victor Vasarely and a Robert Rauschenberg to Honolulu. I wish we had not given the Ellsworth Kelly or the Morris Louis to the Los Angeles County Museum of Art. On the other hand, I'm glad these works are close by. These are the things one does to support the local cultural institutions.

Interestingly, there were two Ellsworth Kellys that we once wanted. One he would not sell–he felt he would keep it forever–and the other was the one we subsequently gave to the Los Angeles County Museum of Art. Kelly ultimately gave the other one to the Museum of Modern Art in New York, so I feel that our taste in Kellys was not bad.

The presentation of works in your home seems very important to you. Can you elaborate on this aspect of your collection and understanding of contemporary art?

MW: If you leave a painting hanging in the same place for too long a period of time, it disappears–you tend to stop seeing it. It becomes rather perfunctory. It has nothing to do with the quality of the painting. You know it is there, but you neglect looking at it, because you are looking at something else. I like to see works in different circumstances.

When people come to your home and look at your collection, how do you hope

that they perceive the works: as key examples of an important artist's career, as important works that exemplify a period, or as particular works that stand on their own?

MW: I would rather have the work perceived as something that we have loved and gathered, as something that in our opinion was the best we could do with a particular artist at a certain moment in time. I would say on the average of once a year the whole collection is changed around, partly because something goes out on loan. If one picture is moved, ten have to move with it. As you well know, you cannot remove one picture and leave a hole on the wall. Consequently, it is ever-changing, and the paintings acquire new life. I would like the collection to be perceived as something very special, where each work stands on its own yet the ambiance of the total makes for heaven.

Do you like to hang works by different artists together, or do you try to keep works by a single artist together?

MW: Right now there is a very blue trend in this part of the room, and it was not until after it was hung that I realized it. I think that I was aware of the Baziotes and the Francis working well together, and I had the red Ad Reinhardt hanging opposite the Baziotes. As I looked at it, I realized that the works were too matched and that they took from, rather than enhanced, each other. Now sometimes they work together and it is fine. It is fun having three de Koonings in one room, which is something we did at one time. I like seeing two Rothkos together, but they are not installed in a position in which they can be compared, but it is nice when people can look at them and see that all Rothkos are not alike. I want to help people to see and understand Rothko's work, but I am not going to build the whole house around it. I love the two Stills hanging next to each other, though I don't think that I would want a room with three Stills hanging in it. I'm not a museum and I don't want to do a retrospective. Yet there are times when they really look special together.

Do you think that an environment or the way that something is installed influences the way the work is seen, that it puts work in a different context, so that it can be read differently?

MW: It must. I think that a painting is affected by how it hangs in the context of other works. The installation can draw you into a particular painting. But the painting does not change, and it is nice to hear someone say, "I've never seen that before," because obviously it had not been hanging in a way that drew the person's eye to it. By changing the installation, someone sees it differently, sees it as something else. The work can acquire another dimension, which

makes me fall in love with it all over again. This is why I can own a painting for such a long period of time, and it doesn't get shelved with the books that were used ten times.

It seems that your collection is not solely a private collection, because it extends itself to include an involvement with artists, public institutions, museums, and with the art world at large. Would you like to comment on that?

MW: Perhaps I may be self-motivated to attempt to teach many people to enjoy what I appreciate. But at the same time, I know the artists need support. They are struggling so hard to create something, and few people take the time to look. I look as much, if not more, than most people who are involved in the art world, and I know how few artists I actually see on a regular basis. If I went to every one of the exhibitions within a twenty-five-mile radius of my home, I would do nothing else all day long. Yet I feel that I must go to openings to support the artist, because he put out the effort. If his work is not any good, he is going to find out by himself–the same way a collector finds out. He will see other art and know where he has failed or where his work needs improvement. But he can only do that when he gets feedback, so it is important that the community support these artists, good or bad. If they are going to fall by the wayside, they will, and they will pick something else. California is my home and I try to do what I can to sponsor the artists here and to make sure that their work is seen.

What characteristics do you see as valuable to a collector of contemporary art?

MW: I think that if people keep an open mind, listen to information, and ignore opinions, they would do very well on their acquisitions. Critics should provide information, not opinions. I really do not care who likes what; I'm interested in what I like. I want the information about where I can go to see examples of an artist's work. If I see a Sol LeWitt in a museum, I want information about where I can find more. I am not interested in other opinions about Sol LeWitt; they do not validate my opinion.

This makes me think of the difference between my brother, Norton Simon, and me. He used to ask me how I could buy all this "junk," rather than wait ten years and find out if it were really any good. I would say, "You know there are those who want to play it safe and those who fall in love. I fall in love, and maybe I'm stupid." But I don't think I've been wrong.

My giving something to a museum does not validate it. A museum accepts a gift for all kinds of reasons, but when it does accept something, keeps it on view, and loans it to other museums, it is a validation of a statement that I made

even before I knew it was a statement. It is a fantastic feeling when you buy a painting for nothing, relatively speaking, and you are proven right. Somebody else says, "Not only were you right, but there are others who have been right and say that you are too." That is good for the ego. I'm sure ego does get involved, but I would like to believe that I have not been tainted by paying attention to "what's in."

I do want to see more of Julian Schnabel's work. Someone will have to prove it to me. At this point I do not buy the argument that the plates replace the action of the paintbrush. The brush was painting while he was putting the plates in, so he is being redundant with the broken plates, as I see it. I have seen some things of his that I do not think are bad, but it is Rauschenberg all over again, with antlers coming out of the front of the paintings. And he is very eclectic. I think that David Salle has had tremendous hype, but he is a good painter and he knows what he is about. I think that the drawing I own is as good as any of his paintings. I do not want to be told what is trendy; that's no fun, but once in a while you see something trendy and you like it. I just fell in love all over again with Niki de Saint Phalle. I have had Nanas floating around in my pool for years, but I do not have one left, and I sure would like another one. When I saw those maquettes in London, they were fabulous; I know that they were made to market perfume, but I was looking at her things differently. It's no different for me than the time I saw the Newman painting. It is what you bring to a work that makes you feel something for it. If you have never seen a Kline before, the work may leave you cold, but if you have seen enough of it, you begin to differentiate between the ones that have made it and those that have not.

What criteria have you adopted in choosing works for your collection?

MW: Sometimes you walk into a gallery or a museum and you see something with which you fall in love. How do you define it? It is so difficult to evaluate these things. Something happens when you see something special. You turn on to it, you want to touch it, you want to live with it. It belongs at home with you. When I buy a work, I do not think about where it will end up. Now that my life has changed, these things do cross my mind. I never thought I would get over the shock of separating our collection. I regret terribly that certain things were sold. Yet they all stay with me, so it does not matter. Of course, I would like to see our collection remain intact, but that has really nothing to do with anything. What will be remembered are the artists who made the works. They deserve the credit. I would like to try to balance the budget as it were, to see that the works are spread around. I would like to see the work of California artists in the East or Midwest.

Do you think the independent collectors will continue to be important, or do you think that corporate purchasing will replace them as the major patron of the future?

MW: I hope that the corporate collector will be the support system for museums, universities, and educational places that publicly enrich people. But I think that personal collecting will, of course, continue. I wonder how committed the big corporate collections will be when the tax benefits disappear. Is that a reasonable question?

In other words, corporate collectors do not have the love factor you're talking about?

MW: Well perhaps not to the same extent. I think Robert O. Anderson has an emotional commitment to art and consequently has pushed ARCO into developing a collection.

How would you describe your collection?

MW: It is a collection of passion. We have works of some artists made at various times in their careers. I have become more aware of collecting works on paper, but I have never adopted a particular direction, though I do not see anything wrong in doing that. I have collected with an eye toward the artist and an eye toward the art. I have also considered the role of the collector. It makes it easier to collect if artists and dealers realize that you are attempting to assemble a meaningful collection. It is a more honest evaluation of where these artists have been and where they are now, and I suppose some of the works in our collection can be appraised in that sense.

My collection will always be ongoing. Although I have not been avidly collecting in the last two years, I recently purchased a Deborah Butterfield, a Robert Walker sculpture, the Kelly, the Gary Stephan, and the David Salle. I just bought a Rauschenberg that he did for me and inscribed to me. I really don't know how you turn the passion off. All my last year's birthday presents are on the wall–I love that.

The range has been broad. I guess it started with Cézanne, and has gone to wherever it is today. I'm acquiring, Fred's acquiring. It's probably the most meaningful thing that ever happened in my whole life outside of my family. I always thought art was a poor monetary investment, but it is just wonderful in other ways. As I said before, I believe that it really has saved my life. When I say "my life," I don't mean from dead to alive; I mean from being a morose zero body moving around to being a living person. And I think that it is the greatest thing that can happen to a human being. I do not think that it has a great

deal to do with being a private collector. If I am going to be a museum director or an art dealer, I had better know my business. But as a collector my business is to live with what I love, and it is just as simple as that. I rather resent people trying to make it more complicated–it's not.

Catalogue

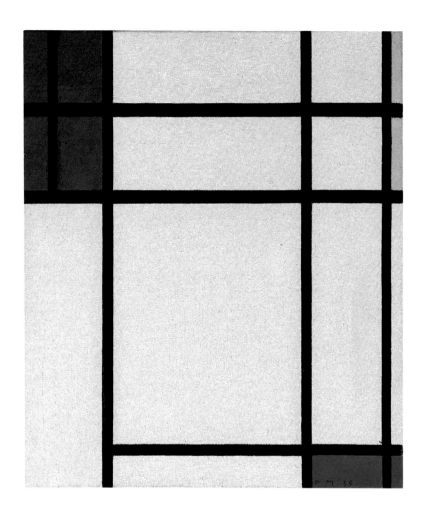

Piet Mondrian. *Abstract Painting*, 1939.
Oil on canvas, 17-5/8 x 15 in.
Collection of Taft and Rita Schreiber.

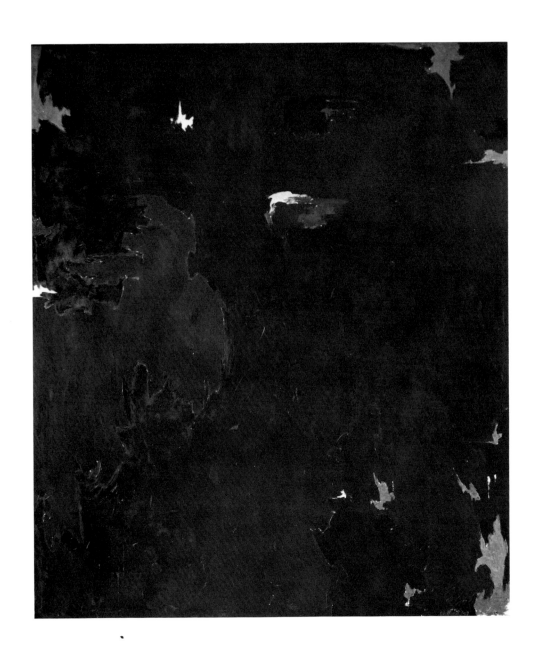

Clyfford Still. *1947-M*, 1947.
Oil on canvas, 105 x 92 in.
Collection of the Weisman Family-Richard L. Weisman.

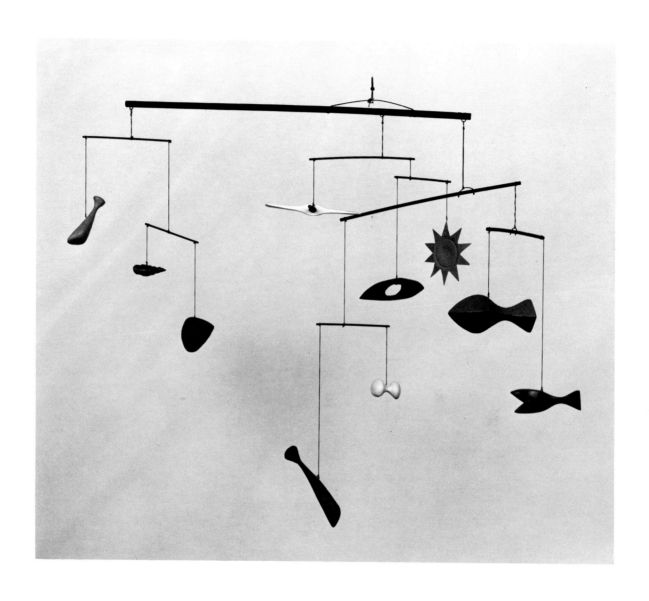

Alexander Calder. *Seascape*, 1947.
Metal, string, and wood, 36-1/2 x 60 x 21 in.
Collection of Whitney Museum of American Art.
Gift of the Howard and Jean Lipman
Foundation, Inc. (and purchase).

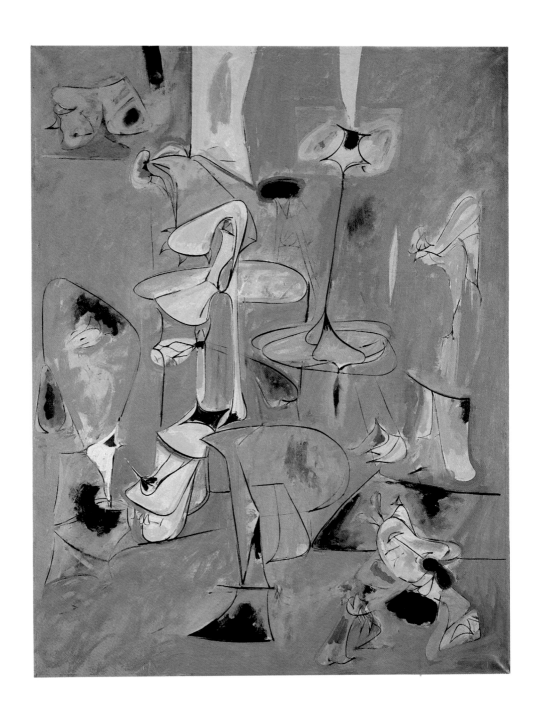

Arshile Gorky. *Betrothal I*, 1947.
Oil on paper on composition board, 51-1/2 x 40 in.
Collection of Taft and Rita Schreiber.

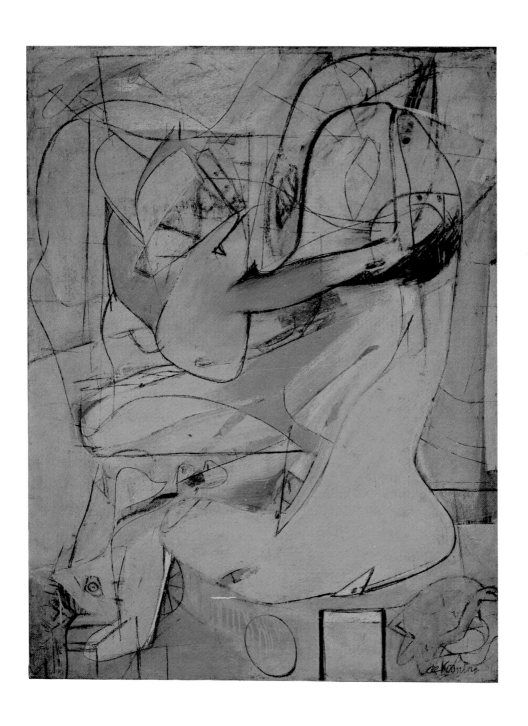

Willem de Kooning. *Pink Angels*, 1947.
Oil on canvas, 52 x 40 in.
Collection of the Weisman Family–Richard L. Weisman.

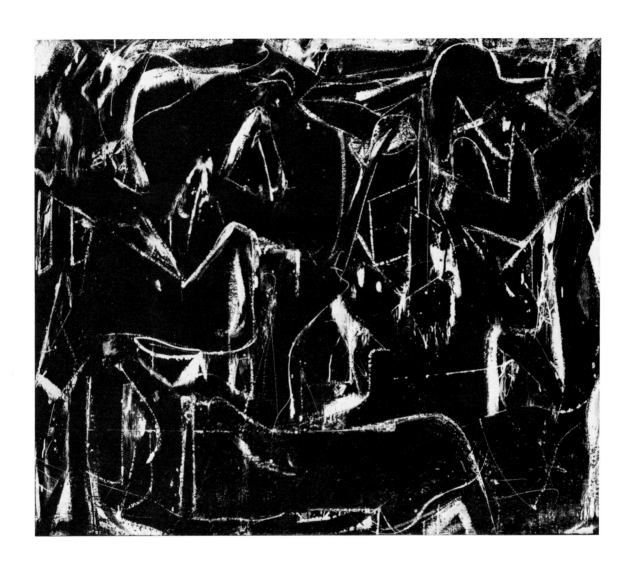

Willem de Kooning. *Dark Pond*, 1948.
Oil on canvas, 46-1/2 x 55-1/2 in.
Collection of the Weisman Family–Richard L. Weisman.

146

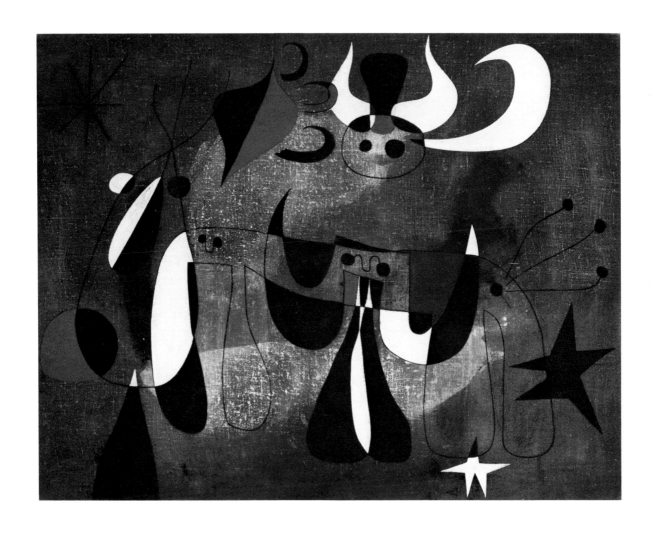

Joan Miró. *Personnages dans la nuit*, 1949.
Oil on canvas/burlap, 35 x 45-3/4 in.
Collection of Taft and Rita Schreiber.

Matta (Sebastian Antonio Matta Echaurren).
Je m'honte, 1948–49. Oil on canvas, 77 x 56 in.
D. and J. de Menil Collection, Houston.

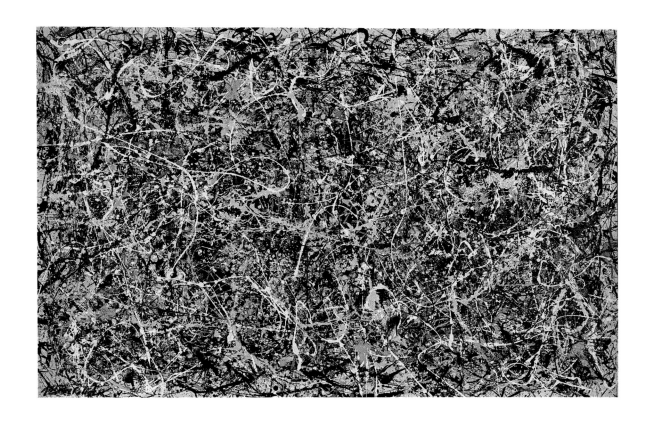

Jackson Pollock. *No. 1*, 1949.
Duco and aluminum paint on canvas,
63-1/8 x 102-1/8 in.
Collection of Taft and Rita Schreiber.

Wols (Alfred Otto Wolfgang Schulze). *Oiseau*, 1949.
Oil on canvas, 36-1/4 x 25-5/8 in.
D. and J. de Menil Collection, Houston.

Jean Dubuffet. *Paysage aux Ivrognes*, 1949.
Oil on burlap, 35 x 45-1/2 in.
D. and J. de Menil Collection, Houston.

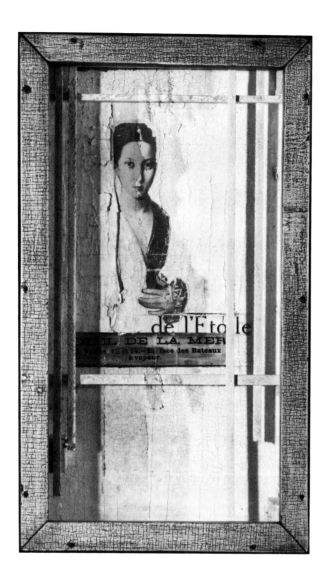

Joseph Cornell. *Untitled* (Hotel Family, Parmigianino
"Bel Antea" series), 1950–52.
Wood box construction, 18-3/4 x 11 x 4-1/2 in.
Menil Foundation Collection, Houston.

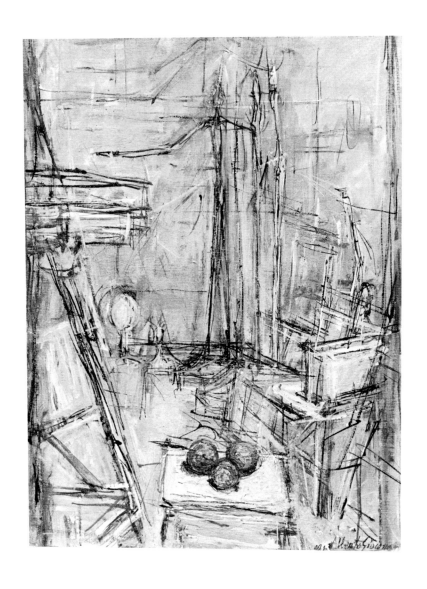

Alberto Giacometti. *Interior of Studio with Man
Pointing and Three Apples*, 1950.
Oil on canvas, 22 x 16-1/4 in.
Collection of Taft and Rita Schreiber.

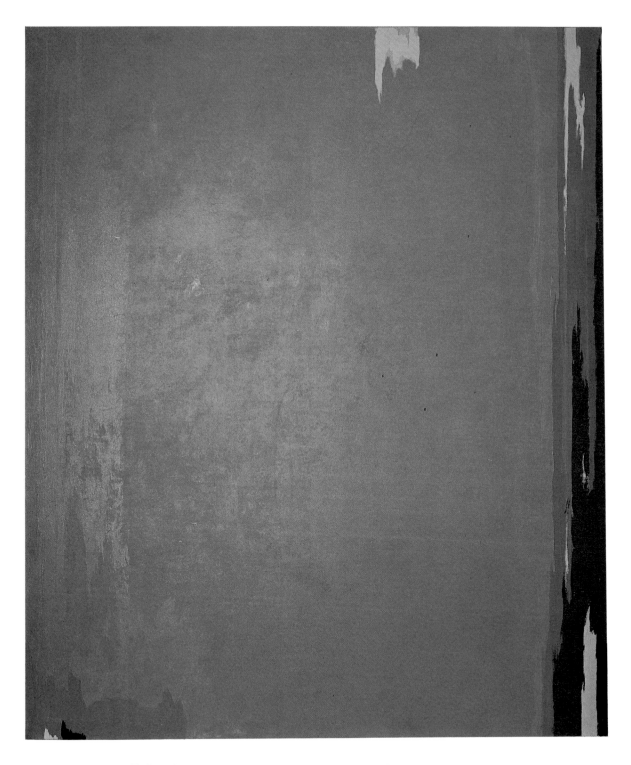

Clyfford Still. *Untitled*, 1951. Oil on canvas, 108 x 92-1/2 in.
Collection of the Weisman Family–Marcia S. Weisman.

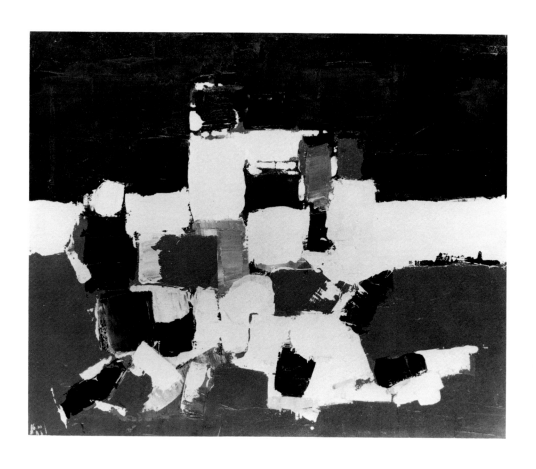

Nicolas de Staël. *The Football Players*, 1952.
Oil on cardboard, 24 x 29-1/2 in.
Collection of Taft and Rita Schreiber.

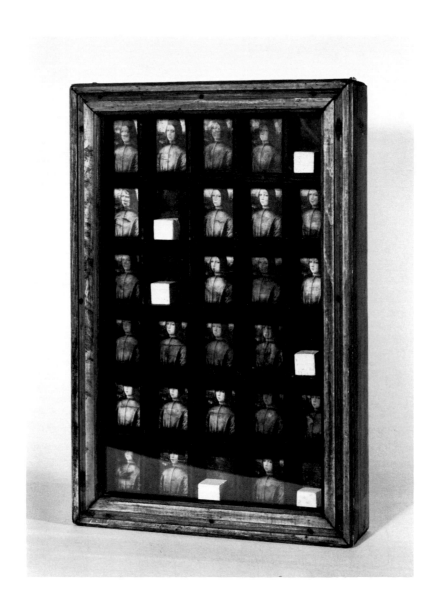

Joseph Cornell. *Untitled* (Medici Family, Bronzino
"Dovecote" Variant), ca. 1952–55.
Wood box construction, 15 x 10-1/4 x 2-1/2 in.
Menil Foundation Collection, Houston.

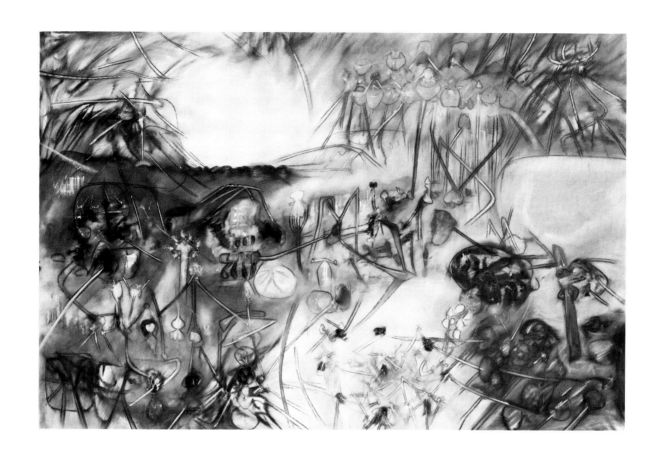

Matta (Sebastian Antonio Matta Echaurren).
The Green of Wheat, 1953.
Oil on canvas, 81 x 124-1/2 in.
Menil Foundation Collection, Houston.

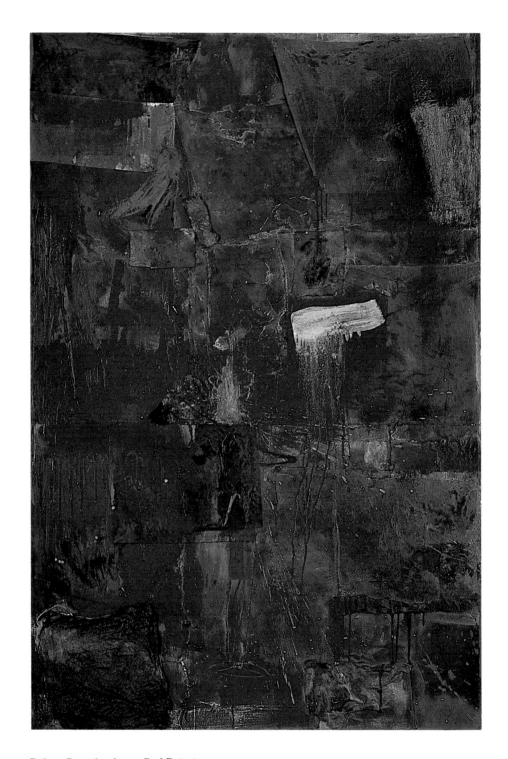

Robert Rauschenberg. *Red Painting*, 1953.
Oil, fabric, and newsprint on canvas, 76 x 51 x 2-3/4 in.
Collection of the Weisman Family–Frederick R. Weisman

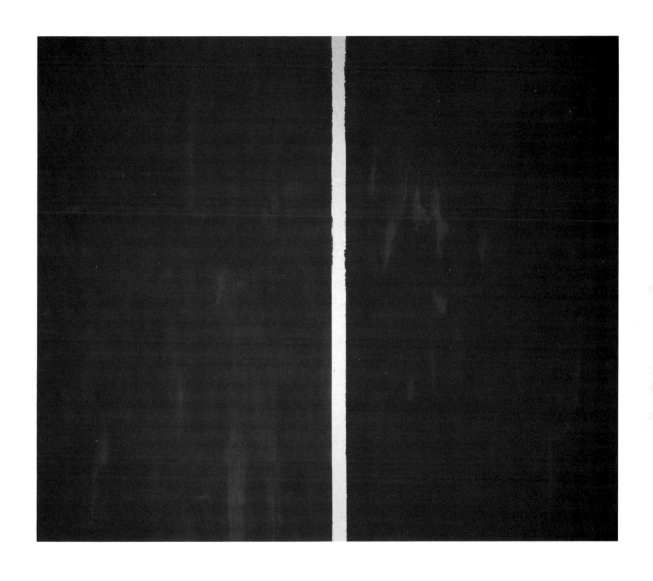

Barnett Newman. *Onement VI*, 1953.
Oil on canvas, 102 x 120 in.
Collection of the Weisman Family–Richard L. Weisman.

Barnett Newman.
Primordial Light, 1954.
Oil on canvas, 96 x 50 in.
Menil Foundation Collection,
Houston.

Jean Dubuffet. *Desert Rose (Pink Desert)*, 1954.
Oil on canvas, 44-7/8 x 57-1/2 in.
D. and J. de Menil Collection, Houston.

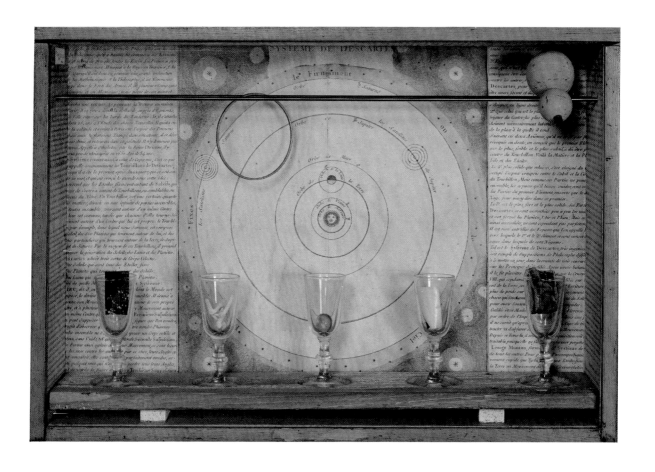

Joseph Cornell. *Untitled*
(Système de Descartes), ca. 1954.
Wood box construction, 12 x 18 in.
Menil Foundation Collection, Houston.

162

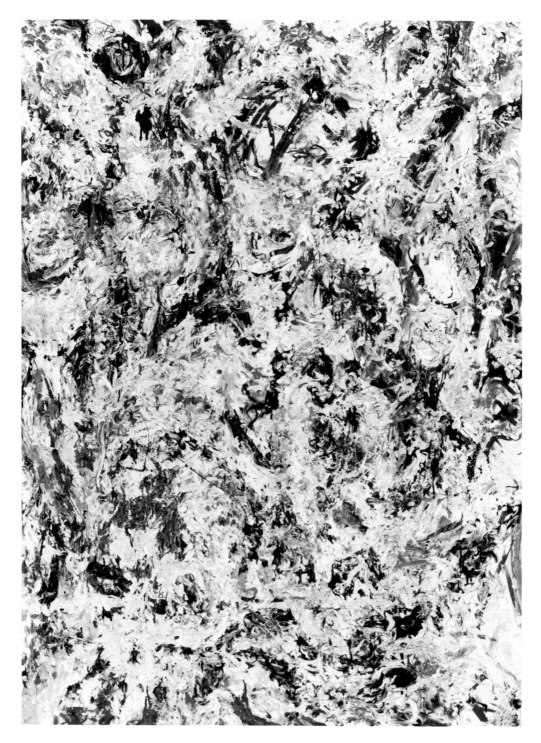

Jackson Pollock. *Scent*, 1955.
Oil on canvas, 79 x 57-1/2 in.
Collection of the Weisman Family–Marcia S. Weisman.

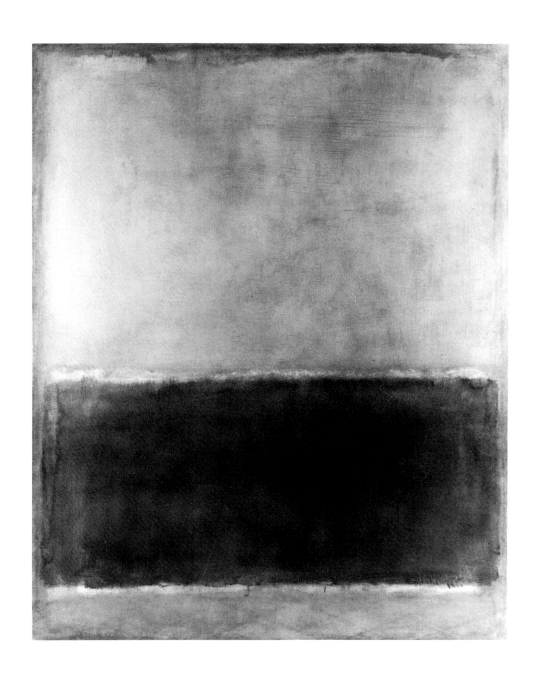

Mark Rothko. *The Green Stripe*, 1955.
Oil on canvas, 67 x 54 in.
D. and J. de Menil Collection, Houston.

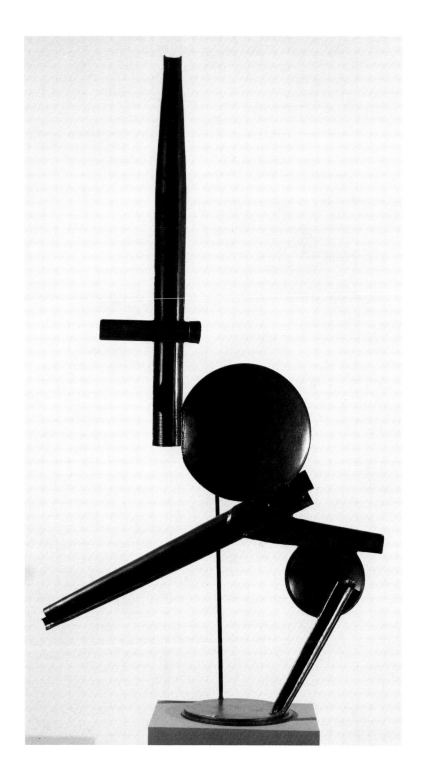

David Smith. *Tank Totem #5*,
1955–56. Steel, 96-3/4 x 52 x 15 in.
Collection of Howard and Jean
Lipman. On extended loan to
Whitney Museum of American Art.

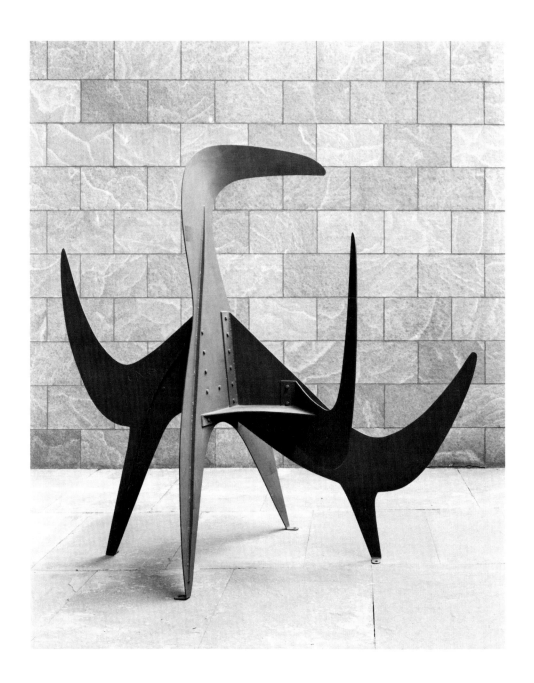

Alexander Calder. *Longnose*, 1957.
Painted steel plate, 98 x 103 x 64 in.
Collection of Howard and Jean Lipman.

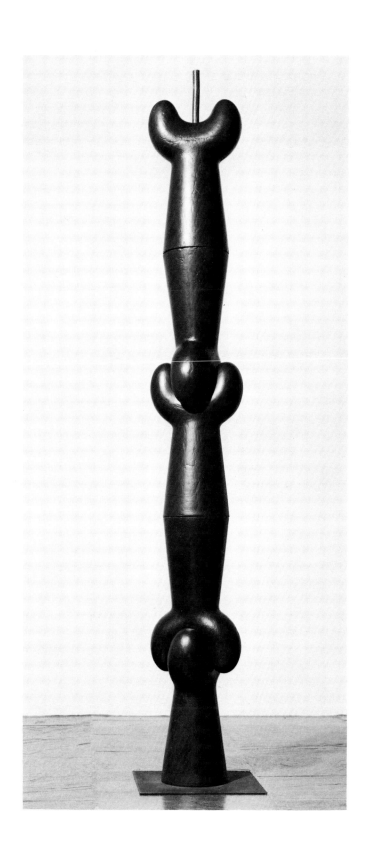

Isamu Noguchi. *Endless Coupling*, 1957.
Iron, 96 in. high.
Collection of Whitney Museum
of American Art.
Gift of Howard and Jean Lipman.

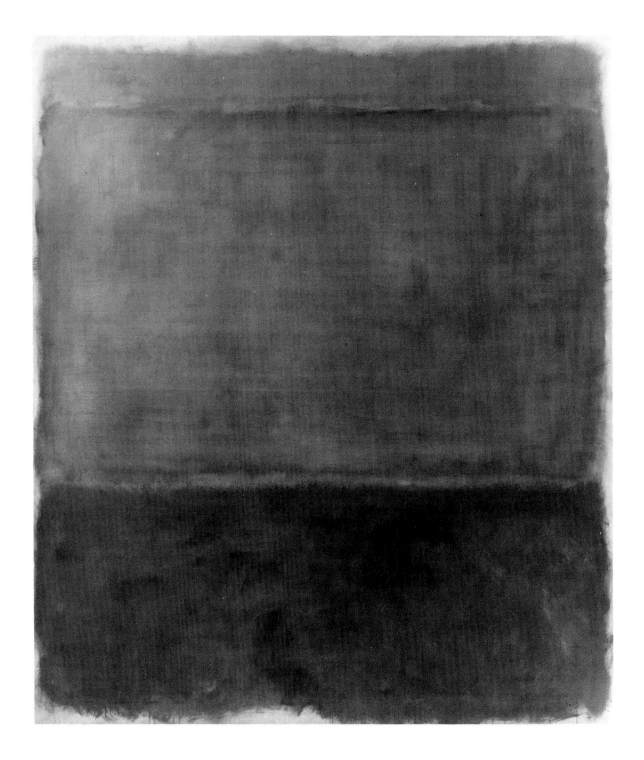

Mark Rothko. *Untitled*, 1957.
Oil on canvas, 79-1/2 x 69-1/2 in.
Collection of the Weisman Family–Richard L. Weisman.

Morris Louis. *Samach*, 1958–59.
Acrylic on canvas, 97 x 140 in.
Collection of Robert A. Rowan.

Peter Voulkos. *Flying Black*, 1958.
Fired clay, 40 in. high.
Collection of the Weisman Family–Richard L. Weisman.

Jean Fautrier. *Grands végétaux*, 1958.
Oil on canvas, 38 x 52 in.
D. and J. de Menil Collection, Houston.

H.C. Westermann. *The Evil New War God,* 1958.
Brass, partly chrome-plated, 16-3/4 x 9-1/4 x 10-1/4 in.
Promised gift to Whitney Museum of American Art
by Howard and Jean Lipman.

Craig Kauffman. *Studio*, 1958.
Oil on linen, 61 x 51 in.
Collection of Robert A. Rowan.

Hans Hofmann. *Equipoise*, 1958.
Oil on canvas, 60 x 52 in.
Collection of the Weisman Family–Marcia S. Weisman.

Mark Tobey. *Lake*, 1959.
Tempera, 10 x 12-1/4 in.
Collection of Taft and Rita Schreiber.

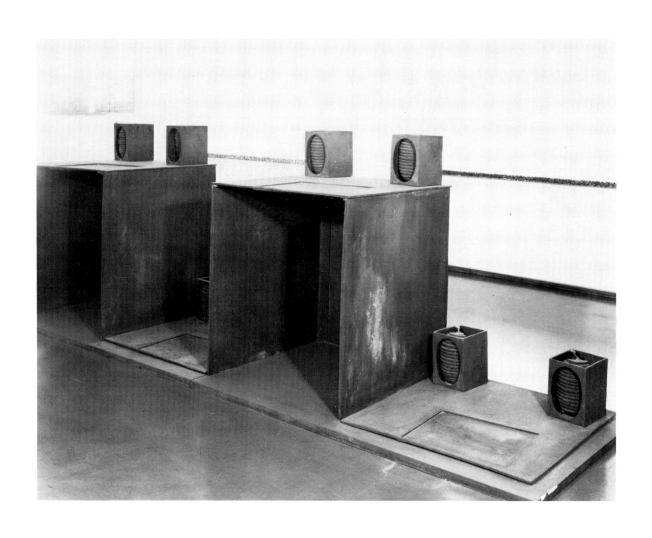

Joseph Beuys. *Doppelaggregat*, 1959 (1969).
Bronze, 42-1/2 x 84-1/4 x 31 in.
Museum Ludwig, Cologne. Gift of Peter and Irene Ludwig.

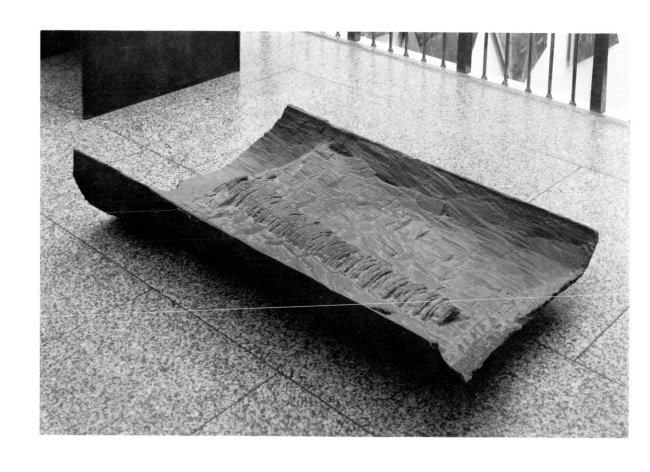

Joseph Beuys. *Val*, 1959 (1969).
Bronze, 10-1/4 x 50-1/2 x 29-1/2 in.
Museum Ludwig, Cologne. Gift of Peter and Irene Ludwig.

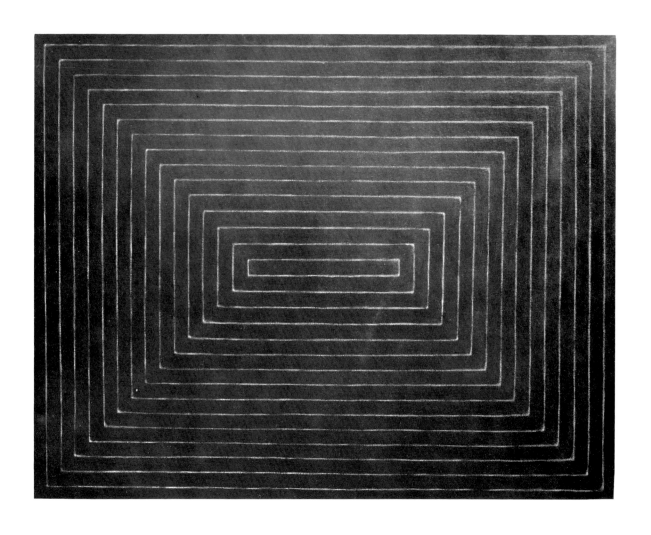

Frank Stella. *Tomlinson Court Park*, 1959–60.
Enamel on canvas, 84 x 108 in.
Collection of Robert A. Rowan.

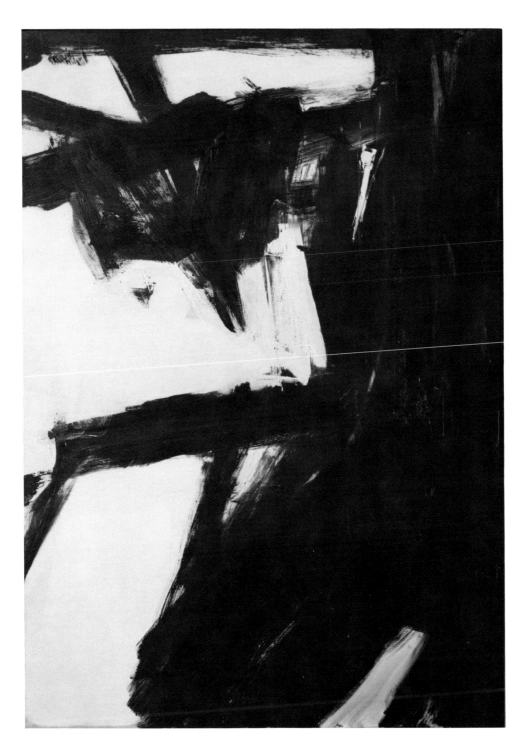

Franz Kline. *Scranton*, 1960.
Oil on canvas, 69-3/4 x 49 in.
Ludwig Collection, Museum Ludwig, Cologne.

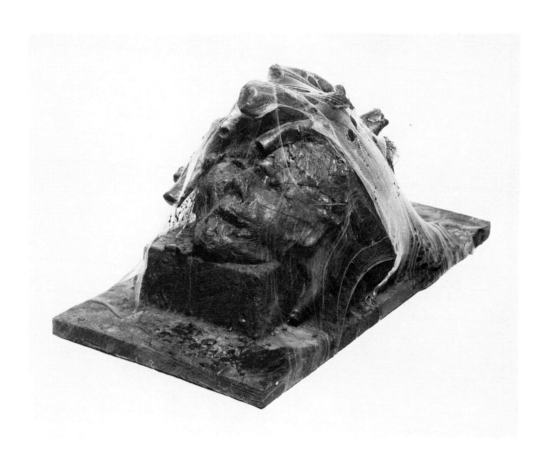

Bruce Conner. *Medusa*, 1960.
Cardboard, hair, nylon, wax, and wood,
10-3/4 x 11 x 22-1/4 in.
Collection of Whitney Museum of American Art.
Gift of the Howard and Jean Lipman Foundation, Inc.

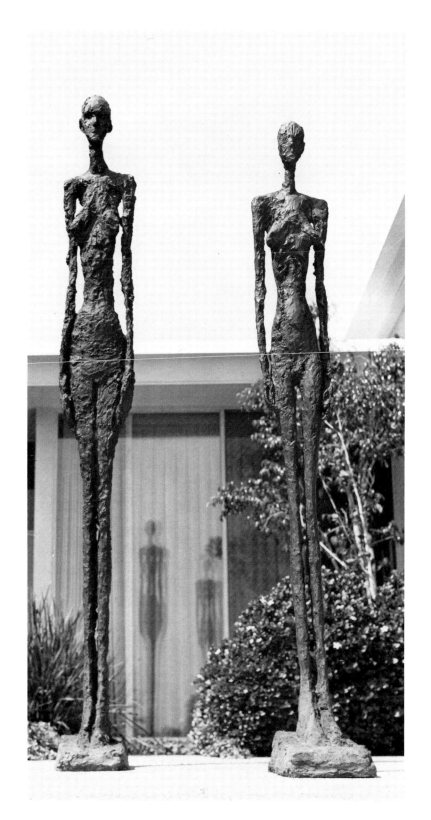

Alberto Giacometti. *Tall Figure II*,
1960. Bronze, 108-1/2 in. high.
Tall Figure III, 1960.
Bronze, 92 in. high.
Collection of Taft and
Rita Schreiber.

Cy Twombly. *Crimes of Passion*, 1960.
Oil, crayon, and pencil on canvas, 74-3/4 x 78-3/4 in.
Museum Ludwig, Cologne. Gift of Peter and Irene Ludwig.

Morris Louis. *Nu*, 1960.
Acrylic on canvas, 103 x 170 in.
Collection of Robert A. Rowan.

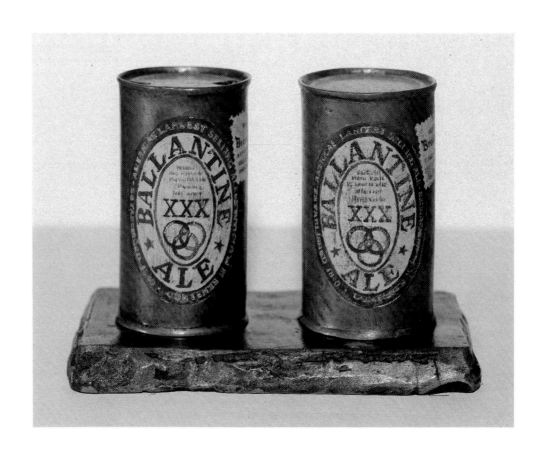

Jasper Johns. *Painted Bronze*, 1960.
Bronze and paint, 5-1/2 x 8 x 4-1/4 in.
Collection Ludwig, Kunstmuseum, Basel.

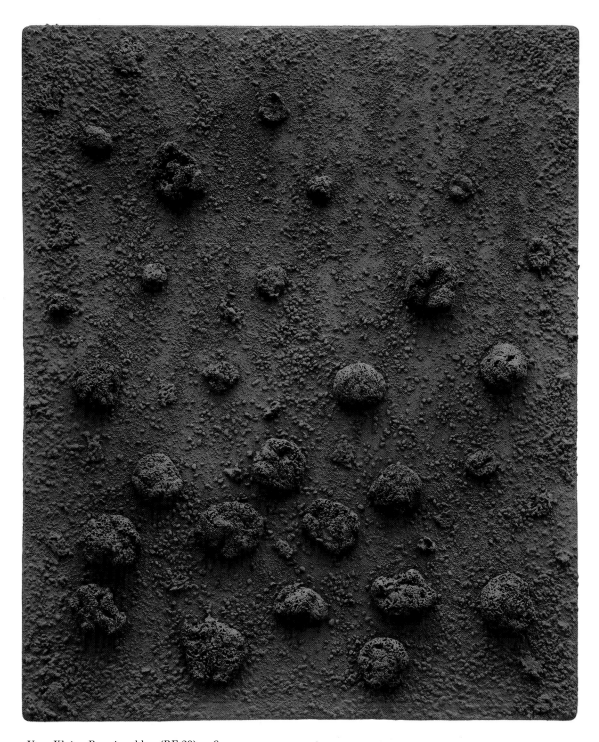

Yves Klein. *Requiem*, blue (RE 20), 1960.
Sponges, pebbles, and dry pigment in synthetic resin
on board, 78-3/8 x 64-7/8 x5-7/8 in.
D. and J. de Menil Collection, Houston.

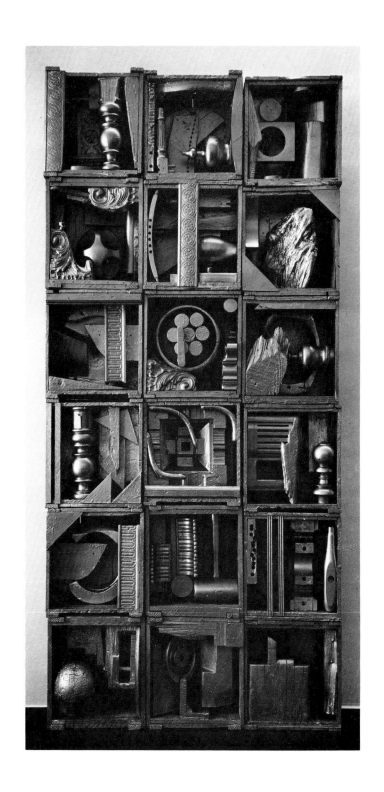

Louise Nevelson. *Royal Tide I*, 1960.
Wood painted gold, 96 x 40 x 8 in.
Collection of Howard
 and Jean Lipman.

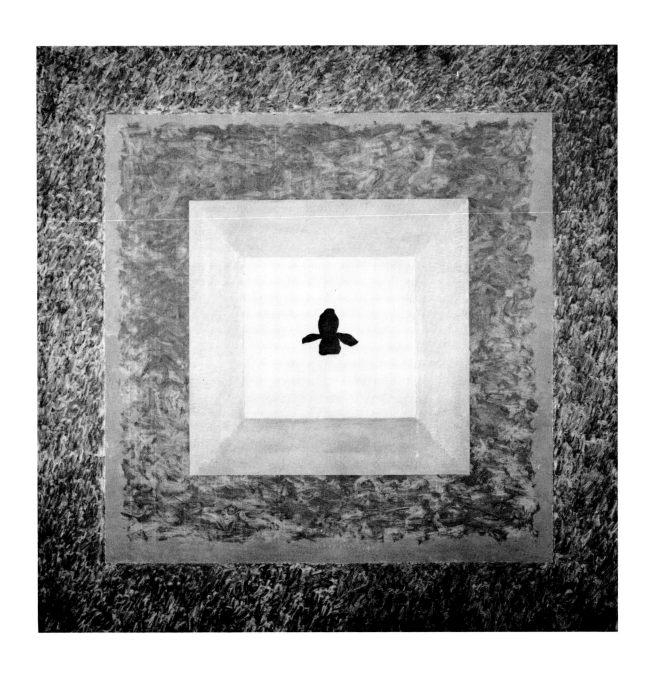

Billy Al Bengston, *Count Dracula I*, 1960.
Oil on canvas, 48 x 48 in.
Collection of Robert A. Rowan.

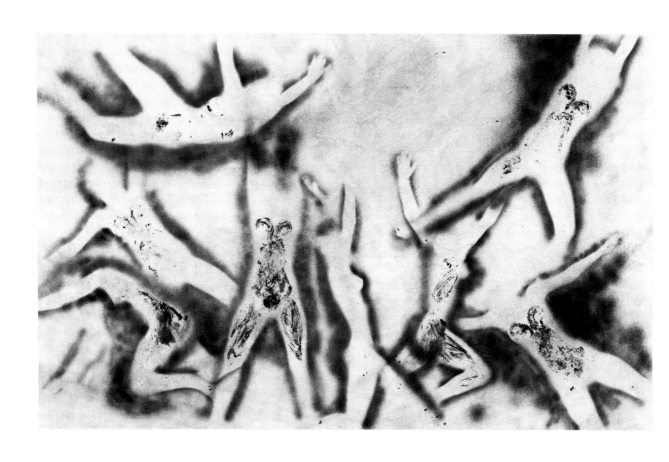

Yves Klein. *People Begin to Fly,* (ANT 96), 1961.
Dry blue pigment in synthetic resin on paper on fabric,
97 x 156-1/2 in.
D. and J. de Menil Collection, Houston.

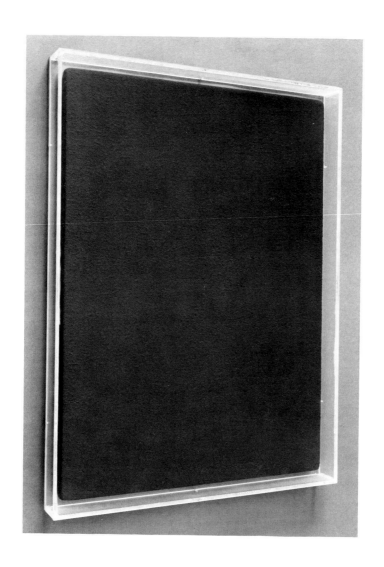

Yves Klein. Untitled blue monochrome (IKB), 1961.
Dry pigment in synthetic resin on fabric on board,
28-3/4 x 21-1/4 x 1 in.
D. and J. de Menil Collection, Houston.

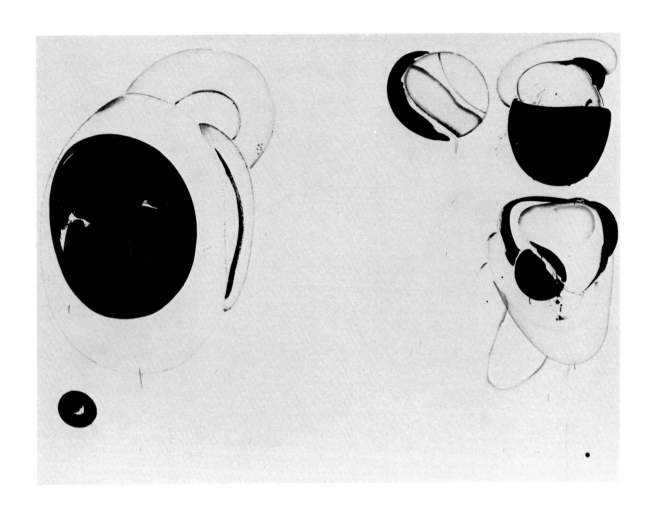

Sam Francis. *Untitled* ("Blue Balls" series), 1961.
Oil on canvas, 73 x 98 in.
Collection of the Weisman Family–Marcia S. Weisman.

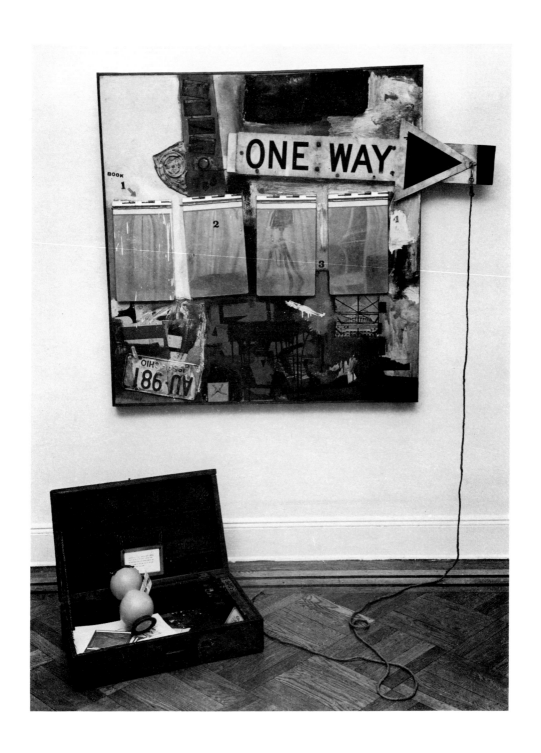

Robert Rauschenberg. *Black Market*, 1961.
Mixed media, 59-3/4 x50 in.
Museum Ludwig, Cologne. Gift of Peter and Irene Ludwig.

John Mason. *Untitled (Green Spear)*, 1961.
Fired clay, 83 x 59 x 6 in.
Collection of the Weisman Family–Richard L. Weisman.

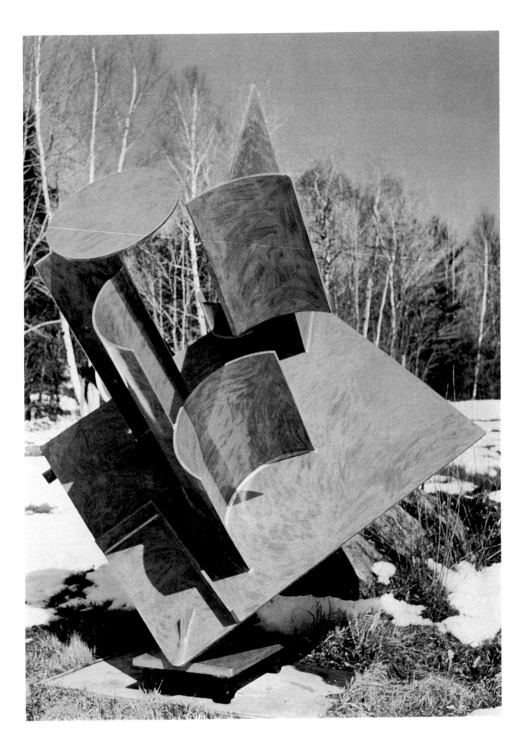

David Smith. *Zig IV*, 1961.
Steel, 95-3/8 x 84-1/4 x 76 in.
Lincoln Center for the Performing Arts.
Gift of Howard and Jean Lipman.

John McLaughlin. *#17*, 1961.
Oil on canvas, 48 x 60 in.
Collection of Robert A. Rowan.

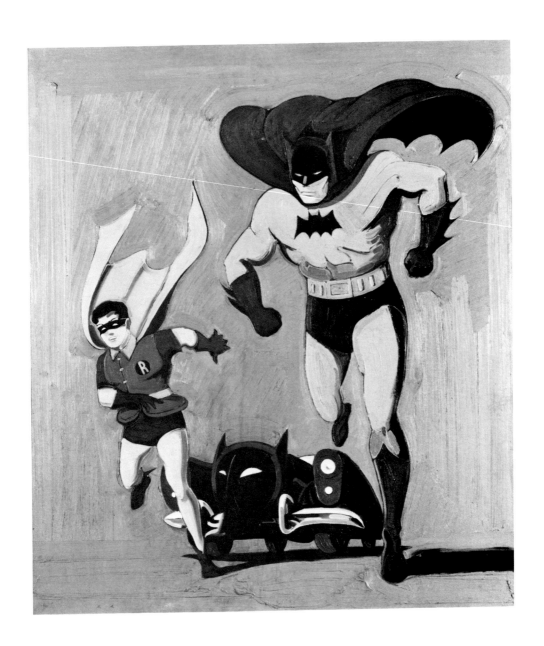

Mel Ramos. *Batmobile*, 1962.
Oil on canvas, 50-1/4 x 44 in.
Museum Moderner Kunst, Vienna.
On loan from Ludwig Collection, Aachen.

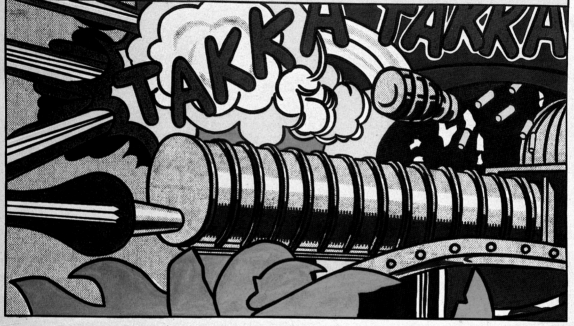

Roy Lichtenstein. *Takka Takka*, 1962.
Magna on canvas, 68 x 56-1/4 in.
Museum Ludwig, Cologne. Gift of Peter and Irene Ludwig.

Andy Warhol. *129 Die in Jet Plane Crash*, 1962.
Acrylic on canvas, 100-1/4 x 71-3/4 in.
Museum Ludwig, Cologne. Gift of Peter and Irene Ludwig.

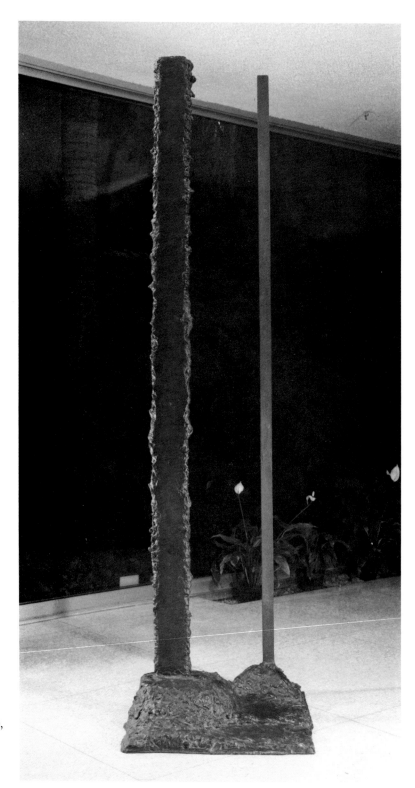

Barnett Newman. *Here I (to Marcia)*,
cast 1962. Bronze,
107-1/4 x 28-1/4 x 27-1/4 in.
Collection of the Weisman Family–
Marcia S. Weisman.

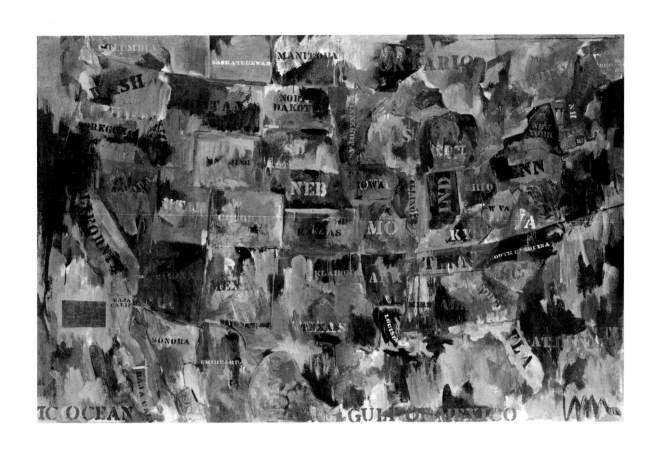

Jasper Johns. *The Map*, 1962–63.
Oil on canvas, 60 x 93 in.
Collection of the Weisman Family–Marcia S. Weisman.

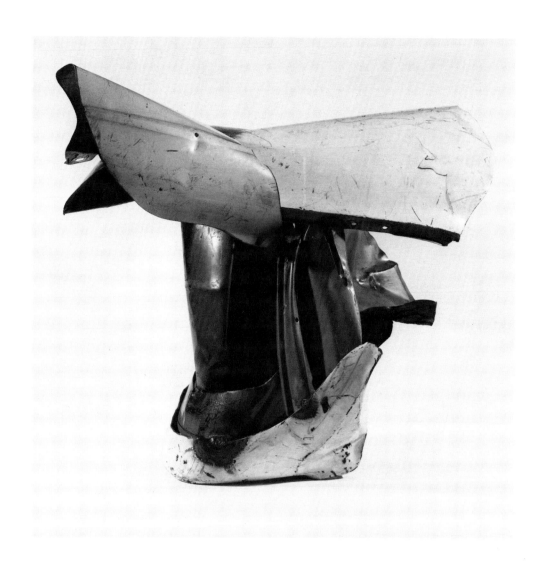

John Chamberlain. *Untitled*, 1963.
Metal, 31 x 37-1/2 x 28 in.
Collection of Whitney Museum of American Art.
Purchase, with funds from the Howard and Jean Lipman
Foundation, Inc. (and exchange).

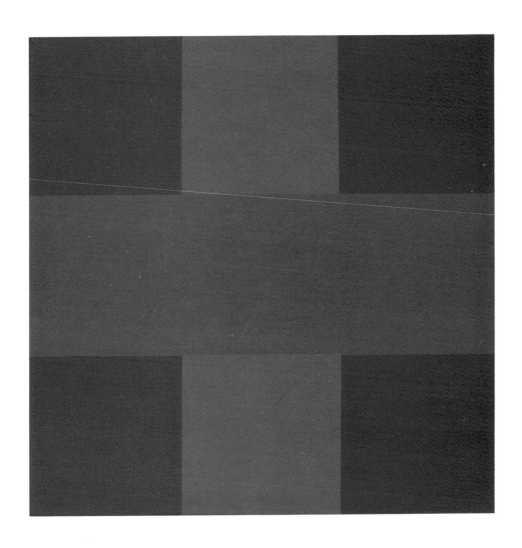

Ad Reinhardt. *Red Painting*, 1963.
Oil on canvas, 30 x 30 in.
Collection of the Weisman Family–Marcia S. Weisman.

Kenneth Noland. *Via Media (Suddenly)*, 1963.
Acrylic on canvas, 102 x 130 in.
Collection of Robert A. Rowan.

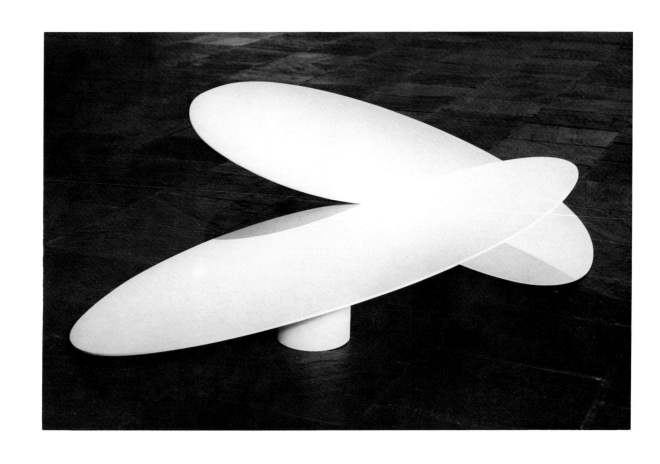

Ellsworth Kelly. *Whites*, 1963.
Painted aluminum, 23 x 70-1/2 x 105-1/2 in.
Collection of Whitney Museum of American Art.
Gift of the Howard and Jean Lipman Foundation, Inc.

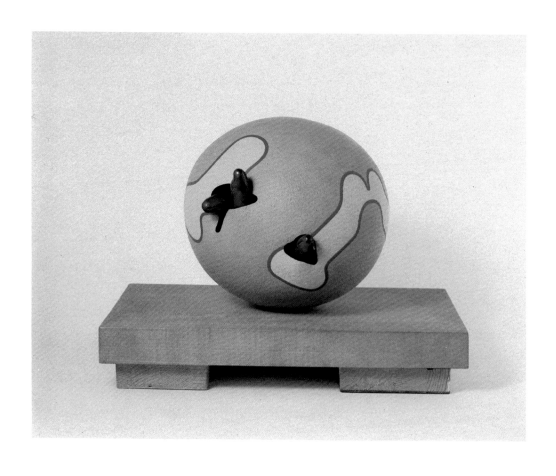

Kenneth Price. *S. L. Green*, 1963.
Painted clay, 9-1/2 x 10-1/2 x 10-1/2 in.
Collection of Whitney Museum of American Art.
Gift of the Howard and Jean Lipman Foundation, Inc.

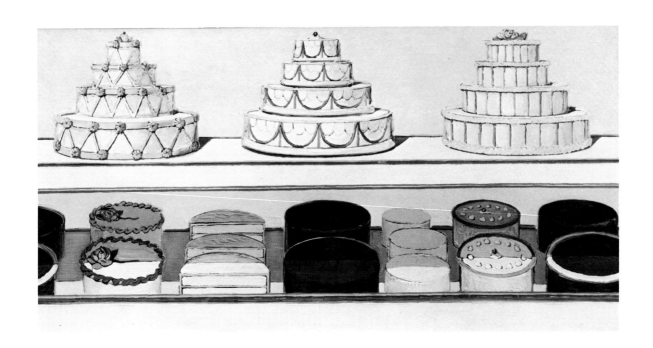

Wayne Thiebaud, *Cake Counter*, 1963.
Oil on canvas, 36-1/4 x 72 in.
Museum Ludwig, Cologne. Gift of Peter and Irene Ludwig.

Richard Hamilton. *My Marilyn*, 1964.
Collage, oil, and paper, 40-1/4 x 48 in.
Ludwig Collection, Neue Galerie, Aachen.

Tom Wesselmann. *Landscape No. 2*, 1964.
Mixed media, 76 x 94 in.
Museum Ludwig, Cologne. Gift of Peter and Irene Ludwig.

Andy Warhol. *28 Brillo Boxes*, 1964.
Acrylic and silkscreen on wood, 17-1/4 x 17 x 14 in.
14 Campbell Boxes, 1964. Acrylic and silkscreen
on wood, 10 x 19 x 9-1/2 in.
Ludwig Collection, Neue Galerie, Aachen.

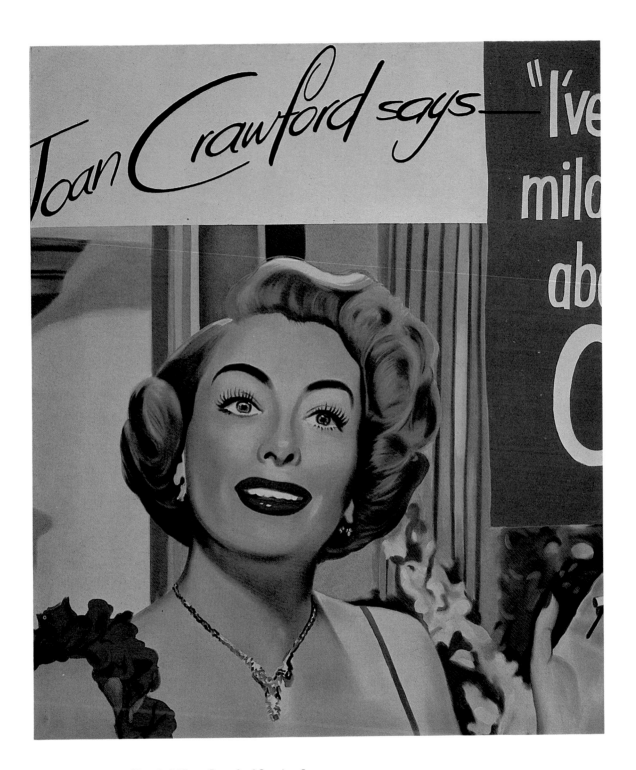

James Rosenquist. *Untitled (Joan Crawford Says)*, 1964.
Oil on canvas, 95-1/4 x 77-1/4 in.
Museum Ludwig, Cologne. Gift of Peter and Irene Ludwig.

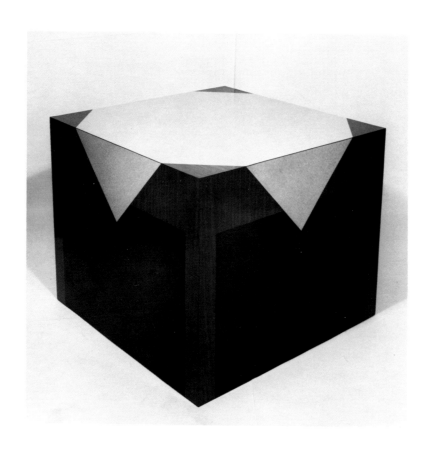

Richard Artschwager. *Description of Table*, 1964.
Formica, 26-1/4 x 32 x 32 in.
Collection of Whitney Museum of American Art.
Gift of the Howard and Jean Lipman Foundation, Inc.

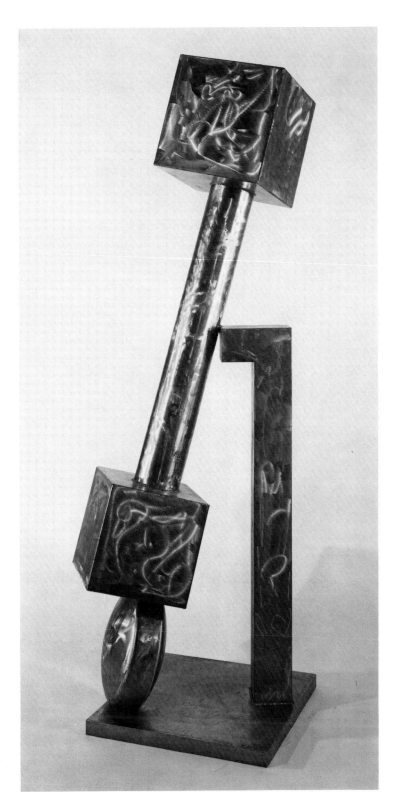

David Smith. *Cubi XXI*, 1964.
Stainless steel, 119-1/2 in. high.
Collection of Howard and Jean Lipman.
On extended loan to Whitney
Museum of American Art.

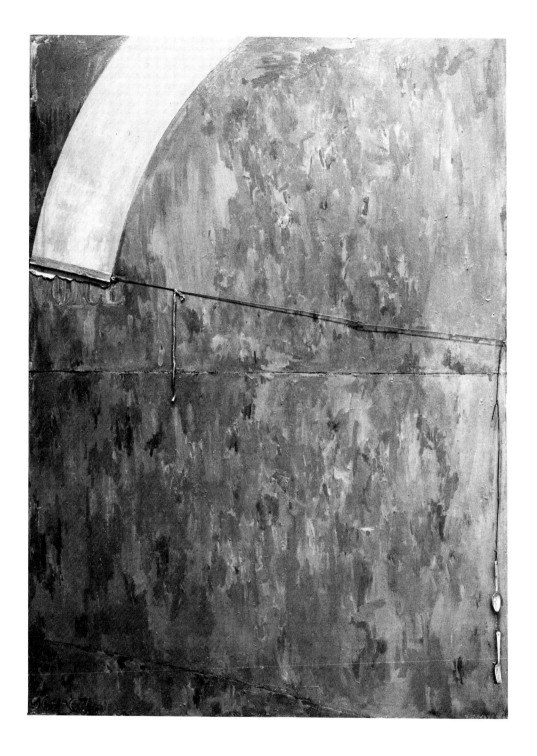

Jasper Johns. *Voice*, 1964–67.
Oil on canvas with objects, 96 x 69-1/2 in.
D. and J. de Menil Collection, Houston.

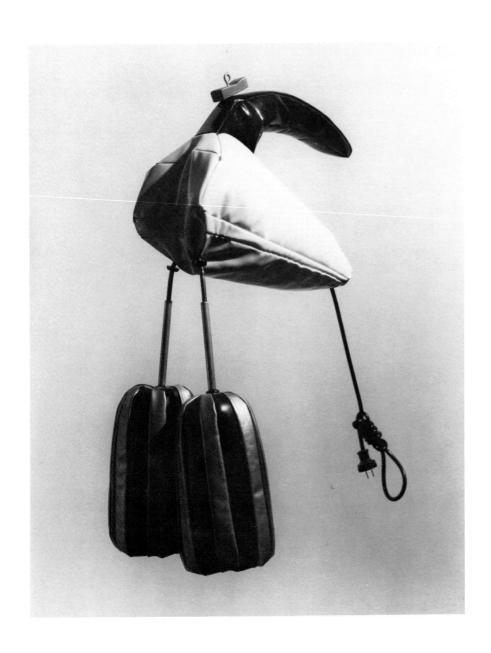

Claes Oldenburg. *Dormeyer Mixer*, 1965.
Kapok, vinyl, and wood, 32 x 20 x 12-1/2 in.
Collection of Whitney Museum of American Art.
Gift of the Howard and Jean Lipman Foundation, Inc.

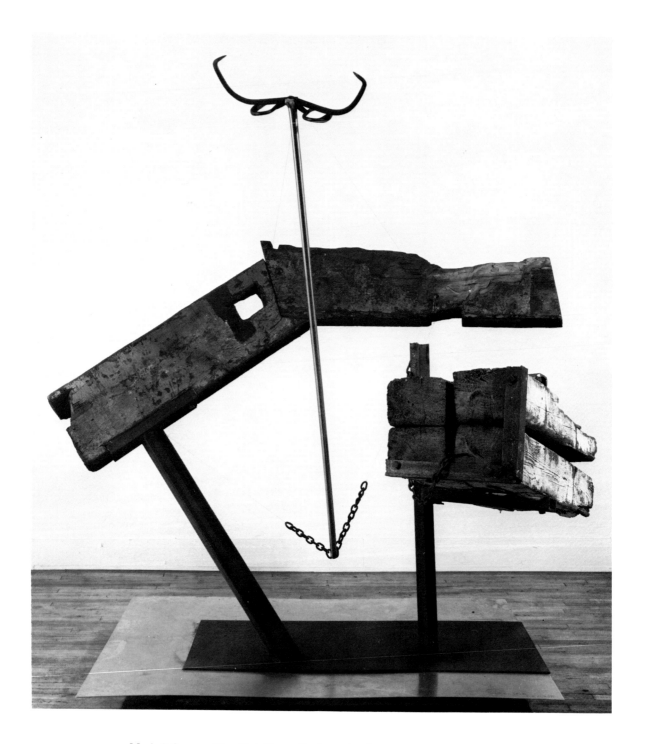

Mark di Suvero. *New York Dawn (for Lorca)*, 1965.
Iron, steel, and wood, 78 x 74 x 50 in.
Collection of Whitney Museum of American Art.
Gift of the Howard and Jean Lipman Foundation, Inc.

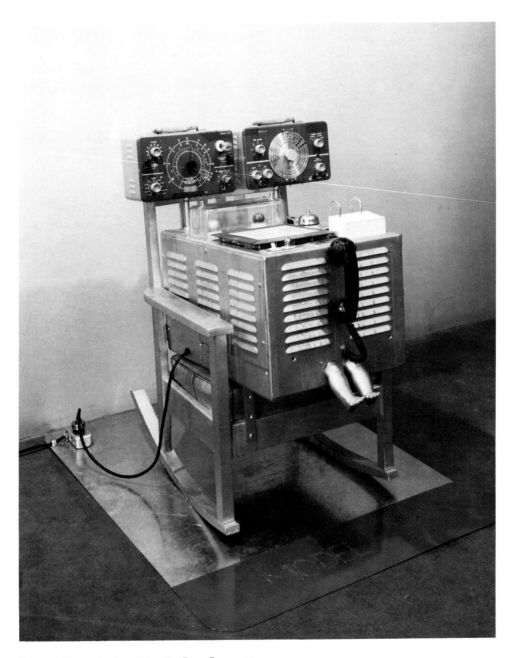

Edward Kienholz. *The Friendly Grey Computer–
Star Gauge Model 54*, 1965.
Motorized construction, 40 x 39-1/8 x 24-1/2 in.,
on aluminum sheet, 48-1/8 x 36 in.
The Museum of Modern Art, New York.
Gift of Howard and Jean Lipman.

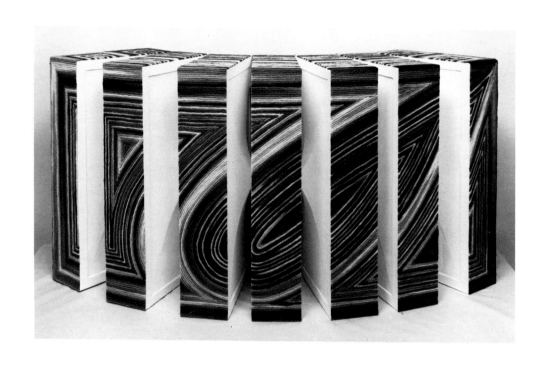

Lucas Samaras. *Box #41*, 1965.
Wood covered with yarn, 17-1/8 x 13-3/4 x 38 in.
open; 17-1/8 x 10-1/4 x 25 in. closed.
Collection of Whitney Museum of American Art.
Gift of Howard and Jean Lipman.

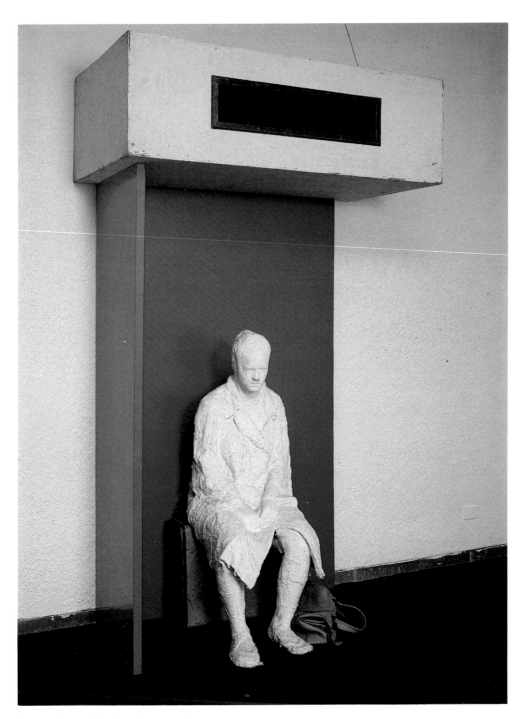

George Segal. *The Bus Station*, 1965.
Plaster, wood, formica, metal, vinyl, cardboard,
and leather, 96-1/4 x 59-1/8 x 29-3/4 in.
Collection of Whitney Museum of American Art.
Gift of Howard and Jean Lipman.

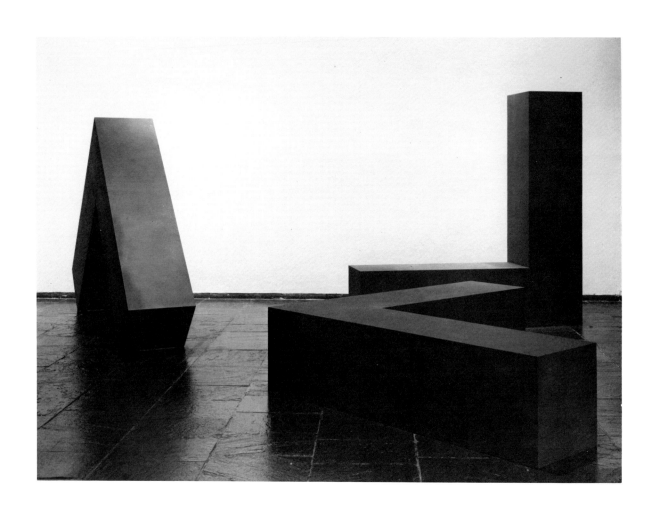

Robert Morris. *Untitled (L-beams)*, 1965.
Stainless steel, 3 beams, 96 x 96 x 24 in. each.
Collection of Whitney Museum of American Art.
Gift of Howard and Jean Lipman.

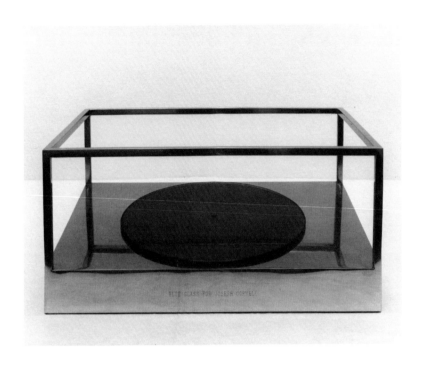

Walter de Maria. *Blue Glass for Cornell*, 1966.
Glass and steel, 15-3/4 x 10-3/4 x 7-1/2 in.
Collection of Whitney Museum of American Art.
Gift of the Howard and Jean Lipman Foundation, Inc.

Mark Rothko. *Untitled*
(alternative painting in the
Rothko chapel series), 1965–66.
Oil on canvas, 177-1/2 x 96 in.
Menil Foundation, Houston.

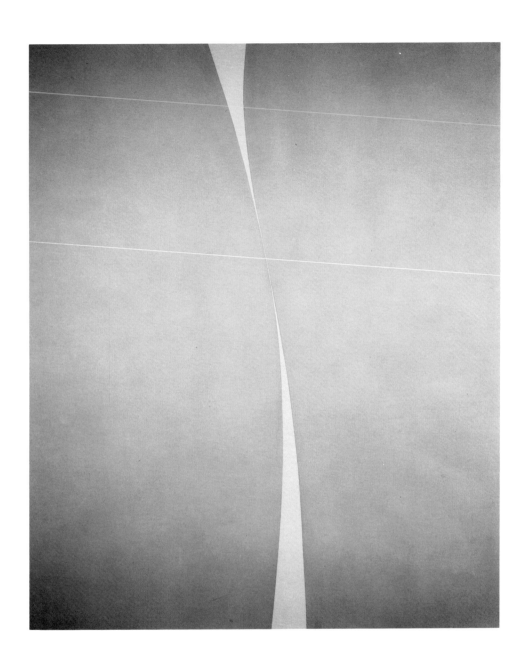

Lorser Feitelson. *Untitled*, 1966.
Enamel on canvas, 72 x 60 in.
Collection of the Weisman Family–Richard L. Weisman.

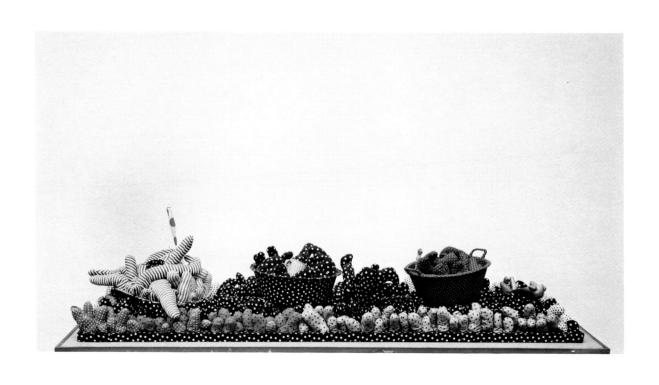

Yayoi Kusama. *Compulsion Furniture*, 1966.
Mixed media, fabric, 81-1/2 x 22-1/2 in.
Museum Ludwig, Cologne. Gift of Peter and Irene Ludwig.

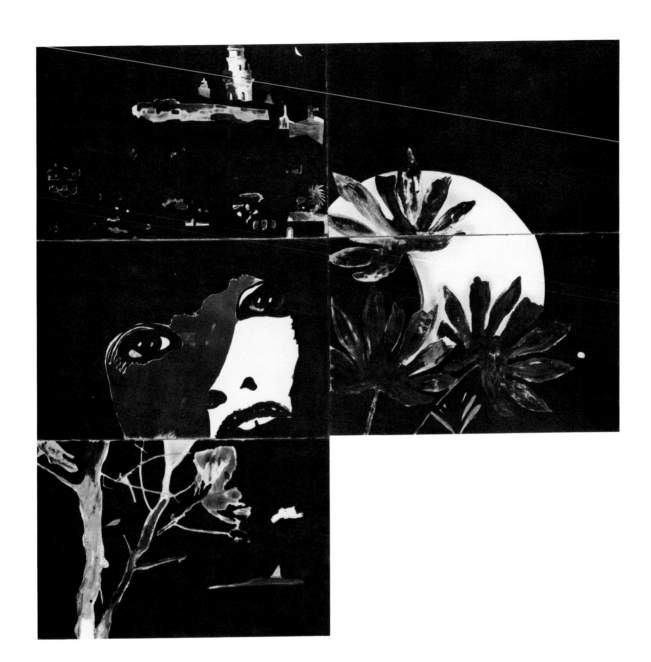

Martial Raysse. *South Islands Style Painting:*
Mediterranean Mood, 1966.
Flocking and fluorescent paint on canvas, 76-3/4 x 78-3/4 in.
D. and J. de Menil Collection, Houston.

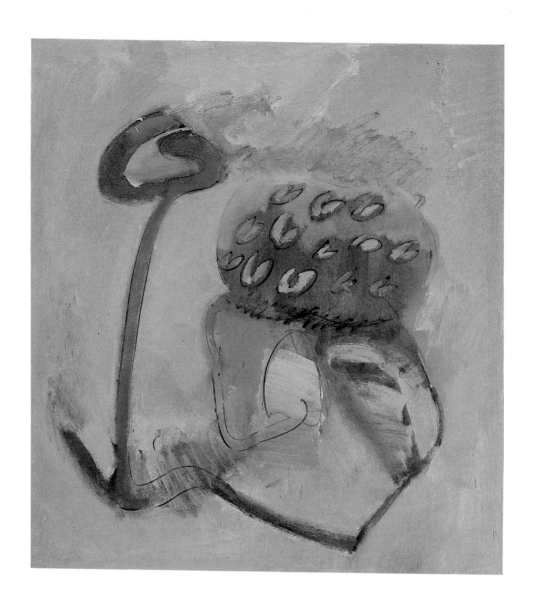

John Altoon. *Untitled*, 1967.
Oil on canvas, 60 x 48 in.
Collection of Robert A. Rowan.

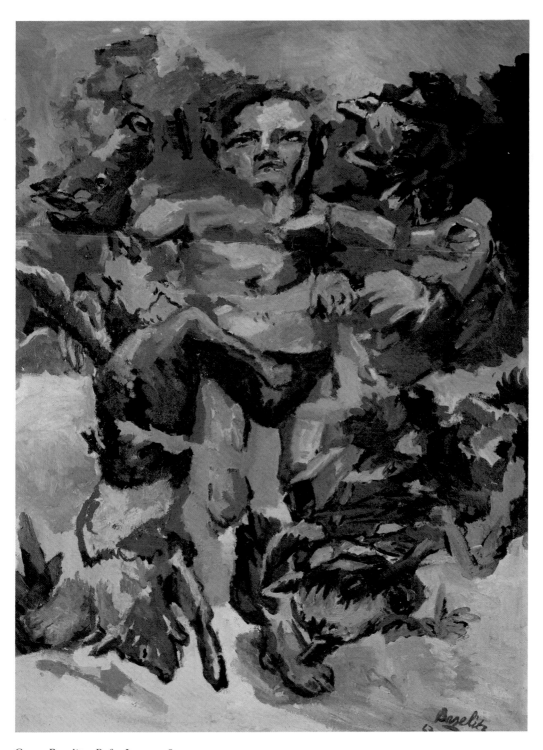

Georg Baselitz. *B. for Larry*, 1967.
Oil on canvas, 98-1/2 x 78-3/4 in.
Collection of Charles and Doris Saatchi, London.

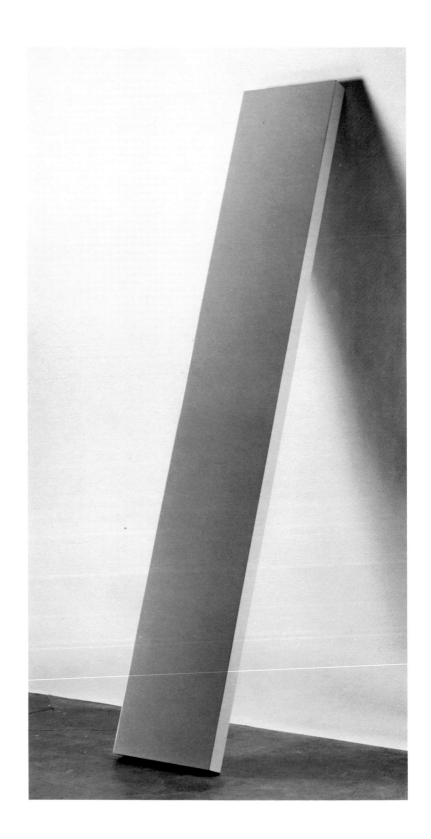

John McCracken. *The Case for Fakery in Beauty*, 1967. Wood and fiberglass, 120 x 18 x 3-1/2 in. Collection of Robert A. Rowan.

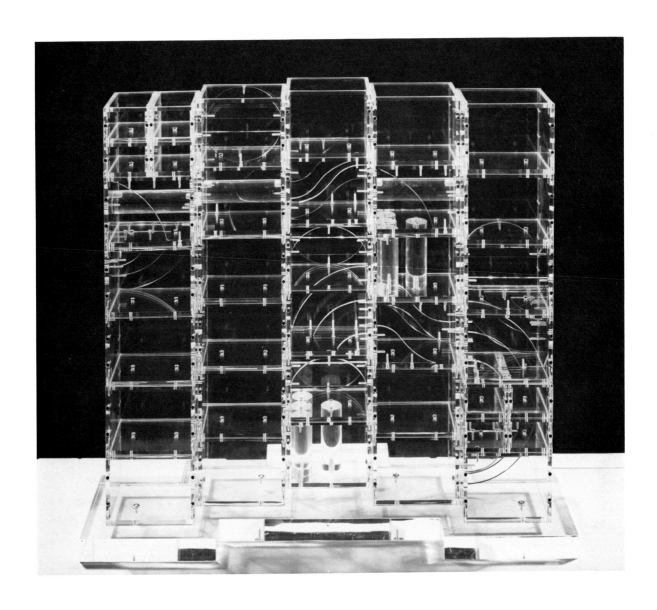

Louise Nevelson. *Transparent Sculpture VI*, 1967–68.
Plexiglas, 19 x 20 x 8 in.
Collection of Whitney Museum of American Art.
Gift of the Howard and Jean Lipman Foundation, Inc.

Jules Olitski. *Tender Boogus*, 1967–68.
Acrylic water-base paint on canvas, 133 x 258 in.
Collection of The Museum of Contemporary Art,
Los Angeles. Gift of Robert A. Rowan.

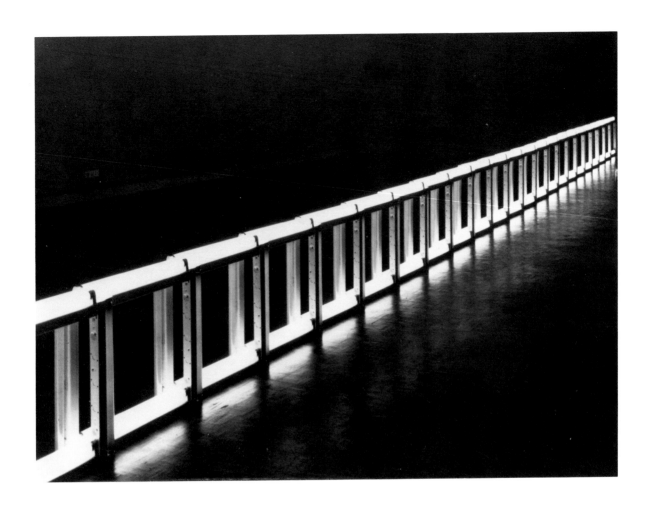

Dan Flavin. *Untitled* (to Flavin Starbuck Judd), 1968.
Blue and red fluorescent light, approximately 24 x 540 in.
Collection of Giuseppe and Giovanna Panza di Biumo, Milan.

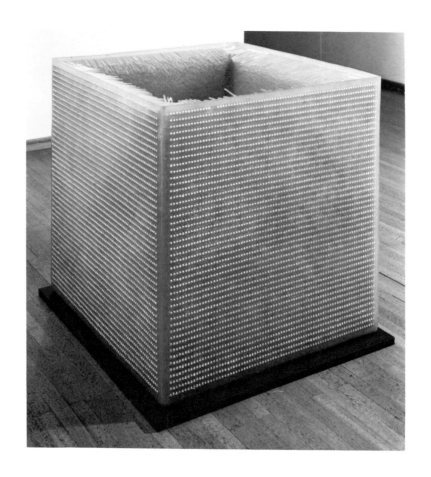

Eva Hesse. *Accession III*, 1968.
Fiberglass, 31-1/2 x 31-1/2 x 31-1/2 in.
Museum Ludwig, Cologne.
Gift of Peter and Irene Ludwig.

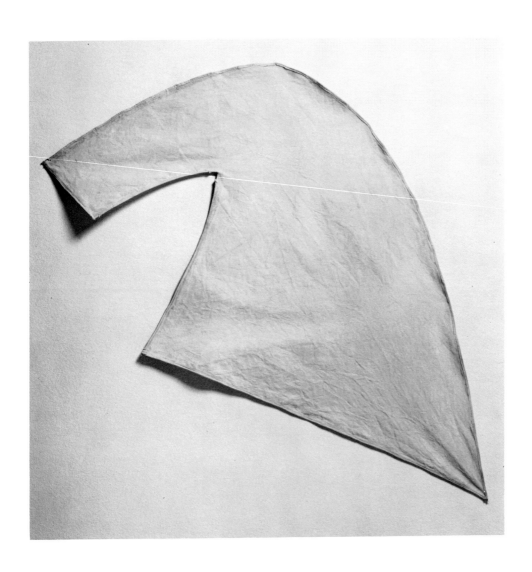

Richard Tuttle. *Untitled*, 1968.
Fabric, 58-1/4 x 70-3/4 in.
Museum Ludwig, Cologne.
Gift of Peter and Irene Ludwig.

```
                Variable Piece #4
                  New York City

On November 23, 1968 ten photographs were made with
the camera pointed west on 42nd Street in New York City.

With his eyes completely closed the photographer sat
on the corner of Vanderbilt Avenue; each photograph was
made at the instant when the sound of traffic approaching
42nd Street stopped enough to suggest that pedestrians
could cross the street.

This statement and the ten photographs join together to
constitute the form of this piece.

                                Douglas Huebler
November, 1968
                          Douglas Huebler
```

Douglas Huebler. *Variable Piece #4*, 1968. One statement, 10 black and white photographs, 8 x 10 in. each. Collection of Giuseppe and Giovanna Panza di Biumo, Milan.

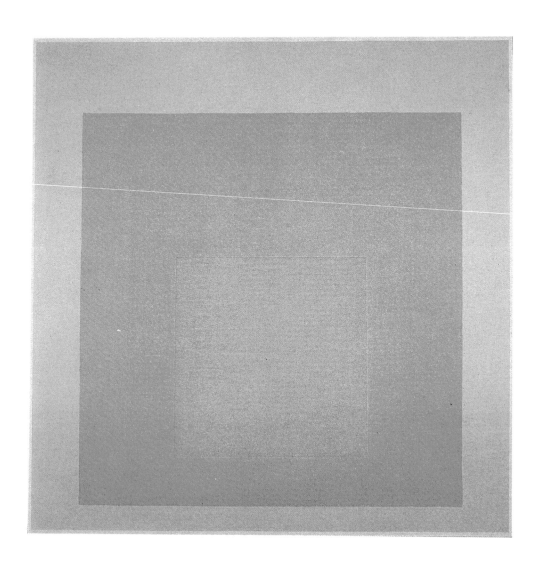

Joseph Albers. *Homage to the Square: Beyond Focus*, 1969.
Oil on masonite, 48 x 48 in.
Collection of Taft and Rita Schreiber and
the Los Angeles County Museum of Art.

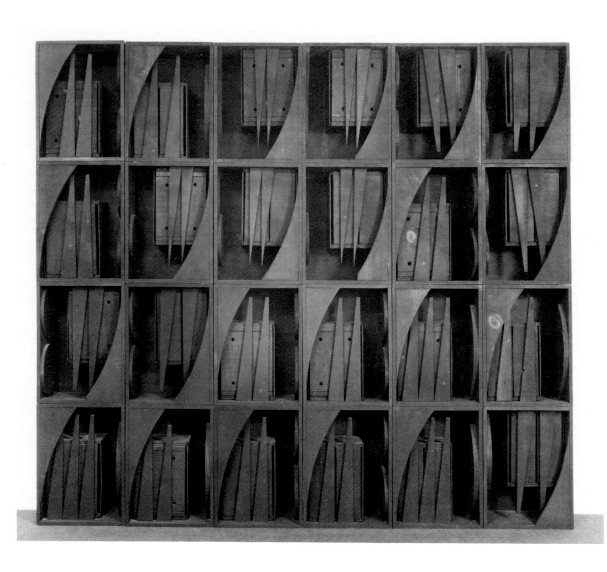

Louise Nevelson. *Night–Focus–Dawn*, 1969.
Painted wood, 102 x 117 x 14 in.
Collection of Whitney Museum of American Art.
Gift of Howard and Jean Lipman.

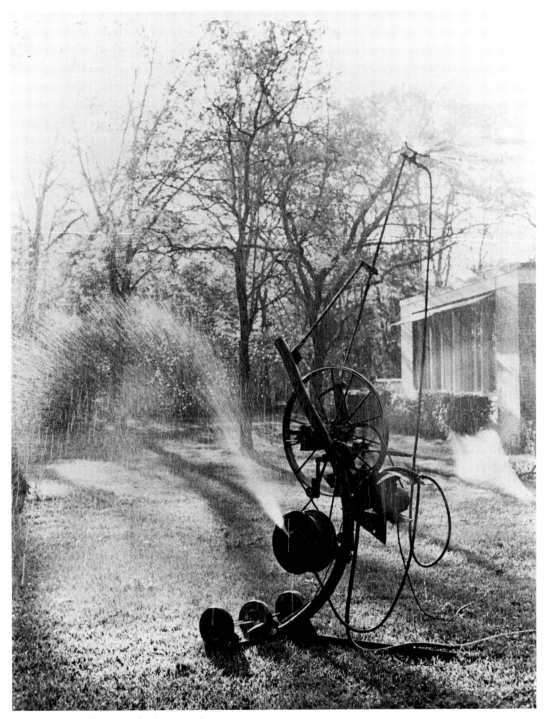

Jean Tinguely. *Fountain Sculpture,* 1969.
Scrap, junk metal, and motors from Houston
junkyards, 107 x 37-1/2 x 66 in.
D. and J. de Menil Collection, Houston.

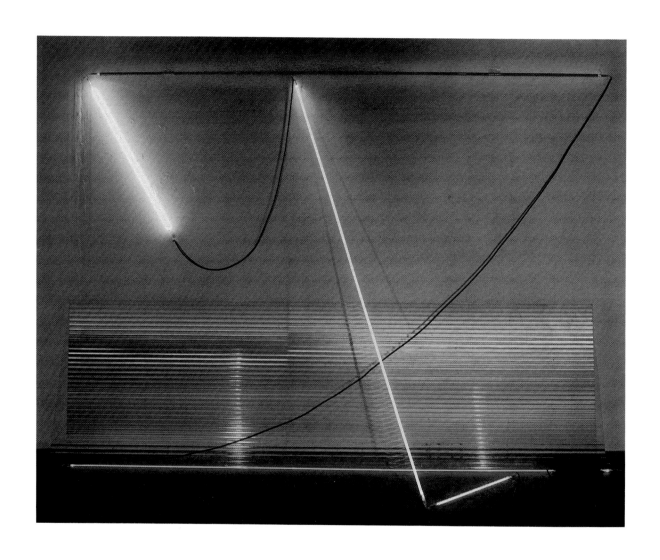

Keith Sonnier. *Ba-O-Ba, Number 3*, 1969.
Glass and neon, 91-1/4 x 122-3/4 x 24 in.
Collection of Whitney Museum of American Art.
Gift of Howard and Jean Lipman Foundation, Inc.

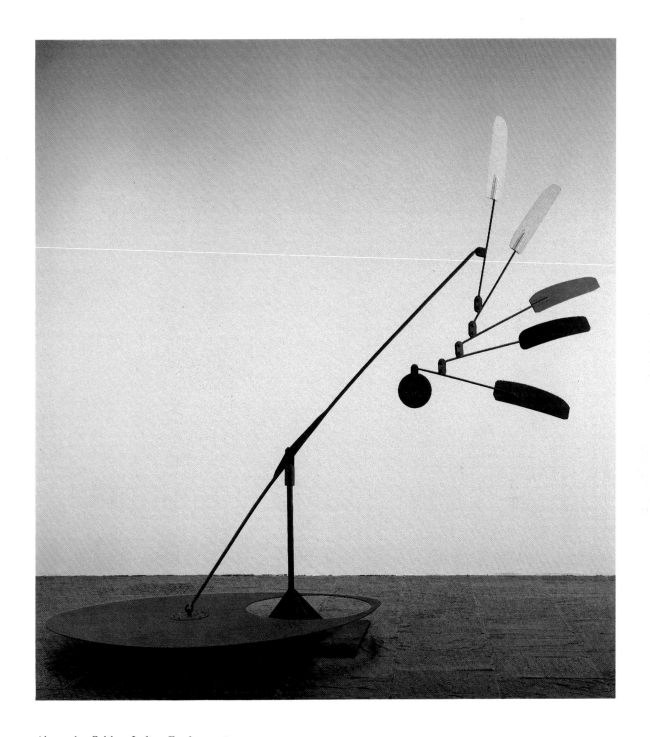

Alexander Calder. *Indian Feathers*, 1969.
Painted aluminum sheet and stainless
steel rods, 136-3/4 x 91 x 63 in.
Collection of Whitney Museum of American Art.
Gift of the Howard and Jean Lipman Foundation, Inc.

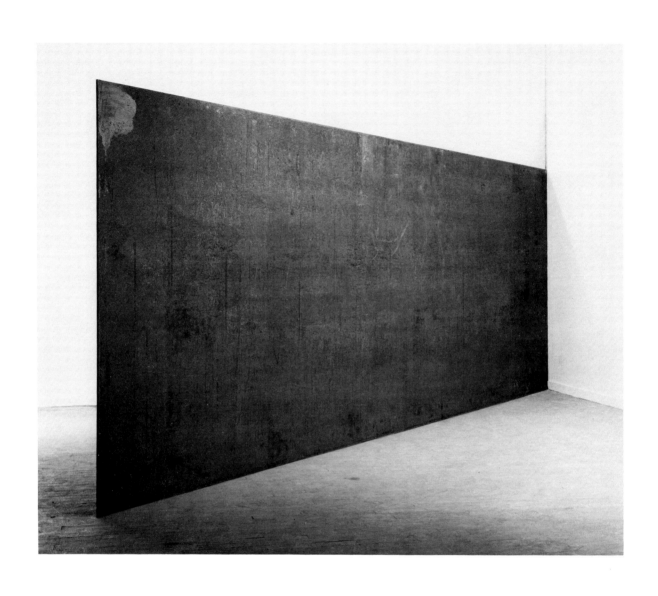

Richard Serra. *Strike*, 1969–71.
Steel plate, 96 x 288 x 1-1/2 in.
Collection of Giuseppe and Giovanna Panza di Biumo, Milan.

Chuck Close. *Richard*, 1969.
Acrylic on canvas, 107-3/4 x 83-3/4 in.
Ludwig Collection, Neue Galerie, Aachen.

Carl Andre. *249 Brass Run*, 1969.
249 brass plates, 2-1/2 x 3-1/4 in. each.
Collection of Giuseppe and Giovanna Panza di Biumo, Milan.

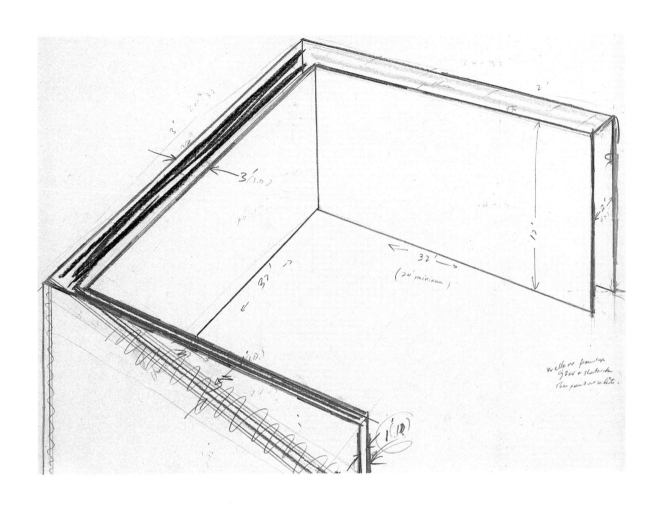

Bruce Nauman. *Red, Yellow, and Blue*, 1970.
Collection of Giuseppe and Giovanna Panza di Biumo, Milan.
Drawing, 1983. Pencil and pastel on paper, 36 x 50 in.
Collection of the artist.

TO THE SEA

ON THE SEA

FROM THE SEA

AT THE SEA

BORDERING THE SEA

Lawrence Weiner, 1970.
Language plus seawater, dimensions variable.
Collection of Giuseppe and Giovanna Panza di Biumo, Milan.

Hanne Darboven. *42N–33K–00–99=NO1–2K–20K*, 1969–70.
One of 138 pages (framed separately). Ink on paper, 11-1/2 x 8-1/4 in.
Collection of Giuseppe and Giovanna Panza di Biumo, Milan.

Ralph Goings. *Airstream*, 1970.
Oil on canvas, 59-3/4 x 84-1/4 in.
Museum Moderner Kunst, Vienna.
On loan from Ludwig Collection, Aachen.

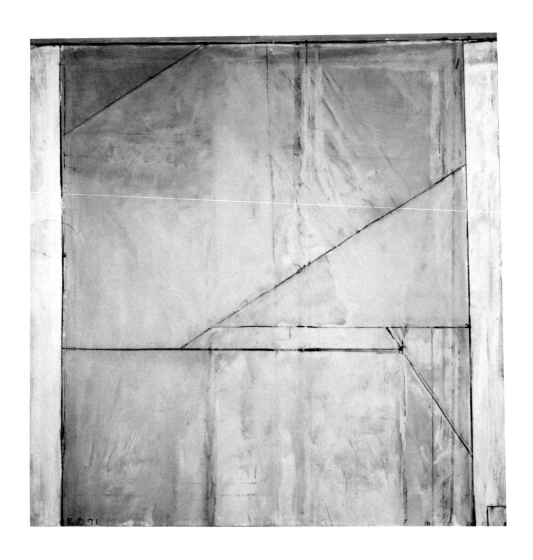

Richard Diebenkorn. *Ocean Park No. 37,* 1971.
Oil on canvas, 50 x 50 in.
Collection of Robert A. Rowan.

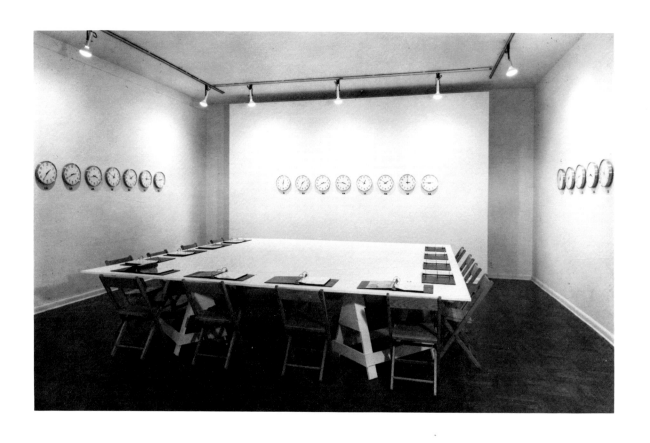

Joseph Kosuth. *The Eighth Investigation*, Proposition 3, 1971.
Mixed materials.
Collection of Giuseppe and Giovanna Panza di Biumo, Milan.

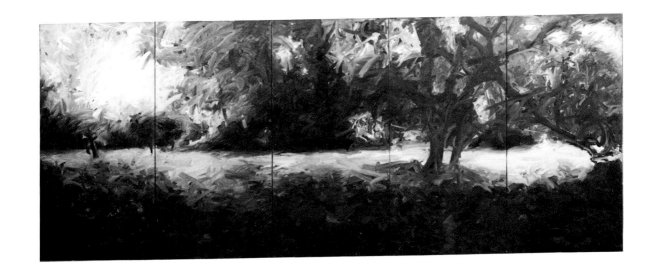

Gerhard Richter. *Das Parkstück*, 1971.
Oil on canvas, 5 panels, 98-1/2 x 246 in.
Museum Moderner Kunst, Vienna.
On loan from Ludwig Collection, Aachen.

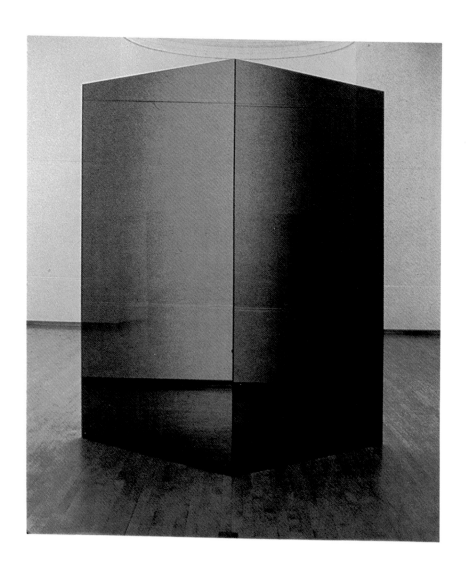

Larry Bell. *Two Glass Walls*, 1971–72.
Glass, 96 x 60 x 3/4 in. each.
Collection of Giuseppe and Giovanna Panza di Biumo, Milan.

Walter de Maria. *Triangle*, 1972.
Stainless steel, flat side to point: 39-1/2 in.;
point to point: 45-5/8 in.; depth: 3-5/8 in.
Circle, 1972. Stainless steel, diameter: 39-3/8 in.; depth: 3-5/8 in.
Square, 1972. Stainless steel, 39-3/8 in. square; depth: 3-5/8 in.
Menil Foundation Collection, Houston.

Malcolm Morley. *School of Athens*, 1972.
Oil on canvas, 67 x 94-1/2 in.
Collection of Charles and Doris Saatchi, London.

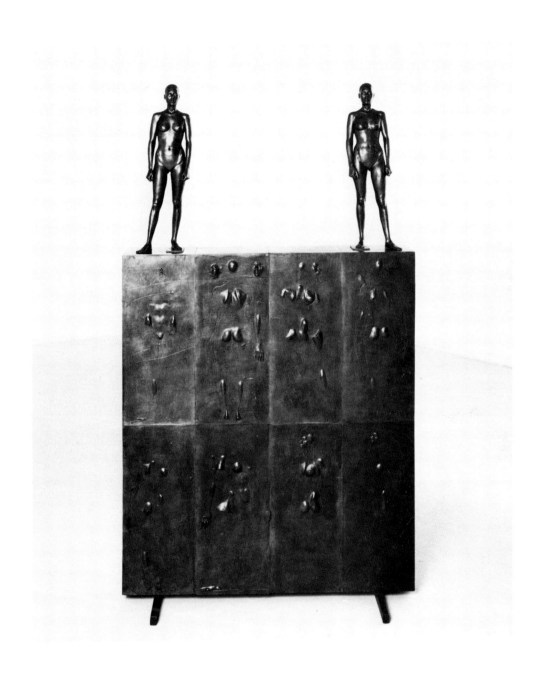

Robert Graham. *Mirror Figure*, 1973–76.
Bronze, 60 x 35 x 8-1/2 in.
Collection of the Weisman Family–Marcia S. Weisman.

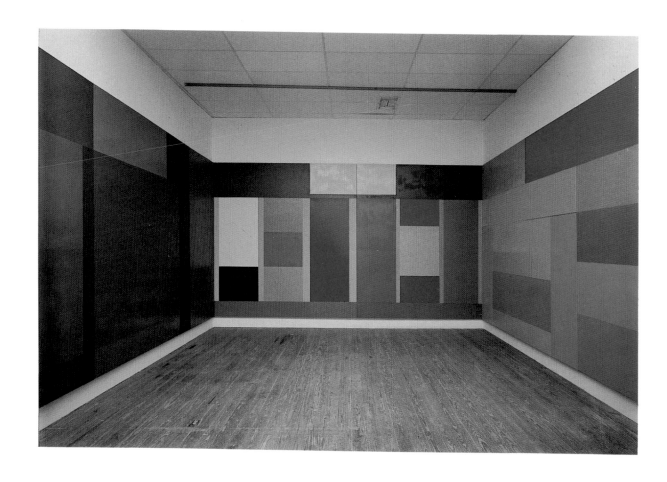

David Novros. *Room 3 (Untitled)*, 1973–75.
Oil on canvas, Wall A: 120 x 178 in.;
Wall B: 120 x 216 in.; Wall C: 120 x 178 in.
Promised gift to the Menil Foundation
and the Fort Worth Art Museum jointly.

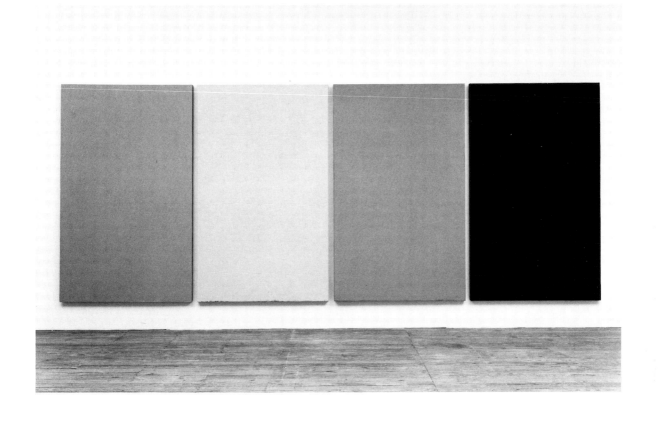

Brice Marden. *The Seasons*, 1974–75.
Oil and wax on canvas, four panels, 96 x 60 in. each.
Menil Foundation, Houston.

PLYWOOD
INSTALLED BETWEEN TWO WALLS

Judd

Donald Judd. Untitled, 1974.
Collection of Giuseppe and Giovanna Panza di Biumo, Milan.
Drawing, 1983. Pencil on paper, 9 x 12 in. Collection of the artist.

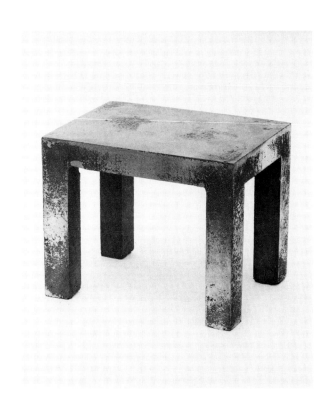

Joel Shapiro. *Untitled*, 1974.
Iron, 5-1/2 x 6-3/4 x 5 in.
Collection of Giuseppe and Giovanna Panza di Biumo, Milan.

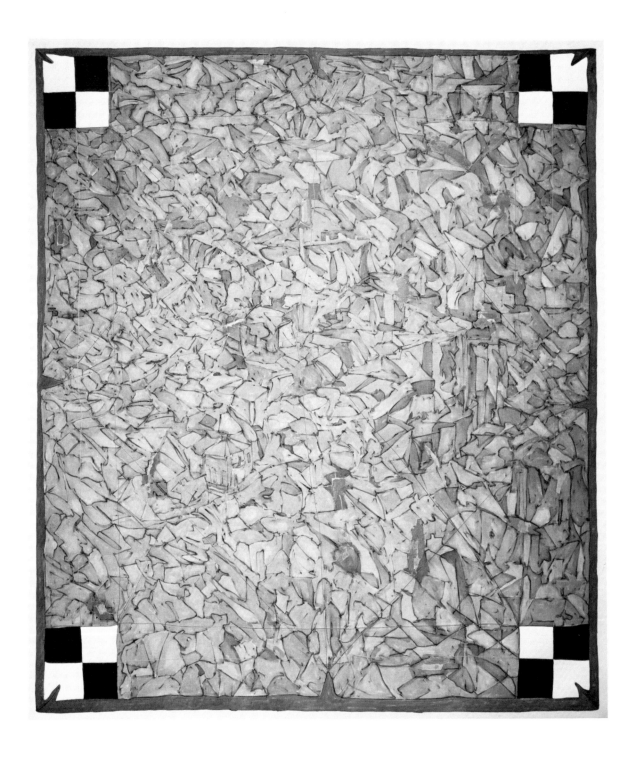

William Wiley. *Village Green*, 1974.
Acrylic and charcoal on canvas, 88-1/2 x 77-1/2 in.
Collection of Robert A. Rowan.

Sol LeWitt. A wall divided into sixteen equal parts with
all one-, two-, three-, and four-part combinations of
lines in four directions and four colors, July 1975.
Collection of Giuseppe and Giovanna Panza di Biumo, Milan.
Detail of a silkscreen printed by Jo Watanabe, 1977.

Laddie John Dill. *Untitled*, 1975.
Plywood, cement and polymer emulsion,
plate glass, and silicone, 83-1/2 x 59-1/2 in.
Collection of the Weisman Family–Frederick R. Weisman.

Zero Mass

Orr '83

Eric Orr. *Zero Mass*, 1975.
Collection of Giuseppe and Giovanna Panza di Biumo, Milan.
Drawing, 1983. 19-1/2 x 24 in. Collection of the artist.

Ed Moses. *Cubist Painting #1*, 1975–76.
Acrylic on canvas, 78 x 66 in.
Collection of the Weisman Family–Frederick R. Weisman.

Doug Wheeler. *SA MI DW SM 2 75 TC LA*, 1975.
Collection of Giuseppe and Giovanna Panza di Biumo, Milan.
Drawing, 1983. Ink and graphite on paper, 30-1/4 x 24 in.
Collection of the artist.

Ron Davis. *Bent Vents and Octangular*, 1976.
Vinyl acrylic copolymer and dry pigment on canvas, 114 x 180 in.
Collection of The Museum of Contemporary Art, Los Angeles.
Gift of Robert A. Rowan.

Philip Guston. *Frame*, 1976.
Oil on canvas, 74 x 116 in.
Collection of Charles and Doris Saatchi, London.

Blinky Palermo. *Himmelsrichtungen I*, 1976.
Acrylic on aluminum, four panels, 10-1/2 x 8-1/4 in. each.
Ludwig Collection, Museum Ludwig, Cologne.

Malcolm Morley. *Age of Catastrophe*, 1976.
Oil on canvas, 60 x 96 in.
Collection of Charles and Doris Saatchi, London.

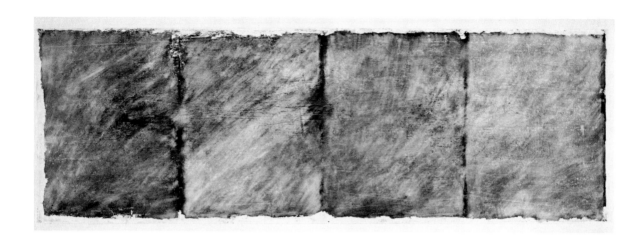

Lita Albuquerque. *California Sunrise*, 1977.
Oil on kimdura, 37-1/2 x 114 in.
Collection of the Weisman Family–Frederick R. Weisman.

266

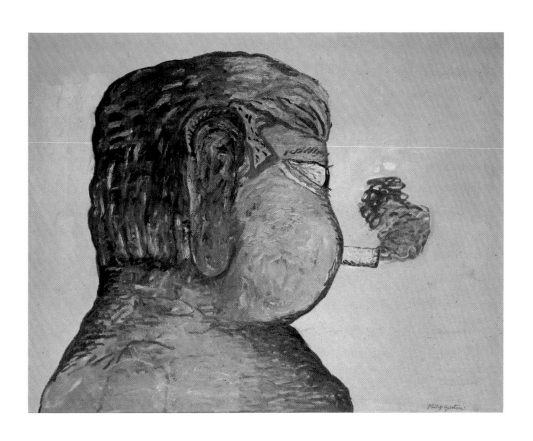

Philip Guston. *Friend to M. F.*, 1978.
Oil on canvas, 66 x 88 in.
Collection of Charles and Doris Saatchi, London.

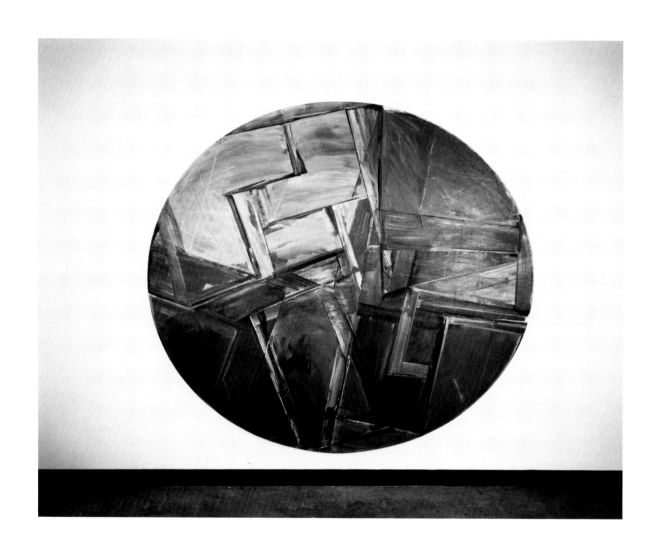

Karen Carson. *Sunrise/Sunset*, 1979.
Oil on canvas, 84 x 96 in.
Collection of Robert A. Rowan.

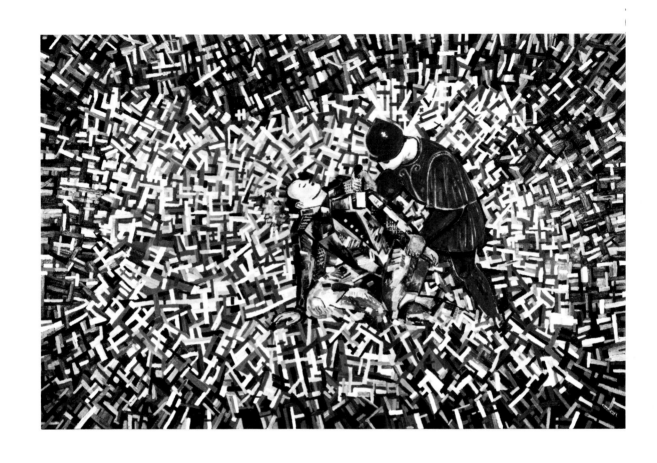

Sandro Chia. *Verso Damasco*, 1980.
Oil on canvas, 90-1/2 x 153-1/2 in.
Collection of Charles and Doris Saatchi, London.

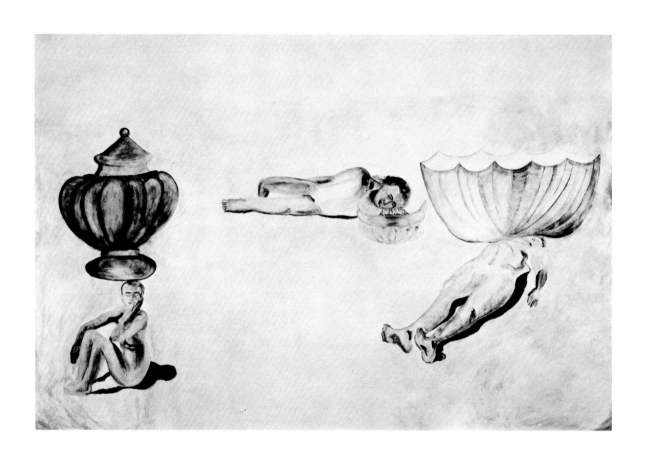

Francesco Clemente. *The Magi*, 1980.
Fresco, 78-3/4 x 118 in.
Collection of Charles and Doris Saatchi, London.

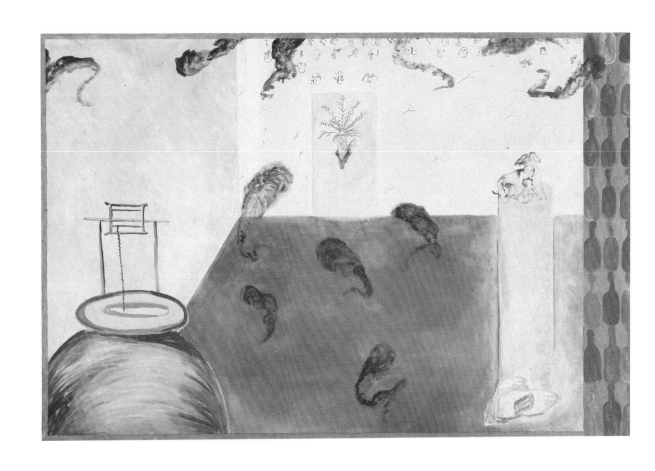

Francesco Clemente. *The Smoke in the Room*, 1981.
Fresco, 78-3/4 x 118 in.
Collection of Charles and Doris Saatchi, London.

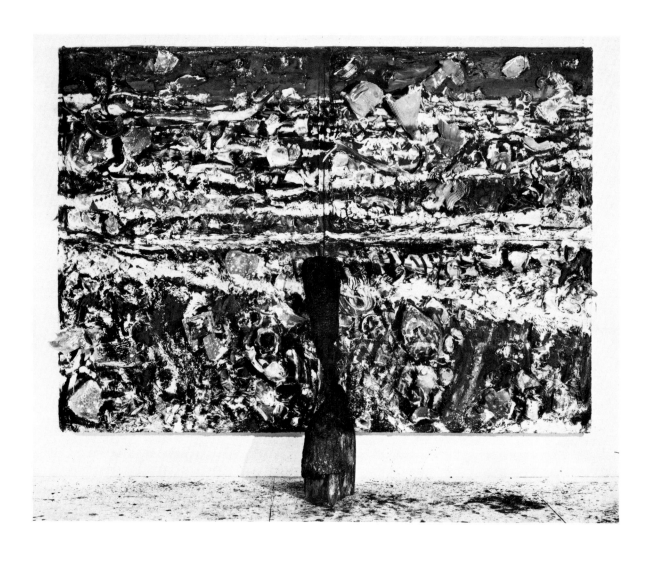

Julian Schnabel. *The Sea*, 1981.
Oil, pots, plaster, and wood, 120 x 156 in.
Collection of Charles and Doris Saatchi, London.

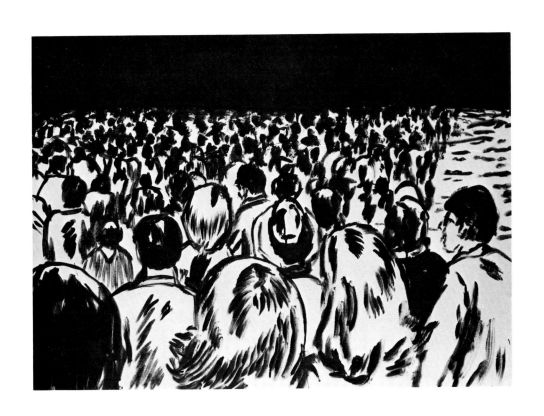

David Amico. *Crowd*, 1981.
Oil/enamel on canvas, 36 x 48 in.
Collection of Robert A. Rowan.

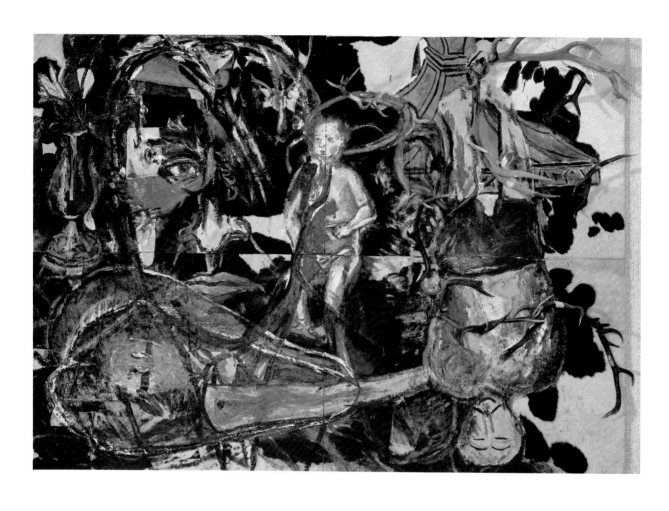

Julian Schnabel. *Pre-History: Glory, Honor, Privilege and Poverty*, 1981.
Oil and antlers on pony skin, 128 x 177 in.
Collection of Charles and Doris Saatchi, London.

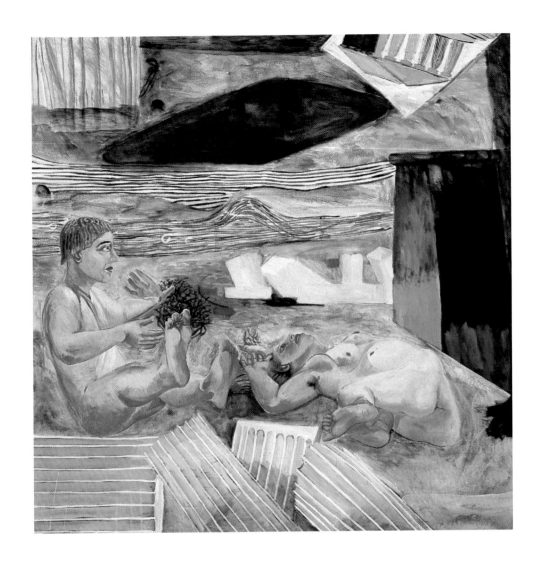

Charles Garabedian. *Ruin V*, 1981.
Acrylic on canvas, 72 x 72 in.
Collection of Robert A. Rowan.

Georg Baselitz. *Die Mädchen von Olmo*, 1981.
Oil on canvas, 98-1/2 x 97-1/2 in.
Collection of Charles and Doris Saatchi, London.

Anselm Kiefer. *Icarus: Märkischer Sand*, 1981.
Oil and sand on canvas, 114-1/4 x 141-3/4 in.
Collection of Charles and Doris Saatchi, London.

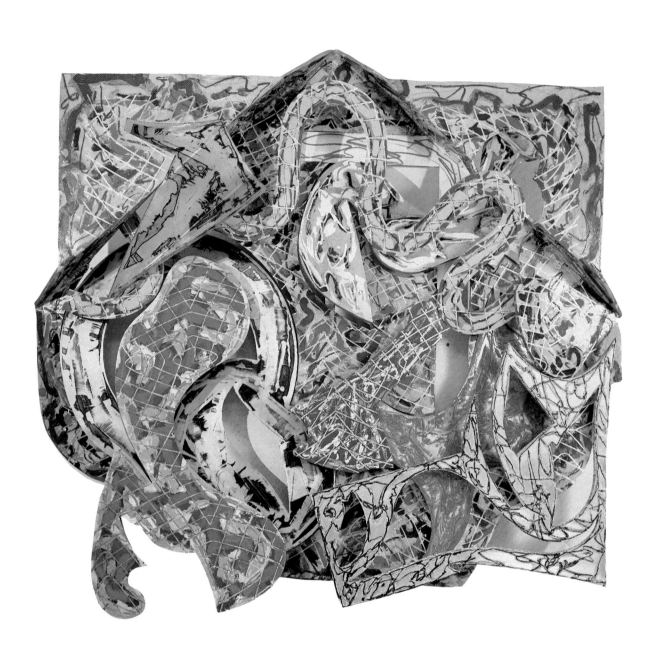

Frank Stella. *Thruxton*, 1981.
Mixed media on etched magnesium, 109-1/2 x 110-3/4 x 23 in.
Collection of Charles and Doris Saatchi, London.

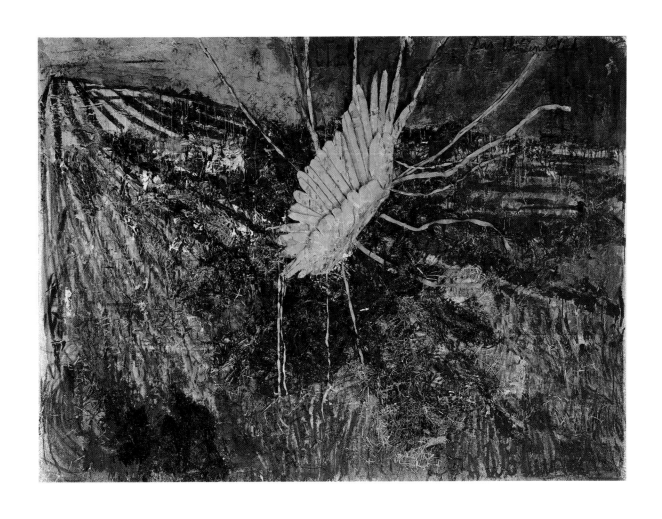

Anselm Kiefer. *Das Wolundlied*, 1982.
Oil, straw, and lead on canvas, 110-1/4 x 149-1/2 in.
Collection of Charles and Doris Saatchi, London.

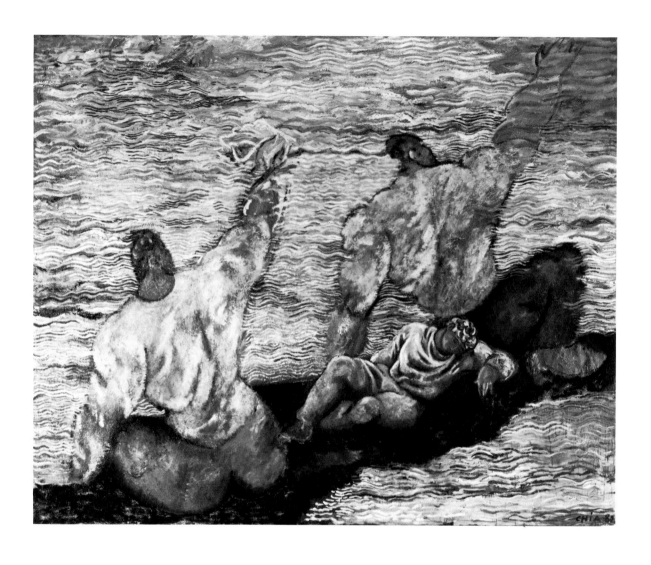

Sandro Chia. *Zattera Temeraria*, 1982.
Oil on canvas, 118 x 146 in.
Collection of Charles and Doris Saatchi, London.

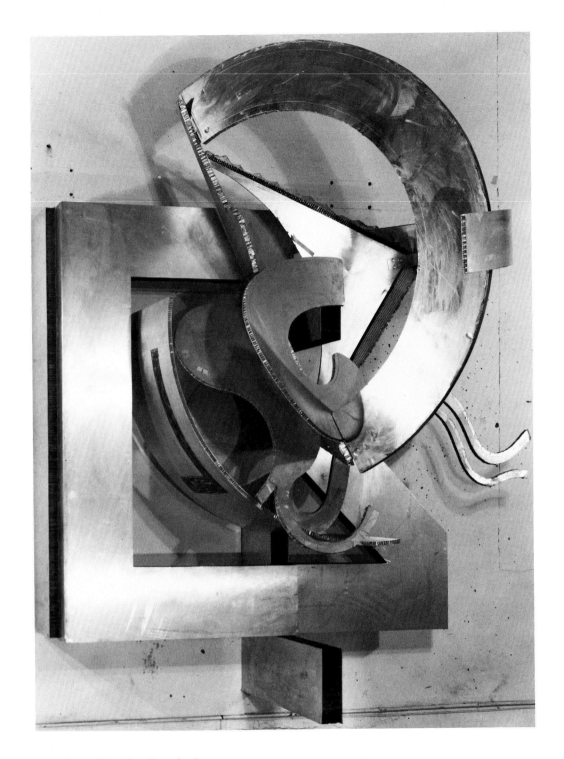

Frank Stella. *President Brand*, 1982.
Honeycomb aluminum, 121 x 101 x 78 in.
Collection of Charles and Doris Saatchi, London.

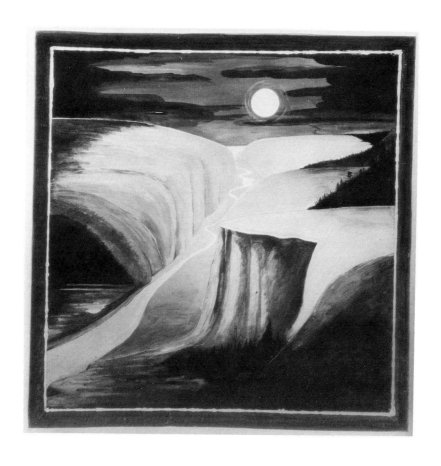

Mike Kelley. *Early American Landscape*
(from the project of meditation on a can of Vernors), 1983.
Acrylic on canvas with cardboard frame, 31-1/2 x 31-1/2 in.
Collection of Robert A. Rowan.

Richard Nonas. *New Slot*, 1983.
Collection of Giuseppe and Giovanna Panza di Biumo, Milan.
Studio version, 1983. Steel, 120 x 45 x 1 in.
Collection of the artist.

Maria Nordman
165 North Central, Los Angeles
November, 1983

Presented also in the context of the collection of
Giuseppe and Giovanna Panza di Biumo, Milan.

Checklist of the Exhibition

Dominique de Menil

Joseph Cornell
Untitled (Hotel Family, Parmigian-ino "Bel Antea" series), 1950–52
Wood box construction, 18-3/4 x 11 x 4-1/2 in.
Menil Foundation Collection, Houston

Joseph Cornell
Untitled (Medici Family, Bronzino "Dovecote" Variant), ca. 1952-55
Wood box construction, 15 x 10-1/4 x 2-1/2 in.
Menil Foundation Collection, Houston

Joseph Cornell
Untitled (Système de Descartes) ca. 1954
Wood box construction, 12 x 18 in.
Menil Foundation Collection, Houston

Walter de Maria
Triangle, 1972
Stainless steel, flat side to point: 39-1/2 in.; point to point: 45-5/8 in.; depth: 3-5/8 in.
Menil Foundation Collection, Houston

Walter de Maria
Circle, 1972
Stainless steel, diameter: 39-3/8 in.; depth: 3-5/8 in.
Menil Foundation Collection, Houston

Walter de Maria
Square, 1972
Stainless steel, 39-3/8 in. square; depth: 3-5/8 in.
Menil Foundation Collection, Houston

Jean Dubuffet
Desert Rose (Pink Desert), 1954
Oil on canvas, 44-7/8 x 57-1/2 in.
D. and J. de Menil Collection, Houston

Jean Dubuffet
Paysage aux Ivrognes, 1949
Oil on burlap, 35 x 45-1/2 in.
D. and J. de Menil Collection, Houston

Jean Fautrier
Grands végétaux, 1958
Oil on canvas, 38 x 52 in.
D. and J. de Menil Collection, Houston

Jasper Johns
Voice, 1964–67
Oil on canvas with objects, 96 x 69-1/2 in.
D. and J. de Menil Collection, Houston

Yves Klein
People Begin to Fly (ANT 96), 1961
Dry blue pigment in synthetic resin on paper on fabric, 97 x 156-1/2 in.
D. and J. de Menil Collection, Houston

Yves Klein
Requiem, blue (RE 20), 1960
Sponges, pebbles, and dry pigment in synthetic resin on board, 78-3/8 x 64-7/8 x 5-7/8 in.
D. and J. de Menil Collection, Houston

Yves Klein
Untitled blue monochrome (IKB), 1961
Dry pigment in synthetic resin on fabric on board, 28-3/4 x 21-1/4 x 1 in.
D. and J. de Menil Collection, Houston

Brice Marden
The Seasons, 1974–75
Oil and wax on canvas, four panels, 96 x 60 in. each
Menil Foundation Collection, Houston

Matta (Sebastian Antonio Matta Echaurren)
Je m'honte, 1948–49
Oil on canvas, 77 x 56 in.
D. and J. de Menil Collection, Houston

Matta (Sebastian Antonio Matta Echaurren)
The Green of Wheat, 1953
Oil on canvas, 81 x 124-1/2 in.
Menil Foundation Collection, Houston

Barnett Newman
Primordial Light, 1954
Oil on canvas, 96 x 50 in.
Menil Foundation Collection, Houston

David Novros
Room 3 (Untitled), 1973–75
Oil on canvas, Wall A: 120 x 178 in.; Wall B: 120 x 216 in.; Wall C: 120 x 178 in.
Promised gift to the Menil Foundation and the Fort Worth Art Museum jointly

Martial Raysse
South Islands Style Painting: Mediterranean Mood, 1966
Flocking and fluorescent paint on canvas, 76-3/4 x 78-3/4 in.
D. and J. de Menil Collection, Houston

Mark Rothko
The Green Stripe, 1955
Oil on canvas, 67 x 54 in.
D. and J. de Menil Collection, Houston

Mark Rothko
Untitled (alternative painting in the Rothko chapel series), 1965–66
Oil on canvas, 177-1/2 x 96 in.
Menil Foundation, Houston

Jean Tinguely
Fountain Sculpture, 1969
Scrap, junk metal, and motors from Houston junkyards, 107 x 37-1/2 x 66 in.
D. and J. de Menil Collection, Houston

Wols (Alfred Otto Wolfgang Schulze)
Oiseau, 1949
Oil on canvas, 36-1/4 x 25-5/8 in.
D. and J. de Menil Collection, Houston

Howard and Jean Lipman

Richard Artschwager
Description of Table, 1964
Formica, 26-1/4 x 32 x 32 in.
Collection of Whitney Museum of
American Art, Gift of the Howard
and Jean Lipman Foundation, Inc.

Alexander Calder
Indian Feathers, 1969
Painted aluminum sheet and stain-
less steel rods, 136-3/4 x 91 x 63 in.
Collection of Whitney Museum of
American Art, Gift of the Howard
and Jean Lipman Foundation, Inc.

Alexander Calder
Longnose, 1957
Painted steel plate, 98 x 103 x 64 in.
Collection of Howard and Jean
Lipman

Alexander Calder
Seascape, 1947
Metal, string, and wood, 36-1/2 x
60 x 21 in.
Collection of Whitney Museum of
American Art, Gift of the Howard
and Jean Lipman Foundation, Inc.
(and purchase)

John Chamberlain
Untitled, 1963
Metal, 31 x 37-1/2 x 28 in.
Collection of Whitney Museum of
American Art. Purchase, with funds
from the Howard and Jean Lipman
Foundation, Inc. (and exchange)

Bruce Conner
Medusa, 1960
Cardboard, hair, nylon, wax, and
wood, 10-3/4 x 11 x 22-1/4 in.
Collection of Whitney Museum of
American Art, Gift of the Howard
and Jean Lipman Foundation, Inc.

Walter de Maria
Blue Glass for Cornell, 1966
Glass and steel, 15-3/4 x 10-3/4
x 7-1/2 in.
Collection of Whitney Museum of
American Art, Gift of the Howard
and Jean Lipman Foundation, Inc.

Mark di Suvero
New York Dawn (for Lorca), 1965
Iron, steel, and wood, 78 x 74 x 50 in.

Collection of Whitney Museum of
American Art, Gift of the Howard
and Jean Lipman Foundation, Inc.

Ellsworth Kelly
Whites, 1963
Painted aluminum, 23 x 70-1/2
x 105-1/2 in.
Collection of Whitney Museum of
American Art, Gift of the Howard
and Jean Lipman Foundation, Inc.

Edward Kienholz
*The Friendly Grey Computer-Star
Gauge Model 54*, 1965
Motorized construction, 40 x 39-1/8
x 24-1/2 in., on aluminum sheet,
48-1/8 x 36 in.
The Museum of Modern Art, New
York, Gift of Howard and Jean
Lipman

Robert Morris
Untitled (L-beams), 1965
Stainless steel, 3 beams, 96 x 96
x 24 in. each
Collection of Whitney Museum of
American Art, Gift of Howard and
Jean Lipman

Louise Nevelson
Night-Focus-Dawn, 1969
Painted wood, 102 x 117 x 14 in.
Collection of Whitney Museum of
American Art, Gift of Howard and
Jean Lipman

Louise Nevelson
Royal Tide I, 1960
Wood painted gold, 96 x 40 x 8 in.
Collection of Howard and Jean
Lipman

Louise Nevelson
Transparent Sculpture VI, 1967–68
Plexiglas, 19 x 20 x 8 in.
Collection of Whitney Museum of
American Art, Gift of Howard and
Jean Lipman Foundation, Inc.

Isamu Noguchi
Endless Coupling, 1957
Iron, 96 in. high
Collection of Whitney Museum of
American Art, Gift of Howard and
Jean Lipman

Claes Oldenburg
Dormeyer Mixer, 1965
Kapok, vinyl, and wood, 32 x 20
x 12-1/2 in.
Collection of Whitney Museum of
American Art, Gift of the Howard
and Jean Lipman Foundation, Inc.

Kenneth Price
S. L. Green, 1963
Painted clay, 9-1/2 x 10-1/2 x 10-1/2 in.
Collection of Whitney Museum of
American Art, Gift of the Howard
and Jean Lipman Foundation, Inc.

Lucas Samaras
Box #41, 1965
Wood covered with yarn, 17-1/8 x
13-3/4 x 38 in. open; 17-1/8 x 10-1/4
x 25 in. closed
Collection of Whitney Museum of
American Art, Gift of Howard and
Jean Lipman

George Segal
The Bus Station, 1965
Plaster, wood, formica, metal, vinyl,
cardboard, and leather, 96-1/4 x
59-1/8 x 29-3/4 in.
Collection of Whitney Museum of
American Art, Gift of Howard and
Jean Lipman

David Smith
Cubi XXI, 1964
Stainless steel, 119-1/2 in. high
Collection of Howard and Jean
Lipman. On extended loan to
Whitney Museum of American Art

David Smith
Tank Totem #5, 1955–56
Steel, 96-3/4 x 52 x 15 in.
Collection of Howard and Jean
Lipman. On extended loan to
Whitney Museum of American Art

David Smith
Zig IV, 1961
Steel, 95-3/8 x 84-1/4 x 76 in.
Lincoln Center for the Performing
Arts, Gift of Howard and Jean
Lipman

Keith Sonnier
Ba-O-Ba, Number 3, 1969
Glass and neon, 91-1/4 x 122-3/4
x 24 in.

Collection of Whitney Museum of American Art, Gift of Howard and Jean Lipman Foundation, Inc.

H.C. Westermann
The Evil New War God, 1958
Brass, partly chrome-plated, 16-3/4 x 9-1/4 x 10-1/4 in.
Promised gift to Whitney Museum of American Art by Howard and Jean Lipman

Drs. Peter and Irene Ludwig

Joseph Beuys
Doppelaggregat, 1959 (1969)
Bronze, 42-1/2 x 84-1/4 x 31 in.
Museum Ludwig, Cologne, Gift of Peter and Irene Ludwig

Joseph Beuys
Val, 1959 (1969)
Bronze, 10-1/4 x 50-1/2 x 29-1/2 in.
Museum Ludwig, Cologne, Gift of Peter and Irene Ludwig

Chuck Close
Richard, 1969
Acrylic on canvas, 107-3/4 x 83-3/4 in.
Ludwig Collection, Neue Galerie, Aachen

Ralph Goings
Airstream, 1970
Oil on canvas, 59-3/4 x 84-1/4 in.
Museum Moderner Kunst, Vienna.
On loan from Ludwig Collection, Aachen

Richard Hamilton
My Marilyn, 1964
Collage, oil, and paper, 40-1/4 x 48 in.
Ludwig Collection, Neue Galerie, Aachen

Eva Hesse
Accession III, 1968
Fiberglass, 31-1/2 x 31-1/2 x 31-1/2 in.
Museum Ludwig, Cologne, Gift of Peter and Irene Ludwig

Jasper Johns
Painted Bronze, 1960
Bronze and paint, 5-1/2 x 8 x 4-1/4 in.
Ludwig Collection, Kunstmuseum, Basel

Franz Kline
Scranton, 1960
Oil on canvas, 69-3/4 x 49 in.
Ludwig Collection, Museum Ludwig, Cologne

Yayoi Kusama
Compulsion Furniture, 1966
Mixed media, fabric, 81-1/2 x 22-1/2 in.
Museum Ludwig, Cologne, Gift of Peter and Irene Ludwig

Roy Lichtenstein
Takka Takka, 1962
Magna on canvas, 68 x 56-1/4 in.
Museum Ludwig, Cologne, Gift of Peter and Irene Ludwig

Blinky Palermo
Himmelsrichtungen I, 1976
Acrylic on aluminum, four panels, 10-1/2 x 8-1/4 in. each
Ludwig Collection, Museum Ludwig, Cologne

Mel Ramos
Batmobile, 1962
Oil on canvas, 50-1/4 x 44 in.
Museum Moderner Kunst, Vienna.
On loan from Ludwig Collection, Aachen

Robert Rauschenberg
Black Market, 1961
Mixed media, 59-3/4 x 50 in.
Museum Ludwig, Cologne, Gift of Peter and Irene Ludwig

Gerhard Richter
Das Parkstück, 1971
Oil on canvas, 5 panels, 98-1/2 x 246 in.
Museum Moderner Kunst, Vienna.
On loan from Ludwig Collection, Aachen.

James Rosenquist
Untitled (Joan Crawford Says), 1964
Oil on canvas, 95-1/4 x 77-1/4 in.
Museum Ludwig, Cologne, Gift of Peter and Irene Ludwig

Wayne Thiebaud
Cake Counter, 1963
Oil on canvas, 36-1/4 x 72 in.
Museum Ludwig, Cologne, Gift of Peter and Irene Ludwig

Richard Tuttle
Untitled, 1968
Fabric, 58-1/4 x 70-3/4 in.
Museum Ludwig, Cologne, Gift of Peter and Irene Ludwig

Cy Twombly
Crimes of Passion, 1960
Oil, crayon, and pencil on canvas, 74-3/4 x 78-3/4 in.
Museum Ludwig, Cologne, Gift of Peter and Irene Ludwig

Andy Warhol
28 Brillo Boxes, 1964
Acrylic and silkscreen on wood, 17-1/4 x 17 x 14 in.
Ludwig Collection, Neue Galerie, Aachen

Andy Warhol
14 Campbell Boxes, 1964
Acrylic and silkscreen on wood, 10 x 19 x 9-1/2 in each.
Ludwig Collection, Neue Galerie, Aachen.

Andy Warhol
129 Die in Jet Plane Crash, 1962
Acrylic on canvas, 100-1/4 x 71-3/4 in.
Museum Ludwig, Cologne, Gift of Peter and Irene Ludwig

Tom Wesselmann
Landscape No. 2, 1964
Mixed media, 76 x 94 in.
Museum Ludwig, Cologne, Gift of Peter and Irene Ludwig

Giuseppe and Giovanna Panza di Biumo

Carl Andre
249 Brass Run, 1969
249 brass plates, 2-1/2 x 3-1/4 in. each
Collection of Giuseppe and Giovanna Panza di Biumo, Milan

Larry Bell
Two Glass Walls, 1971–72
Glass, 96 x 60 x 3/4 in. each
Collection of Giuseppe and Giovanna Panza di Biumo, Milan

Hanne Darboven
42N–33K–00–99=NO1–2K–20K, 1969–70
Ink on paper, 138 pages (framed

separately), 11-1/2 x 8-1/4 in. each
Collection of Giuseppe and
Giovanna Panza di Biumo, Milan

Dan Flavin
Untitled (to Flavin Starbuck Judd),
1968
Blue and red fluorescent light,
approximately 24 x 540 in.
Collection of Giuseppe and
Giovanna Panza di Biumo, Milan

Douglas Huebler
Variable Piece #4, 1968
One statement, 10 black and white
photographs, 8 x 10 in. each
Collection of Giuseppe and
Giovanna Panza di Biumo, Milan

Robert Irwin
Untitled, 1966–67
Painting on aluminum, 60 in. in
diameter
Collection of Giuseppe and
Giovanna Panza di Biumo, Milan

Donald Judd
Untitled, 1974
Plywood, dimensions for this
exhibition: 48 x 408 x 96 in.
Collection of Giuseppe and
Giovanna Panza di Biumo, Milan

Joseph Kosuth
The Eighth Investigation
Proposition 3, 1971
Mixed materials
Collection of Giuseppe and
Giovanna Panza di Biumo, Milan

Sol LeWitt
*Wall Drawing #267. A wall divided
into sixteen equal parts with all
one-, two-, three-, and four-part
combinations of lines in four direc-
tions and four colors. First drawn
by J. Imanishi, Kazuko Miyamoto,
S. Stavris, and Jo Watanabe, July
1975.*
Colored pencils on white wall,
dimensions determined by mea-
surement of wall
Collection of Giuseppe and
Giovanna Panza di Biumo, Milan

Bruce Nauman
Red, Yellow and Blue, 1970

Colored fluorescent light, wood,
and wall board. Red corridor: 36
in. wide; yellow corridor: 24 in.
wide; blue corridor: 12 in. wide;
dimensions for this exhibition: 288
in. square.
Collection of Giuseppe and
Giovanna Panza di Biumo, Milan

Richard Nonas
New Slot, 1983
Steel, 120 x 45 x 1 in.
Collection of Giuseppe and
Giovanna Panza di Biumo, Milan

Maria Nordman
165 North Central, Los Angeles,
November 1983
Presented also in the context of the
collection of Giuseppe and
Giovanna Panza di Biumo, Milan

Eric Orr
Zero Mass, 1975
Light, 144 x 456 x 138 in.
Collection of Giuseppe and
Giovanna Panza di Biumo, Milan

Richard Serra
Strike, 1969–71
Steel plate, 96 x 288 x 1-1/2 in.
Collection of Giuseppe and
Giovanna Panza di Biumo, Milan

Joel Shapiro
Untitled, 1974
Iron, 5-1/2 x 6-3/4 x 5 in.
Collection of Giuseppe and
Giovanna Panza di Biumo, Milan

Lawrence Weiner
*To the Sea, On the Sea, From the
Sea, At the Sea, Bordering the Sea,*
1970
Language plus seawater, dimen-
sions variable
Collection of Giuseppe and
Giovanna Panza di Biumo, Milan

Doug Wheeler
SA MI DW SM 2 75 TC LA, 1975
Two rooms, 8-kw quartz halogen
lights, black ultraviolet fluorescent
light, white ultraviolet neon light,
automatic dimmer, 312 x 360 in.
and 390 x 570 in.
Collection of Giuseppe and
Giovanna Panza di Biumo, Milan

Robert A. Rowan

John Altoon
Untitled, 1967
Oil on canvas, 60 x 48 in.
Collection of Robert A. Rowan

David Amico
Crowd, 1981
Oil/enamel on canvas, 36 x 48 in.
Collection of Robert A. Rowan

Billy Al Bengston
Count Dracula I, 1960
Oil on canvas, 48 x 48 in.
Collection of Robert A. Rowan

Karen Carson
Sunrise/Sunset, 1979
Oil on canvas, 84 x 96 in.
Collection of Robert A. Rowan

Ron Davis
Bent Vents and Octangular, 1976
Vinyl-acrylic copolymer and dry
pigment on canvas, 114 x 180 in.
Collection of The Museum of Con-
temporary Art, Los Angeles, Gift of
Robert A. Rowan

Richard Diebenkorn
Ocean Park No. 37, 1971
Oil on canvas, 50 x 50 in.
Collection of Robert A. Rowan

Charles Garabedian
Ruin V, 1981
Acrylic on canvas, 72 x 72 in.
Collection of Robert A. Rowan

Craig Kauffman
Studio, 1958
Oil on linen, 61 x 51 in.
Collection of Robert A. Rowan

Mike Kelley
Early American Landscape (from
the project of meditation on a can
of Vernors), 1983
Acrylic on canvas with cardboard
frame, 31-1/2 x 31-1/2 in.
Collection of Robert A. Rowan

Morris Louis
Nu, 1960
Acrylic on canvas, 103 x 170 in.
Collection of Robert A. Rowan

Morris Louis
Samach, 1958–59
Acrylic on canvas, 97 x 140 in.
Collection of Robert A. Rowan

John McCracken
The Case for Fakery in Beauty, 1967
Wood and fiberglass, 120 x 18 x
3-1/2 in.
Collection of Robert A. Rowan

John McLaughlin
#17, 1961
Oil on canvas, 48 x 60 in.
Collection of Robert A. Rowan

Kenneth Noland
Via Media (Suddenly), 1963
Acrylic on canvas, 102 x 130 in.
Collection of Robert A. Rowan

Jules Olitski
Tender Boogus, 1967–68
Acrylic water-base paint on canvas,
133 x 258 in.
Collection of The Museum of Con-
temporary Art, Los Angeles, Gift of
Robert A. Rowan

Frank Stella
Tomlinson Court Park, 1959–60
Enamel on canvas, 84 x 108 in.
Collection of Robert A. Rowan

William Wiley
Village Green, 1974
Acrylic and charcoal on canvas,
88-1/2 x 77-1/2 in.
Collection of Robert A. Rowan

Charles and Doris Saatchi

Georg Baselitz
B. for Larry, 1967
Oil on canvas, 98-1/2 x 78-3/4
Collection of Charles and Doris
Saatchi, London

Georg Baselitz
Die Mädchen von Olmo, 1981
Oil on canvas, 98-1/2 x 97-1/2 in.
Collection of Charles and Doris
Saatchi, London

Sandro Chia
Verso Damasco, 1980
Oil on canvas, 90-1/2 x 153-1/2 in.
Collection of Charles and Doris
Saatchi, London

Sandro Chia
Zattera Temeraria, 1982
Oil on canvas, 118 x 146 in.
Collection of Charles and Doris
Saatchi, London

Francesco Clemente
The Magi, 1980
Fresco, 78-3/4 x 118 in.
Collection of Charles and Doris
Saatchi, London

Francesco Clemente
The Smoke in the Room, 1981
Fresco, 78-3/4 x 118 in.
Collection of Charles and Doris
Saatchi, London

Philip Guston
Frame, 1976
Oil on canvas, 74 x 116 in.
Collection of Charles and Doris
Saatchi, London

Philip Guston
Friend to M.F., 1978
Oil on canvas, 66 x 88 in.
Collection of Charles and Doris
Saatchi, London

Anselm Kiefer
Icarus: Märkischer Sand, 1981
Oil and sand on canvas, 114-1/4 x
141-3/4 in.
Collection of Charles and Doris
Saatchi, London

Anselm Kiefer
Das Wolundlied, 1982
Oil, straw, and lead on canvas,
110-1/4 x 149-1/2 in.
Collection of Charles and Doris
Saatchi, London

Malcolm Morley
Age of Catastrophe, 1976
Oil on canvas, 60 x 96 in.
Collection of Charles and Doris
Saatchi, London

Malcolm Morley
School of Athens, 1972
Oil on canvas, 67 x 94-1/2 in.
Collection of Charles and Doris
Saatchi, London

Julian Schnabel
*Pre-History: Glory, Honor, Privilege
and Poverty*, 1981
Oil and antlers on pony skin, 128 x
177 in.
Collection of Charles and Doris
Saatchi, London

Julian Schnabel
The Sea, 1981
Oil, pots, plaster, and wood,
120 x 156 in.
Collection of Charles and Doris
Saatchi, London

Frank Stella
Thruxton, 1981
Mixed media on etched mag-
nesium, 109-1/2 x 110-3/4 x 23 in.
Collection of Charles and Doris
Saatchi, London

Frank Stella
President Brand, 1982
Honeycomb aluminum, 121 x 101
x 78 in.
Collection of Charles and Doris
Saatchi, London

Taft and Rita Schreiber

Joseph Albers
*Homage to the Square: Beyond
Focus*, 1969
Oil on masonite, 48 x 48 in.
Collection of Taft and Rita
Schreiber and The Los Angeles
County Museum of Art

Nicolas de Staël
The Football Players, 1952
Oil on cardboard, 24 x 29-1/2 in.
Collection of Taft and Rita
Schreiber

Alberto Giacometti
*Interior of Studio with Man Point-
ing and Three Apples*, 1950
Oil on canvas, 22 x 16-1/4 in.
Collection of Taft and Rita
Schreiber

Alberto Giacometti
Tall Figure II, 1960
Bronze, 108-1/2 in. high
Collection of Taft and Rita
Schreiber

Alberto Giacometti
Tall Figure III, 1960
Bronze, 92 in. high
Collection of Taft and Rita
Schreiber

Arshile Gorky
Betrothal I, 1947

Oil on paper on composition board, 51-1/2 x 40 in.
Collection of Taft and Rita Schreiber

Joan Miró
Personnages dans la nuit, 1949
Oil on canvas/burlap, 35 x 45-3/4 in.
Collection of Taft and Rita Schreiber

Piet Mondrian
Abstract Painting, 1939
Oil on canvas, 17-5/8 x 15 in.
Collection of Taft and Rita Schreiber

Jackson Pollock
No. 1, 1949
Duco and aluminum paint on canvas, 63-1/8 x 102-1/8 in.
Collection of Taft and Rita Schreiber

Mark Tobey
Lake, 1959
Tempera, 10 x 12-1/4 in.
Collection of Taft and Rita Schreiber

The Weisman Family

Lita Albuquerque
California Sunrise, 1977
Oil on kimdura, 37-1/2 x 114 in.
Collection of the Weisman Family–Frederick R. Weisman

Willem de Kooning
Dark Pond, 1948
Oil on canvas, 46-1/2 x 55-1/2 in.
Collection of the Weisman Family–Richard L. Weisman

Willem de Kooning
Pink Angels, 1947
Oil on canvas, 52 x 40 in.
Collection of the Weisman Family–Richard L. Weisman

Laddie John Dill
Untitled, 1975
Plywood, cement and polymer emulsion, plate glass, and silicone, 83-1/2 x 59-1/2 in.
Collection of the Weisman Family–Frederick R. Weisman

Lorser Feitelson
Untitled, 1966
Enamel on canvas, 72 x 60 in.
Collection of the Weisman Family–Richard L. Weisman

Sam Francis
Untitled ("Blue Balls" series), 1961
Oil on canvas, 73 x 98 in.
Collection of the Weisman Family–Marcia S. Weisman

Robert Graham
Mirror Figure, 1973–76
Bronze, 60 x 35 x 8-1/2 in.
Collection of the Weisman Family–Marcia S. Weisman

Hans Hofmann
Equipoise, 1958
Oil on canvas, 60 x 52 in.
Collection of the Weisman Family–Marcia S. Weisman

Jasper Johns
The Map, 1962–63
Oil on canvas, 60 x 93 in.
Collection of the Weisman Family–Marcia S. Weisman

John Mason
Untitled (*Green Spear*), 1961
Fired clay, 83 x 59 x 6 in.
Collection of the Weisman Family–Richard L. Weisman

Ed Moses
Cubist Painting #1, 1975–76
Acrylic on canvas, 78 x 66 in.
Collection of the Weisman Family–Frederick R. Weisman

Barnett Newman
Here I (to Marcia), cast 1962
Bronze, 107-1/4 x 28-1/4 x 27-1/4 in.
Collection of the Weisman Family–Marcia S. Weisman

Barnett Newman
Onement VI, 1953
Oil on canvas, 102 x 120 in.
Collection of the Weisman Family–Richard L. Weisman

Jackson Pollock
Scent, 1955
Oil on canvas, 79 x 57-1/2 in.

Collection of the Weisman Family–Marcia S. Weisman

Robert Rauschenberg
Red Painting, 1953
Oil, fabric, and newsprint on canvas, 76 x 51 x 2-3/4 in.
Collection of the Weisman Family–Frederick R. Weisman

Ad Reinhardt
Red Painting, 1963
Oil on canvas, 30 x 30 in.
Collection of the Weisman Family–Marcia S. Weisman

Mark Rothko
Untitled, 1957
Oil on canvas, 79-1/2 x 69-1/2 in.
Collection of the Weisman Family–Richard L. Weisman

Clyfford Still
1947-M, 1947
Oil on canvas, 105 x 92 in.
Collection of the Weisman Family–Richard L. Weisman

Clyfford Still
Untitled, 1951
Oil on canvas, 108 x 92-1/2 in.
Collection of the Weisman Family–Marcia S. Weisman

Peter Voulkos
Flying Black, 1958
Fired clay, 40 in. high
Collection of the Weisman Family–Richard L. Weisman

Photographic Credits

Photographs of artwork reproduced in this catalogue have, in most instances, been provided by the owners or custodians of the work, as cited in the accompanying captions. Additional credit for photographs is given in the following list.

Lita Albuquerque: p. 266

BC Photography, Laguna Beach, California: p. 260

Larry Bell: p. 248

Rheinisches Bildarchiv, Cologne: pp. 179, 197, 205, 207, 230, 231

Mary Boone Gallery, New York: p. 277

Rudolph Burckhardt, New York: pp. 172, 186, 191

Leo Castelli Gallery: pp. 229, 238, 246, 281

Geoffrey Clements Photography, New York: pp. 165, 180, 200, 203, 210, 213, 214, 216, 217, 218, 219, 227, 234

Bevan Davis Photography, New York: p. 265

E.P. Dutton: p. 193 (from a photograph taken by David Smith at his home in Bolton Landing, New York)

Xavier Fourcade, Inc., New York: p. 250

Ann Gold, Aachen: p. 206, 208, 239

Robert Graham: p. 251

Hickey-Robertson Photography, Houston: pp. 152, 160, 185, 188, 189, 220, 249, 252, 253

Hans Hinz, Basel: p. 184

Nancy Hoffman Gallery, New York: p. 265

Bruce C. Jones Fine Art Photography, New York: p. 281

Ulrike Kantor Gallery, Los Angeles: p. 273

L.A. Louver Gallery, Venice, California: p. 275

R. Mates: p. 148

David McKee, Inc., New York: p. 263

A. Mewbourn, Houston: p. 223

Peter Moore, New York: p. 238

Galerie Neuendorf, Hamburg: p. 276

Richard Nonas: p. 283

Douglas M. Parker, Los Angeles: pp. 145, 146, 174, 190

R. Peterson: p. 215

Eric Pollitzer, New York: p. 228

Robert Rauschenberg: p. 191

F. Wilbur Seiders: pp. 151, 157, 161

Gian Sinigaglia, Milan: pp. 232, 240, 243, 255

Steven Sloman Fine Art Photography, New York: p. 263

Taylor & Dull Photography, New York: p. 171

Grant Taylor Photography: p. 262

Frank J. Thomas Photography, Los Angeles: pp. 169, 178, 187, 194, 256

Jerry L. Thompson, New York: pp. 166, 167, 204, 211, 237

University Art Museum, California State University, Long Beach: p. 260

Tom Vinetz, Los Angeles: pp. 141, 144, 149, 158, 159, 163, 168, 173, 198, 199, 201, 224, 226, 241, 254, 257, 258, 259, 261, 282

Zindman/Fremont Photography, New York: p. 277